Library Learning Information

Idea Store®
Whitechapel
321 Whitechapel Road
London E1 1BU

020 7364 4332
www.ideastore.co.uk

Created and managed by
Tower Hamlets Council

WILD SWIM

River, lake, lido and sea: the best

places to swim outdoors in Britain

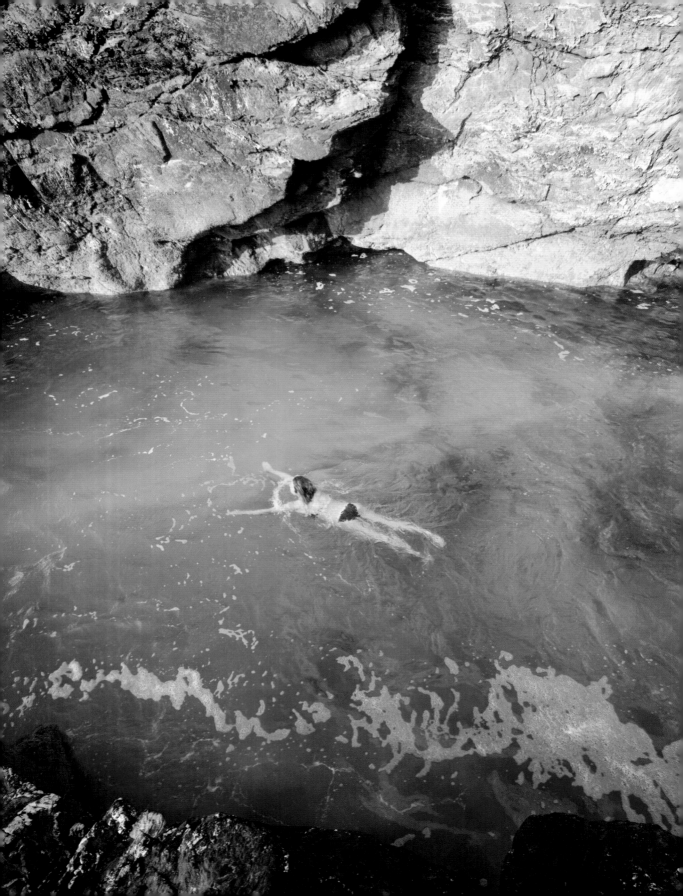

WILD SWIM

River, lake, lido and sea: the best
places to swim outdoors in Britain

Kate Rew

Photography By
Dominick Tyler

guardianbooks

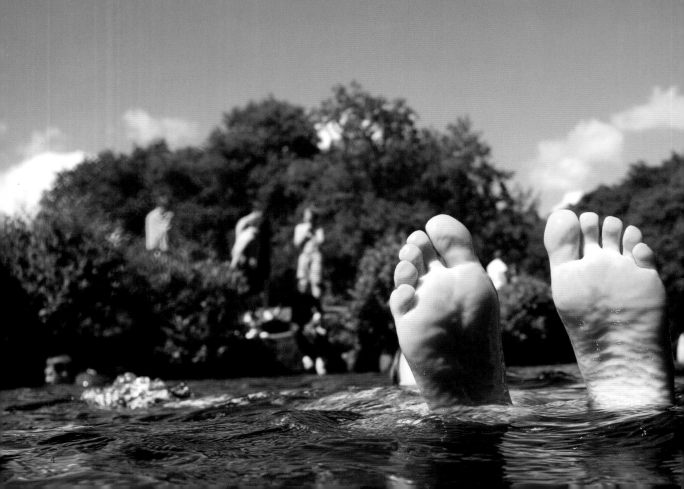

In memory of my grandmother, Doris

K R

To Sarah and Martha

D T

SWIMMING SONG

This summer I went swimming
This summer I might have drowned
But I held my breath, I kicked my feet
I moved my arms around
I moved my arms around

This summer I swam in the ocean
And I swam in a swimming pool
Salt my wounds, chlorined my eyes
I'm a self-destructive fool
Self-destructive fool

This summer I did the back stroke
And you know that that's not all
I did the breast stroke, the butterfly
And the old Australian crawl
The old Australian crawl

This summer I swam in a public place
And a reservoir to boot
At the latter I was informal
At the former I wore my suit
I wore my swimming suit

Oh, this summer I did swan dives
And jack-knives for you all
And once when you weren't looking
I did a cannon-ball
I did a cannon-ball

This summer I went swimming
This summer I might have drowned
But I held my breath, I kicked my feet
And moved my arms around
I moved my arms around

Loudon Wainwright III

Spitchwick Common, Dartmoor, Devon.

CONTENTS

FOREWORD

To enter wild water is to cross a border. You pass the lake's edge, the sea's shore, the river's brink, and you break the surface of the water itself. In doing so, you move from one realm into another: a realm of freedom, adventure, magic and occasionally of danger.

So the book you hold in your hands isn't so much a guidebook as a passport to a different world or worlds. For once you see open water as something to be entered, rather than driven around, flown over or stopped at the brink of, and even familiar landscapes become rife with adventure. Britain seems newly permeable, excitingly deepened. Every lake or loch or lough or llyn is a bathing pool, every river a journey, every tide or wave a free ride. As a wild swimmer, you become an explorer of the undiscovered country of the nearby, passing through great geological portals (Durdle Door in Dorset), floating over drowned cities (Dunwich in Suffolk) and kelp jungles (The Isles of Scilly), spelunking into sea-caves (The Llyn Peninsula), or stroking out into the centre of cold Loch Ness, where the water – as Kate Rew beautifully puts it – is 'black as space'.

There's nothing faintly class-based about all of this. What could be more democratic than swimming? What more equalising than near-nakedness? You need even less equipment to swim than you do to play football. A bathing costume, if you insist. Then, just enough common sense to avoid drowning and just enough lunacy to dive in.

A century ago, Britain had hundreds of outdoor swimming clubs: The New Town Water Rats, The Tadpoles, The Serpentine, The Sheep's Green Swimmers, The Highgate Diving Club...names that now seem to shimmer in a sepia haze. Back then, it didn't seem remotely eccentric to wallow in a tidal pool, or crawl down a flashy river. But after the Second World War came the decline of lido culture, the rise of the municipal pool, the pollution of the river systems, and the understandable prizing of what we oddly call creature-comforts: air-conditioning, thermostats, the sofa.

Over the past decade or so, however, a desire for what might be termed 'reconnection' has emerged. A yearning to recover a sense of how the natural world smells, tastes and sounds. More and more people are being drawn back to the woods, hills and waters of Britain and Ireland. More and more would agree with Gary Snyder (forester, poet, tool-maker, Buddhist) when he writes: 'That's the way to see the world, in our own bodies.' As though our skin has eyes. Which, in a way, it does.

For when you are swimming outdoors your sensorium is transformed. You see the world in All-New Glorious Full-Body Technicolour! Everything alters, including the colour of your skin: coin-bronze in peaty water, soft green near chalk, blue over sand. You gain a stealth and discretion quite unachievable on land – you can creep past chub and roach, or over trout and pike, finning subtly to keep themselves straight in the current. You can swim with seals or eels (take your pick; I know which I prefer). You acquire what my friend Roger Deakin, author of Waterlog – a powerful inspiration for Wild Swim – once called 'a frog's eye view' of things.

And the smells! The green scent of the riverbank. The estuary's Limpopo-gunge whiff. The mineral smell of high mountain lakes. Virginia Woolf, who used to bathe in the River Cam, near Granchester, described its odour as one of 'mint and mud'. When I first came across this phrase, I misread it as 'mind and mud', which also seemed right for that university river.

'You can never step into the same stream', noted Heraclitus, philosopher of flux, back in the fifth century BC, 'for new waters are always flowing onto you'. Just so: a version of the truth that you can never go for the same wild swim twice. Weather, tide, current, temperature, company – all of these shift between swims. Different types of water actually feel different. Wild water comes in flavours. Not just salt and fresh, but different kinds of fresh. Next time you're on chalkland, for instance, find a spring or a river, and take up a handful of water as you might do a handful of earth. It feels...silky between the fingers. Smooth, almost rounded. Quite different to granite water or slate water.

Let's be clear, though, wild swimming is about beauty and strangeness and transformation – but it's also about companionship, fun, and a hot cup of tea or nip of whisky afterwards. Nor do all wild swims have to take place in what we might conventionally call a wild place. It's among the many merits of this book that it doesn't shy away from the agricultural-industrial aspect to outdoor swimming in Britain. Some of the most memorable plunges described here occur in sight of a nuclear power station, or a farm building or pig ark, or off a sea-beach thick with marine debris (those two-stroke oil bottles, those Tetrapak cartons, those ubiquitous chunks of sofa foam).

There's also the question of the cold. I used to be something of a cold-water fetishist. I have dipped into a part-frozen Himalayan river, bathed at midwinter in an imperial lake in Beijing, and once cracked the ice on a Cumbrian tarn and plunged in. But a dive into a Devon lake on New Year's Day, which left me green and nauseous with shock, has now put me off really cold-water swimming. Still, even in summer, there's no avoiding what James Joyce unforgettably called 'the scrotumtightening' moment of entry – which is usually accompanied by noisy intakes and expulsions of breath, raucous hooo-s, and haaa-s. Kate Rew has coined a great new verb to describe the first few strokes of swimming in chilly water: 'to fwaw' (as in 'I fwaw fwaw fwawed into the middle of the lake'). I hope it makes it into the OED.

Wild Swim is a lovely book in all its aspects. Its tone accommodates comedy, glee, beauty, discomfort and hard fact. It's inspiring, without being prescriptive. It sends the mind out adventuring, but also makes specific adventure possible. There are some fine touches: the 'oil-rig' water that Kate finds roiling darkly around the legs of the Brighton piers, or Dominick Tyler's description of a llyn up in the Rhinog hills as 'gruff' – so unexpected as an adjective, so exactly right (not least because the Rhinogs have a healthy population of wild goats).

This is a wonderful – in the old sense of that word – and joyful romp of a book. It's been researched with bravery and impishness and written with the same qualities: a dash of Huck Finn and plenty of Mole and Ratty. Roger Deakin spoke to me several times about his wariness of any commercialisation of wild swimming. He was concerned that the improvisation of it all would be lost. But I know that he would have approved of Wild Swim. This is a book that, like Waterlog, will launch a thousand swimmers. So go on. Dive in.

Robert Macfarlane, April 2008

INTRODUCTION

Wild Swim is by no means an exhaustive catalogue of places to swim; there are far too many glorious swims in the UK to fit into one book. Nor is it a definitive guide to the places we do describe. Each will be different every time you visit and different again for every swimmer.

As with any attempt to record the nature of water, we have had to decide whether to fight it or go with the flow, to try to pin it down with absolutes or to let it wash over us and leave its impressions on our eyes, our skin and our minds. What we present here are those impressions from over a hundred exceptional swims together with all the practical information you will need to follow our journeys, plus a further 200 referenced swim spots for you to explore for yourself.

Each sea, river, and lake swim in the main section of this book has a swim rating – easy: accessible for anyone who can swim; moderate: requires greater swim ability, confidence in water or awareness of conditions; or advanced: may involve a longer swim or walk or require the ability to read a map or research tides and currents.

We have embraced British inconsistency when it comes to metric and imperial measurements: heights are given in feet, road journeys and walks in miles, but swim distances in metres and kilometres, so they can easily be equated to laps in a pool (outdoors, we hope). A glossary explains any less familiar 'Wild Swimming Terminology' used in the text and 'Featured Wild Swimmers' introduces Vicky, Kari, Michael and a few others frequently mentioned in the text.

After we've inspired you with our adventures, the 'Resources' section at the end of the book gives general advice on technique, safety, kit and access issues. (If you're new to wild swimming, please read the safety tips before plunging in!)

Within 'Resources' there are also four directories. The first three provide details of lidos and outdoor pools, tidal pools and popular training sites around the country while the fourth lists festive swims that wild swimmers can take part in every year – all are fun and safe ways to dip your toe into the world of outdoor swimming. Finally, there's a map to locate all 307 swims referenced in this book, plus a guide to swims by county.

Swim trips are an adventure, you make them up as you go along, and like all creative endeavours there's the chance that things won't turn out the way you thought – that it'll be cold and bleak and you'll forget your towel. What we found is that it didn't matter if it didn't turn out 'right'. Some days the water would sparkle and the sun would be high and other days we'd mistime the tides and end up sitting in a car rocking in the wind as the sky went black. But we never had a bad swim, because there was always freedom and spontaneity and fun.

We hope that this book will become a valued companion to many wild swimmers, not only as a guide to swimming places but also as an inspiration for, and celebration of, swimming outdoors in Britain.

Kate Rew and Dominick Tyler

1 SEA & TIDAL POOLS

Sea swimming opens up a different world to swimmers. Pounding surf, buoyant salt water, seals, crabs and cliffs: these are experiences we don't get anywhere else.

Some enjoy the sea's unruly nature; being bobbed up and down by waves, moving with the ebb and flow of the tides. The open sea is a force that one can learn to be with, but not one that can be controlled or contained.

Some prefer long calm beaches where you can stretch out in an endless front crawl never far out of your depth, a view of a cliff or horizon seen under each front-crawling arm. In the sea you can circumnavigate islands or skinny dip with seals on white sand beaches, snorkel above crabs and kelp forests, or wave your hands around like an aquatic Merlin should you be lucky enough to find a warm shallow bay with phosphorescence at night.

For some people who live along the coast, the sea is their life: going to bed and waking up with the sound of the surf, taking a morning dip come rain, shine or hailstorm. It's a lifestyle many of us instinctively take to the minute we go on holiday, punctuating the day with dips in the healing salt water.

This section contains all these kinds of swims, as well as longer distance swims suitable for strong swimmers and triathletes. Long-distance sea swims have fixated men and women for centuries, from Captain Webb's first crossing of the English Channel in 1875 to Byron's crossing of the Turkish Hellespont, a famously wild stretch of water. (Many poets and writers are dedicated swimmers: the repetitiveness of swimming seems to awake creativity.) Swims like this are a different beast to our sun and sandcastle dips, taking swimmers deep inside themselves in a psychological game: where they butt up against a sense of their own relentlessness, their will to persist in the face of fear, tedium and pain.

But if life is made with persistence, it's also made out of play. Swimmers dominate most of the coast in Britain with their suncream, beach balls, windbreaks and bright towels, so this section focuses on places that offer something different – cathedral-style cliff arches you can swim through, blue lagoons that attract jumpers, beaches tracked by sheep and deer rather than people. It also features sea pools – some of the best fun parks ever invented – where you can swim in safety as hundreds of gallons of water smash and shower over the walls.

Peninnis Head, Isles of Scilly.
Previous page: Samson to Bryher, Isles of Scilly

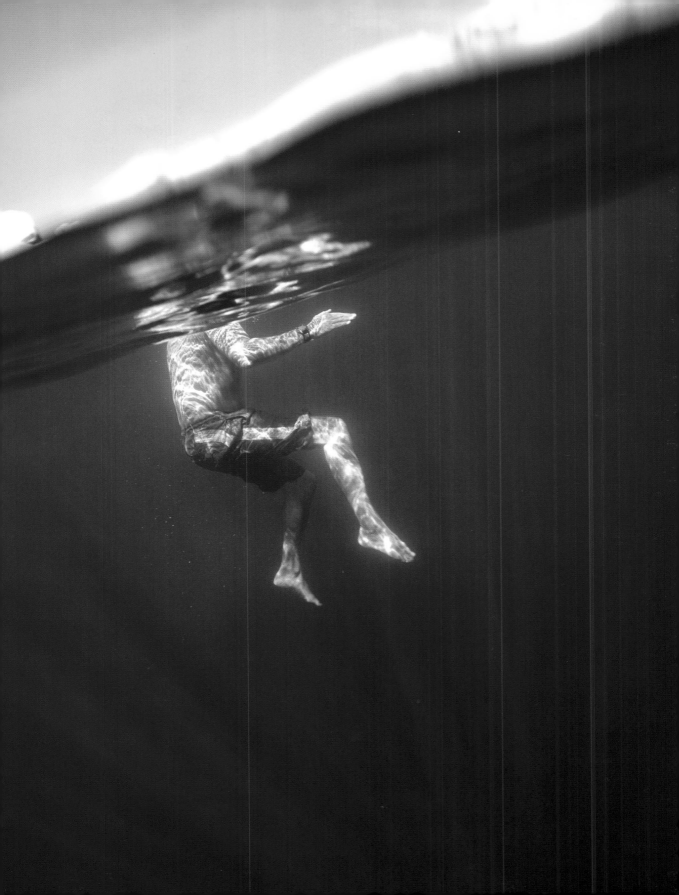

1. BLUE LAGOON, ABEREIDDY, PEMBROKESHIRE

It's the jumping that people most come to the Blue Lagoon for. There's a nice beach, and great scuba diving, but it's the chance to hurtle off the blackened walls of an old quarry into clear, deep blue water that draws the crowds.

We are the first people to arrive after a morning storm, with families and holidaymakers not far behind; all of us are on the move with beach towels after the first rays of sun. One family says they heard about the Blue Lagoon back in Yorkshire and brought their children especially, another reports that the place was crammed yesterday. A rumour goes around that the tide is too low to jump from the tallest wall today, and it's passed from parent to child to newcomers, even before the first children in wetsuits have crossed the lagoon.

The sea is still full of white caps, but the lagoon, protected by steep cliffs, is flat and calm. Occasional gusts spread out over its flat surface like fast-moving ink blots.

Standing on the lowest wall a South African kayaker teaches me how to jump 'properly'. 'Cross your arms over your chest, and keep your feet together. Don't hold your nose, you might break it when you land. And don't jump with your arms out – you could disclocate your shoulders.' He tells a cautionary tale of a jumper in Dorset who hit the water with his head forward and knocked himself out – luckily someone was watching and jumped in to get him.

Duly instructed I plunge off the baby wall, which feels high to me, and then float around looking at the children in shortie wetsuits on the giants. The walls are between 20 and 45 feet above the water. The South African hurtles off the very top in a running leap, clearing 6 feet of wall before leg pedalling out into the water.

Billy points out her friend Hermione, a little blonde girl of about ten, who has jumped off the top wall 'five times'. Gus, 12, is standing on the middle wall in blue shorts. 'He's in a tough situation there,' says his mum, who's here on holiday. 'He doesn't like heights. But he likes Billy.' Gus's battle with his contradictory desires continues for at least ten minutes. Eventually Gus jumps. 'Two kisses!' he shouts up triumphantly to his friend on the wall, after Billy has given him his reward.

Afterwards we swim out of the channel that connects the Lagoon to the sea, the bubbly rock beneath us covered in flat slate pebbles, and then swim around into the beach. The caravan on the beach serves us huge cups of chai, and we sign a petition to keep Abereiddy car park open.

Swim: Easy. With clear water, a blue lagoon and an old quarry, this is a popular coastal spot for scuba-diving and jumping.

Directions: Abereiddy can be reached by following signs from Croesgoch on the A487 (St David's to Fishguard Road). Fishguard Harbour station is 11 miles away. There are fine coastal walks in both directions and scuba-diving, canoeing and kayaking. Divers and swimmers may see seals, soft corals, anemones, spider crabs and ribbons of kelp.

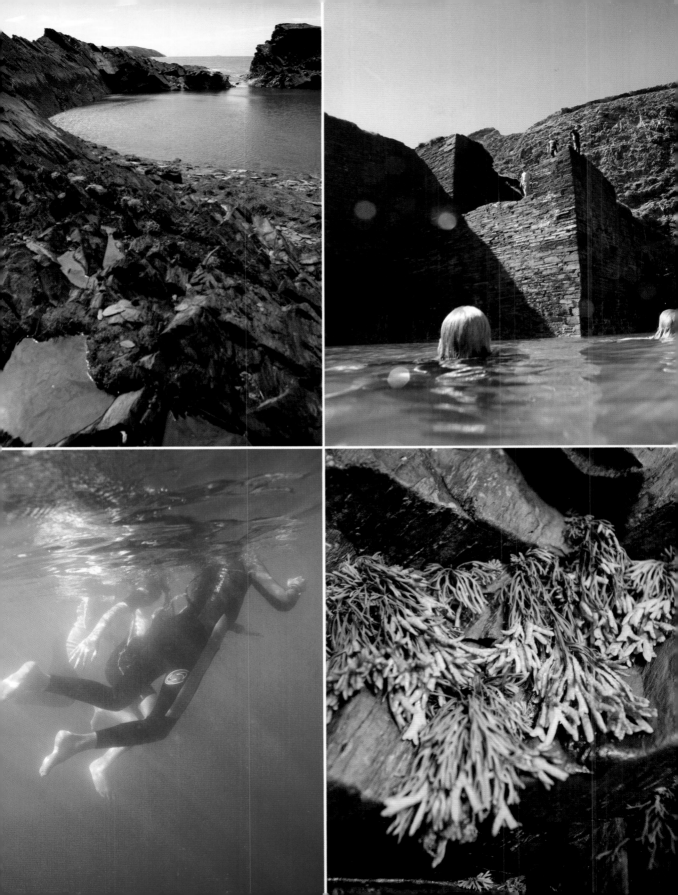

2. BOTANY BAY TO RAMSGATE, KENT: THE SEVEN BAY SWIM

It's 9.43am at Botany Bay, Kent. A dog is barking; the sand is golden; Margate smells of seaweed and Mark Sawyer, my channel-relay swimming friend, is looking tanned and muscled. This morning we're swimming from Botany Bay to Ramsgate, a total distance of just under 4 miles, and Mark has a dry bag attached to his ankle by a leash, holding a few clothes, £20, and a taxi number so we can get back to the start.

With the current working in our favour we get in. Mark has checked the direction of tidal flow and its speed with charts from the RNLI (see 'Tips for Wild Swimming'), having tried the same swim the week previously and fallen foul of the tide.

We swim past the chalk cliffs, trillions of crushed sea plankton skeletons shining white in the sunshine. Mark calls this the 'Seven Bay Swim' and loves it for its proximity to London (90 minutes) and the cliffs. 'The chalk stacks, stumps and caves are a crowd puller,' he says, 'particularly if you did Geography A level.'

The chalk affects the water too. At times it's like swimming through milk, and then light reflecting off the chalk particles turns it turquoise, or a soft green. With Mark's blue dry bag, red hat, orange trunks and tan, it's a colourful scene.

We pass the little bays with holidaymakers and beach huts. Diving seagulls follow a shoal of fish. It's like going for a cliff swim, instead of a cliff walk. Mark points out Bleak House in Broadstairs, the inspiration for Charles Dickens' novel of the same name.

Within about an hour we get to Viking Bay, Broadstairs' main sandy bay, site of the first Anglo Saxon invasions of England. Today the only thing to repel any invaders are happy toddlers, ice cream vendors and some large inflatable giraffes. It feels like the scene from 'The Spy Who Loved Me' where James Bond emerges from a deep, private world, driving his Lotus Esprit out of the sea into oblivious holidaymakers throwing beach balls. We wade through throngs of splashing children and out of the water, put on sarongs, and have a breakfast of fried eggs on thick slices of white toast in the sunshine.

Mark gets back in immediately to make sure he gets to Ramsgate before the tide turns. I decide to walk for a while, which turns out to be the next hour as I'm sidetracked by the sensation of the sun baking my skin for the first time this summer. I walk along transfixed by the cliffs and exposed chalk beds, like beds of giant white molars covered in green seaweed.

Swim: Advanced. This 3 to 4 mile sea swim takes you along the white chalk cliffs of Dover and past seven bays. It can be tide-assisted and takes a bit of planning.

Details: *Botany Bay is 2 miles north of Ramsgate and 3 miles east of Margate on the B2052 (nearest railway station Broadstairs). There is lifeguard cover from June to September. There are also tidal pools at Margate, but it's high tide when we visit and we can only see children walking along the wall knee-deep in sea, and red and white posts marking the perimeter.*

The swim starts in Botany Bay and passes Kingsgate Bay, Joss Bay, Stone Bay, Viking Bay, Louisa Bay and Dumpton Gap. See map refs 111-116.

3. BRIGHTON SEA SWIMMING CLUB, EAST SUSSEX

Brighton is all about the sea. Without fishing there would never have been a town, and without the 18th-century fashion for seawater cures there would be none of the Regency squares and crescents that give the city its shape today. It boomed again in the 1960s as a seaside resort – Victorian piers being overtaken with funfairs, deckchairs, and pink sticks of rock – and that spirit lives on today, with locals saying some part of them feels as if they are on permanent holiday. Visitors to the town generally walk along the pier that juts out over the sea, book into a room next to it, and eat the fish that come out of it. At some point it seems only respectful to get into it – and what better way than an early morning dip with the Brighton Sea Swimming Club?

Brighton Sea Swimming Club was founded in 1860 by some local tradesmen and ever since locals have gathered on the beach for a morning dip in temperatures ranging from 5°c to 20°c (coldest at the end of January and warmest mid-August). On Christmas Day hundreds turn up for a festive swim (in 2004 450 swimmers and 4000 spectators gathered by the shore) and the daily view of the English Channel has inspired one local, Mike Read, to swim it no fewer than 33 times (three times in one summer in order to maintain the title 'King of the Channel').

So, on a cold stormy Tuesday in November, eager to experience the force that has made, shaped and defined the city, I find myself walking down the slip-road to Arch 205E, near Brighton Pier, at 7.20am to join the Brighton Sea Swimmers. It's still dark, the town buildings grey behind the ornate Regency street lights that line the sea front, glowing pale orange. But by the time I arrive 19 swimmers are already gathered for their morning dip, sporting nothing but Speedos, goose pimples and goggles.

While I am used to outdoor swimming, this is one of my first attempts at winter swimming and I am nervous of the cold (see 'Tips for Wild Swimming' for ways to conquer your fears). With its abandoned flip-flops and historic towels, the club house is as ramshackle as a family garage, the only heating coming from a 1970s blow heater propped precariously on a three-legged stool. 'You can wear a wetsuit if you like,' says Julie, a 32-year-old graphic designer who comes here before work. 'But you don't need to – it's the warmest November on record.' The others crammed into the small space with me agree. Keen to return my hosts' congeniality (they welcome their rare guest swimmers), I leave my wetsuit behind.

'My grandmother's grandfather was one of the founders,' says Dave Sawyer, a 54-year-old local who has swum every day for 20 years, as we hobble down the beach. I'm hobbling because I'm barefoot on pebbles, Dave because he has severe osteoarthritis (but he finds the cold water relieves his pain and so spends hours in the sea).

At the shoreline the wind is whipping tears from my eyes and carrying spray 20 metres inland. But the swimmers, a multicoloured mass of bright caps – yellow and red and pink and orange and green – race into the water amongst the froth and white caps. I follow them gasping for breath at the shock; it's only 40 minutes since I was warm in my winter pyjamas. 'Exhale,' says Julie, 'if you exhale more air will come in.' I puff out the air in my contracted ribs and she's right, I can breath.

Within a minute the shock has passed and the burning cold of the water is making me feel alive. There's a low mist and a pink streak of

sunrise on the horizon and gradually the sun looms large and round behind the pier.

'I have to do it,' says Henry, a club member. 'It feels so good. I'm like a drug addict without his fix if I don't come – miserable and disorientated.'

Swim: Moderate. Brighton Swimming Club is one of the oldest outdoor swim clubs in the country. Joining the club for a dip is a great way of enjoying this sometimes rough bit of sea.

Details: See www.brightonsc.co.uk/sea.htm for details. The club meets under Arch 205E, near Brighton Pier. Weather and sea conditions permitting, members swim every day at 7.30am and 11.30am Monday to Saturday, and 10.15am on Sundays. There may also be swims in the evening and at other times during summer. Take a brightly coloured rubber cap and a pair of beach shoes – the stones can be painful.

4. BRIGHTON PIER TO PIER, EAST SUSSEX

Simon Murie and I have had a date in the diary to do the Brighton Pier to Pier for a while, so when the day comes we set off, rather than pay any attention to the news that after weekend storms 'half of Hove beach is on the promenade'.

Simon is a 6ft 5in Channel swimmer with a laidback Aussie attitude, hands like paddles and feet like flippers. A guy called Graham who's training for the Channel puts us up for the night, and we all go down to the beach at dawn to check conditions.

Conditions are not good: it feels gusty outside the house, but is blowing a gale by the end of the road; my glasses whitened by salt spray within seconds. We stumble over the rocks on the promenade and when we pass the white line of Hove beach huts even my male companions can lean into the wind.

After discussion with the sea swimming club,

the verdict is that we 'should be OK', and so we descend to the burnt-out shell of West Pier with no one taking full responsibility for the conditions ahead. We get into our bathers beside the kind of water you see around North Sea oil rigs: grey, rough and boiling. The roar of the undertow dragging through the pebbles is deafening.

I put on flippers (to help me keep up with Simon) and we plunge in and are swirled around by the rusty hull of the pier, trying to get out to sea while simultaneously wondering whether we should do this at all. The noise, churning foam, indecision and mouthfuls of sea water create chaos. Every now and then waves bob us up at the same time and we mouth 'What do you think? Should we?' and then we put our heads down and go nowhere. This goes on for about 20 minutes, and then eventually one of my companions gives a decisive nod: we are going to do this.

Intention is everything. I get out and run 20 metres down the beach and get back in, where the currents are different, while they push hard to get through the immediate swell by the pier. Then our journey is on: with West Pier behind us and the bright lights of East Pier in front. In the distance I can hear the sound of a siren.

We're halfway through the swim when the unbroken waves become 10 feet tall. We're doing front crawl and every other breath I see these grey towers approaching.

'Simon, the waves are freaking me out! They're freaking me out!' I hear myself say. 'Don't look at them,' says Simon. 'Breathe facing the shore'. I'm not sure that having huge waves creep up behind me is really going to help.

But looking at the shore, I notice the swell doesn't break until it dumps on the steeply shelving shoreline. There's no way out, and no way back so the only option is to swim. It simplifies things. I resolve to be calm, and count my strokes to drown out any panic, keeping the reassuring sight of Simon in view at all times. (I would not have attempted this swim with anyone else, but in terms of rescuing power, I trust him.)

And then, after a while, we're at the pier. The waves break before the shore here but there's still a tremendous 'suck-back' at Brighton, where the undertow will pull you back out to sea. Some days crowds have gathered watching swimmers try and leave the water for up to an hour without success. We hover in the white foam judging our timing, then shout 'Go!' and paddle in with a wave and sprint up the pebbles before the wave turns.

Even the seagulls here look tough, with big beaks and battered feathers. We feel rugged and victorious and go to Carats Café by Shoreham Power Station for a giant breakfast. Condensation drips down the inside of the windows and tankers pass by on the horizon. I warm my hands on a cup of tea while men in hi-vis jackets eat stacks of toast.

Swim: Moderate to advanced. A great journey swim between the bright lights and Kiss Me Quick stalls of one Brighton pier to the burnt out shell of the other. 1000m.

Details: Brighton Sea Swimming Club organise a Pier to Pier swim once a year. (See www.brightonsc.co.uk/sea.htm)

5. BURGH ISLAND, BIGBURY ON SEA, DEVON

It's 11.30 on Saturday morning at Bigbury on Sea car park. The sun is out, the sea is flat, seagulls are crying and so am I – from sunburn. Yesterday was the first day of sunshine since April and it took Dom and me by surprise. We're on a three-day swimming expedition in Devon and this is the finale: the circumnavigation of Burgh Island, home of an art deco hotel and many a mystery and Agatha Christie novel.

We meet a local friend, Jackie, and set off. Our journey's been plotted: anticlockwise around the island, past the spider crabs, around Cormorant Corner, through 'Death Valley' and back to the start. We pay £1.50 to cross to the island on the elevated sea tractor that's used when the sandy spit that connects the island and mainland is cut off. We've timed our swim at the slack point of high tide to avoid currents, and the sea is flat and welcoming.

We tell the red and yellow lifeguards what we're doing. 'Do you want us to send a lifeboat if you're not back in an hour?' they ask. We decline; while we're all secure swimmers we tend to dawdle and cloud watch on pretty swims, spending time inspecting bays and floating on our backs. The swim can take 40 minutes, but if we get distracted we won't be back in an hour.

The board by Burgh slipway tells us it's 14°c. We put on wetsuits, booties and silicon hats and wade in, in front of customers at The Pilchard Inn. I didn't know how tolerant people in this country are of 'individuality' before I took up wild swimming: you can swim past fishermen in the dead of a November night or tread past a family of picnickers in what is, frankly, a ditch, and the most that people say is, 'Is it cold in?'

I spuddle about in snorkelling position, all the better to find two spider crabs beneath me. 'They're fighting!' I say. 'How do you know they're not mating?' says Dom. We don't.

We turn the corner – dark grey slate rocks to our left, sea to the right. At the start of the swim we were in bucket and spade territory, with stripey windbreaks and ice cream. Now we're in sea that's properly wild.

'Once you get used to the idea that you won't get dashed against rocks, it's quite delightful,' says Dom. Walkers from the cliff top above us look down as we swim between two rocks and around Cormorant Corner. The dark black cormorants are there, eight lined up on a rock. Birds and fish seem unfussed by people once you're in the water, and we swim right up to them before they take off.

The coves and cliffs that looked forbidding from the cliff top (we checked out the swim from the land before we set off) now look beautiful rather than frightening. One cliff is a giant flat slab of slate, bright with reflected sun. We bob about and Jackie and I take a break with our feet on a rock.

'We're going through that gap,' I say, pointing to Death Valley, a chasm between the island and a smaller outcrop. Dom thinks it's impossible; so did I the first time I swam here. It takes a leap of faith to swim through; waves carry you into the chasm and also push against you as you swim out. But the sea is mild so I'm sure it will be safe.

When we come out the other side we're two-thirds of the way around our journey. We can relax now, the wild section over, but this side of the island is noticeably colder. We launch a wetsuited assault on Burgh Island's hotel pool, a beautiful aqua lagoon with a private beach and a wooden life raft, and then feel guilty and jump back out into the sea. There are no rip tides around Burgh Island and, although

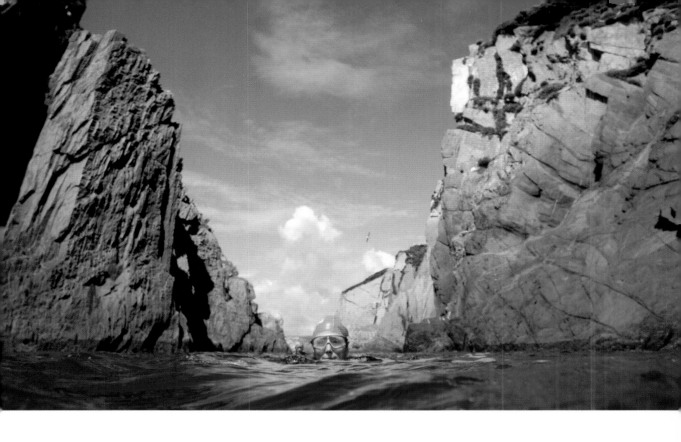

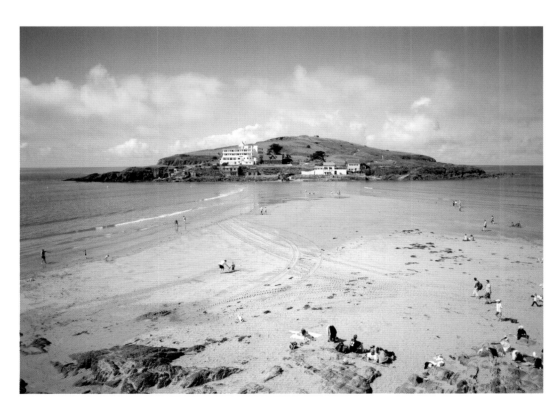

the tide is starting to go out, it's not much to swim against.

Then we turn the final corner and get back to the beach, busy with sandcastle builders and kite surfers. Swimming outdoors washes away all that goes before it, making a quick dip after work feel like a mini-break and a Saturday morning swim feel like a complete holiday. As we step out of the water our eyes are a little brighter, our smiles a little broader: our weekend has begun.

Swim: Advanced. This 1.5km swim around an island takes swimmers past spider crabs, cormorants, dramatic cliffs and unseen coves.

Details: Bigbury on Sea is about 3 miles off the A379 from Plymouth to Dartmouth (nearest railway station, Plymouth). It is possible to get out at the beginning of this circuit, but after that you are committed. See Safety in 'Tips for Wild Swimming' about swimming within your limits.

Burgh Island Hotel (www.burghisland.com) is a wonderful place for a cocktail or slap-up meal afterwards.

6. BURTON BRADSTOCK, DORSET

Part of the National Trust's 700 miles of coastline, outdoor swimmer Roger Deakin called this beach 'heaven on earth'. We arrive early on a sunny Sunday and it's such a golden and twinkly blue expanse that it's like being transported to the Mediterranean.

We pay a teenager in a wooden hut a few pounds and are waved into a car parking space by a National Trust volunteer armed with a traffic cone. Almost immediately we are drawn to the tented canvas conservatory of the Hive Café. It's full of people peacefully reading papers and eating breakfast behind zipped windows. AA Gill gave it four stars for its perfect plaice and potato-tasting chips, and if it weren't so popular we'd try the coffee.

Up and down this coastline beaches are scarred by signs and cordons, but here there is no man-made clutter, just a landscape of stripes: bands of beach, cliff, sky and sea running off into the distance. The whole effect combines to make us want to swim for miles. The sea laps against the pebbled beach in a repetitive rush and trickle and the water is calm and safe. We stretch out in endless front crawl, catching the occasional glimpse of a pensioner on a cliff path or a gull dive-bombing the water.

Before leaving we take the time to examine the honey-coloured cliffs, their horizontal strata buffeted by the waves into magnificent frills. If you want humbling, and bobbing about in a big sea hasn't done the trick, standing underneath the cliffs will remind you how tiny you are.

Swim: Easy. Remarkable honeycomb cliffs and a long, calm stretch of shore make this a heavenly swim.

Details: Burton Bradstock is about 3 miles off the

A35 between Bridport and Dorchester. For more information about the Hive Beach Café and the local area check out www.hivebeachcafe.co.uk Hive Beach is also a popular shore dive. Had we been wearing goggles, we might have seen pout and pollock using the cover of boulders and seaweed to ambush smaller fish and the magnificently named tompot blenny attacking sea anemones. Like a fishy version of a tabby cat, this 20cm fish has minute teeth that also crunch through barnacles and crab.

Many people believe there's a fine line between wild swimming and naturism. At Cogden Beach at Swyre (SY520872 – see swim 117), just east of Burton Bradstock, they've crossed it. 'Ideal for worry-free Naturism' says Naturist website 'Nuff' (cleverly getting 'nude', 'buff' and the concept of sufficiency into one word). There are also great walks in this area – along Chesil Beach and on coastal paths – and Burton Bradstock is on some cycle routes.

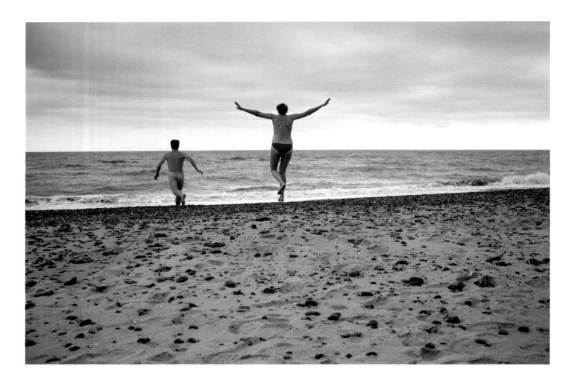

7. COVEHITHE BEACH, SUFFOLK

On the approach to Covehithe there are bare-bottomed pigs looking purplish with cold, and a field of turnips that haven't been pulled, their leaves turning black. Overturned earth and corrugated iron pig arks set the landscape's tone. The sea itself is brown, the colour of water that has been used to wash many colours off a paintbrush.

The land here is slipping into the sea. This coast is retreating by over 4 metres a year: there will be less land to farm next year and the road itself simply stops. The sandy beach is littered with the stumps of fallen trees, their roots and trunks washed smooth by the sea and bleached of colour. A couple of red house bricks lie on the sand smoothed into lozenges.

There's a strange light, a bright grey. We walk along the beach, under cliffs the colour of a wet Crunchie bar – a crumbling sand version of Burton Bradstock. This is a great swimming beach for lengths along the shore. A grey mouse scoots along and then freezes, 'I'm a pebble', before scampering off.

There's a post-apocalyptic beauty here – a stunning, natural dereliction. We decide to swim near a tree that is standing upright in the middle of sand, where it shouldn't be, its branches cleared of bark and colour by the sea. Robert Macfarlane calls it the 'Waiting for Godot' tree. A toy red boat is adrift in a puddle between its boughs and 'Joe Biff' is still carved into the trunk. It's next to the marshes and birdwatching area with its wooden look-out.

We shelter in a curve in the cliff, strip off to underpants and run in. The water is lovely – not rough but hilly, which only serves to underline the flatness of the rest of this landscape. We get out and walk back along the cliff, occasional clover, buttercups, dandelions and poppies mixing up the seasons and providing brief glimpses of colour.

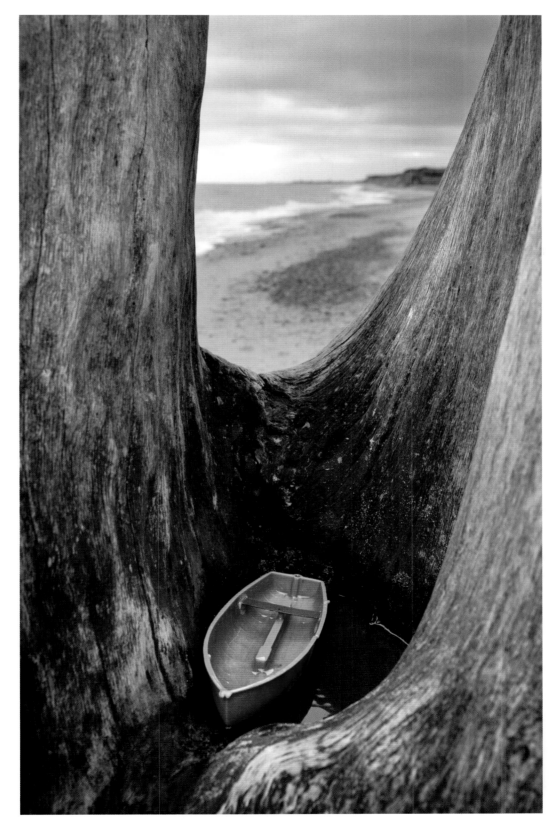

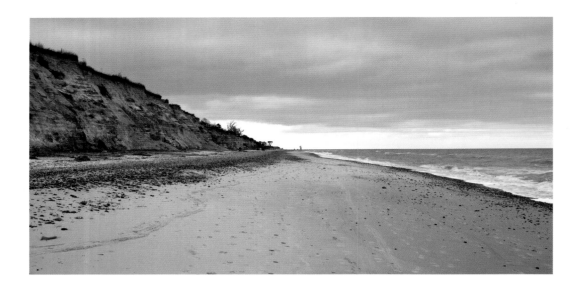

Swim: Easy to moderate. Cliffs crumbling into the sea on this stretch of Suffolk coast give a derelict beauty to this shoreline swim.

Details: Covehithe is 2 miles east of Wrentham (just off the A12) and 4 miles north of Southwold. Michael has swum here before and says that even on August Bank Holidays the beach has enough room for visitors. There are good walks in the area.

Medieval churches ('so many churches!' says Robert Macfarlane) have also slipped into the sea at nearby Dunwich, although none can be seen while swimming. See map ref 109.

8. DANCING LEDGE, DORSET

Dancing Ledge is a small tidal pool that was blasted into the rock for the use of local prep schools about a hundred years ago. It looks more like a rock pool than a swimming pool, with florets of purple and green seaweed and a large crab scuttling along its bottom. It's a tight squeeze for two people doing breaststroke, but a great place for ten to sit and cool down on a hot day.

The pool is made special by its location in a rock amphitheatre. Swimmers are surrounded by two semi-circular cliffs with climbers dangling off them. The clusters of climbers give the place an atmosphere of camaraderie. It feels like a cross between a library and church; a sense of people engaged in the private worship of something they love.

It makes visitors gently expansive: on an April visit Vicky and I get in. Within minutes a 40-something couple on a first date have dared each other to take the plunge, followed soon after by some student climbers who set up a tightrope, attempt to wobble across it and fall in.

The rock at Dancing Ledge itself has a peculiar texture: smooth but rippled, like a petrified version of the sea on a mild day. The ripples form comfortable perches and the cliff

has small caves at its base in which to crouch and change. The pool is visible a few hours either side of low tide. My friend Jo recommends jumping into the sea for a bigger swim. 'You just have to be careful of the cliff and the shelving as you get in and out. But once in, it's a gorgeous deep-water swim and you can bob around away from crowds. The water is clear because the shore is rocky.'

Swim: Easy but with a tricky, steep scramble down to the pool. A great place for a dip on a hot day. Walking here is part of the pleasure.

Details: Dancing Ledge (SY997768) is owned by the National Trust, and can be reached from a lane running south from Langton Matravers on the B3069 between Swanage and Kingston (nearest station: Wareham). Park at the National Trust car park at Spyway Farm. From here it is a good half mile walk, signed from the car park, followed by a vertiginous scramble and jump down to the pool itself. On the way, an open-sided barn that acts as an impromptu information centre has a chalkboard that lists birds that may currently be seen. From here, walk through a couple of cliff top pastures with crumbling grey stone walls: one contains a cow's head carved into a stone. Go down some limestone steps and into the amphitheatre of rock. This is when it gets tricky: after milling about looking for the shallowest jump to the bottom ledge, there's nothing for it but to leap. If you're interested in climbing here, the two cliffs of the disused quarry are about 30 and 60ft tall.

9. DOVER HARBOUR, KENT

My visit to Dover Harbour with Mark Sawyer, who has crossed the Channel a few times in a relay, is a pilgrimage from curiosity rather than a swim of beauty. The harbour is like a giant grey industrial swimming pool, with the ferry port over the harbour wall to the right and cranes to the left. But it's the home of Channel swimming – the site of training and the start of the 35 kilometre swim to Calais.

The English Channel is known as the Everest of long distance swimming, and only 811 people have made it since the first crossing by Captain Martin Webb in 1875. It took him 21 hours and 45 minutes. According to the *New York Times*, like many swimmers his battle came in the last few miles, with bad weather, the tide and the wind against him.

There are many factors that make swimming the Channel so difficult. Swimmers are given the go-ahead on weather by their boat captain the evening before, so many embark on the ultimate endurance test in the dark, after a long drive and a few hours' sleep in a car park. Once in the water they encounter jellyfish, tankers, sewage slicks and unpredictable weather. Tides are strong and change direction every six hours. It's cold and wetsuits aren't allowed. Fingers claw and separate, legs cramp and stroke rate diminishes as the chill gets into the body.

'The body is tired after the first two to three hours and after that Channel swimming is all about mental strength,' says Mark. Cramps carve their way deep into muscles from the repetitive movement, tongues swell up too big for mouths, waves and diesel fumes from support boats make swimmers seasick. Far from entering a Zen state of flow the mind has to spend long hours doing battle with excruciating pains and an overwhelming sense of aloneness.

Of all the reasons that people swim the Channel, a love of swimming is generally not one; it's much more about testing their physical and mental strength.

It takes about two years to train for the crossing and every weekend from May onwards many would-be swimmers gather at Dover Harbour to put in their time, building up to back-to-back 'Channel Split' – 6 or 7 hour swims on both Saturday and Sunday. They meet on the pebble beach at 9am, and are greeted by Freda Streeter, the unofficial Channel Swimming Piloting Federation coach.

International swimmers generally use coaches, but with typical British eccentricity, most UK swimmers train with Freda, who is unpaid but sits on the beach all day come rain, hail and sunshine, smoking and barking orders, and calling the swimmers in for Maxim (a glucose drink) when she deems it necessary. Mark tells me that 'She'll stay there waiting for her swimmers even if they are doing it for ten hours, with her assistant Barry in his yellow wet weather gear mixing Maxim and smearing Vaseline on people's armpits and necks so they don't rub when they swim.'

Freda's daughter, Alison Streeter, has crossed the Channel 43 times, once 3 times in succession, a feat which took her 34 hours 40 minutes. She once passed out on a crossing but carried on swimming – she was pulled out of the water when her mother noticed she hadn't taken a breath for 12 strokes.

We're visiting on a weekday so there's no Freda, and we get in and swim. The walls of the harbour are curved and massive, and the water grey and deep and surprisingly choppy. Although contained, the water here feels huge and awe-inspiring, tides shifting the seabed stones beneath us, harbour walls looming high above us like a perimeter fence.

Swim: Moderate. An industrial swim, but a chance to get a taste of Channel swimming.

Details: The Channel Swim begins on Shakespeare Beach. For training, most swimmers swim between the Ferry Pier and the West Pier. The distance between them is approximately 1400m. Most get in the water just down from a statue on the promenade erected in honour of Channel swimmers. Water temperature is about 11°c to 12°c in May and 16°c to 17°c in August.

10. DURDLE DOOR, NEAR LULWORTH COVE, DORSET

If nature is your church, Durdle Door is its cathedral. Swimming under the huge arch of Durdle Door inspires the same wonder as the Blue Mosque in Istanbul or St Paul's in London: the rock doming above us, the buoyant sea holding us aloft. You can't help but feel uplifted. The best aspect to be had is swimming out through the arch into the open sea: even with hundreds of people eating hot dogs back on the beach it feels like an adventure, a journey into boundless possibility.

The downside of Durdle Door is its popularity: so spectacular a feature draws 200,000 visitors a year. Getting to the beach involves crossing a mobile caravan park and descending a steep limestone path with Mr Benn qualities: we start out as individuals and end up as part of the tourist mass. Food choices are restricted to irradiated sandwiches, and hot dogs dragged down by a tractor to a halfway point.

When we visit, the sea is tranquil, giving the water remarkable clarity, part of a stunning white-green-blue landscape. We content ourselves with trips through the Door and around the headland, but there are also swims from the Door to the offshore rocks along the beach – The Bull, The Cow and The Calf (see map ref 118). An even longer journey could be made to the chalk headland, Bat's Head, roughly 1 kilometre away (see map ref 119). For those without hardy feet Aqua shoes give the option of swimming to one of these points and walking back comfortably over the pea-pebble stones.

Swim: Easy to advanced. A swim through an awe-inspiring cathedral-like arch, made of natural rock, with options to cover up to 1km by swimming to other rocks along the shore.

Details: Access to the beach is from Durdle Door Holiday Park about 2 miles from the A352 from Dorchester to Wareham. Durdle Door is part of the Jurassic Coast, where dinosaur bones are still found (more than one excited amateur archaeologist teacher has gone home with an Iguanodon tooth, worn smooth by masticating green things 120 to 140 million years ago). The Door itself was formed about a thousand years ago. Take goggles so that you can see shoals of sand eels and mackerel that shelter between the arch and the beach. In early summer you may hear artillery fire at the nearby Tyneham ranges, a strange accompaniment to sunbathing families.

You can also swim around from Man o'War Bay to the Door (see map ref 120). The bay itself is great for swimming and snorkelling in choppier conditions, when Durdle Door seems too exposed, and is also a quieter location because it's in shade later in the afternoon. Be aware of currents and tides once in the water. A little further along the coast to the east, Lulworth Cove is a spectacular horseshoe about 300m across (see map ref 121). It's used as a harbour so there are always a few sailing boats at anchor. The water may not appeal as much as the open sea at Durdle Door and Man o'War but it's more sheltered, access is easier and there are toilets and a café nearby.

11. FISHING COVE, GWITHIAN, CORNWALL

The world's finest minds have yet to research people's favourite swims as a guide to personality, but a dashing man recommended the dashing rocks at Fishing Cove. Lively, elegant, audaciously good-looking and liable to do your head in at any moment, he and the rocks have quite a lot in common.

One of the best things about this beach is the secret garden approach. A long narrow path hugs an almost-vertical cliff, with steps carved into the earth, reinforced against gravity with planks of wood. It's a hot sunny summer's day as we begin the sharp descent past brambles, daisies, gorse, clover, sloes, honeysuckle and foxgloves. Heat bounces off the rocks, and there are roped sections to help walkers cling on to the path.

We confirm the way with a wily grey-haired

gentleman so well-bred he growls as he speaks, like the low guttural roar of a revving stationary motor bike. He directs us towards the 'German nudists' and we get an aerial view of them on our way down – a large, bald man in a black vest with no pants, his naked wife flopped beside him, and two couples wearing clothes.

A recent storm has brought in piles of marine junk which is surging back and forth in the waves, so I do a sea clearance before we swim, picking green netting, blue sacking and orange ropes from the water and plastic cartons from the shoreline.

Once the waves are clear we get in and head to the handsome grey rock: a great jumping and diving spot on a calm day, but undoubtedly 'dashing' – in the bruising, skin-removing, dangerous sense on a day like today.

Godrevy Point is nearby, a popular hauling out place for Atlantic grey seals who bask on

the rocks. Wearing masks we keep an eye out for them but don't spot any, so, after a long while, we go back in. Dom looks back at the sea and there it is: the head of a seal that has followed us into shore. It looks at us with its wet, furry, grey face and sparkling black eyes, and we look back at it. It's the first seal either of us has seen and we're delighted. I guess we're probably the only ones gazing kindly, but it feels like mutual curiosity at the time.

Swim: Easy to advanced. A hidden, skinny-dipping beach with great jumping rocks, Atlantic grey seals and a secret garden approach.

Details: Fishing Cove is 1km from Gwithian, east along the coast from Navax Point about halfway between Portreath and Hayle on the B3301 (nearest station: Hayle).

Gwithian, Portreath and Hayle are all popular surf beaches. See map refs 122-124.

12-13. FLAMBOROUGH HEAD: THORNWICK BAY & NORTH LANDING, YORKSHIRE

Some of the most spectacular cliffs in the country are at Flamborough Head, a landscape carved out by the sea. The white cliffs are 400 feet tall, with coves, caves and stacks drilled into 7 miles of chalk headland to explore. A local tells us that in places it's possible to swim through the headland, so Michael, Dominick and I set off in search, parking at Thornwick Bay.

The beach is a rough mass of pervious rock, bubbled and cratered by erosion and covered by sharp barnacles and heavy ribbon seaweed. We clamber over it inelegantly, Michael and I in Aqua shoes and Dom sustaining three bloodied toes.

We've timed our visit for the two hours around low tide when the sea is static and tide is slack: it's a calm day so the waves are small. We have not swum in caves before but know that conditions can change fast. In just a few minutes the swell can pick up, and alter currents around underwater rocks, and even small waves turn into big ones when funnelled into the mouth of a cave. Caution is the order of the day. We plan to swim only where it feels safe. Wetsuits and Dom's flippers and flotation aid give us extra security. There is also some safety in numbers: if there had only been two of us we would feel too exposed.

We swim across to the cliffs and bob close to them, heads tipped back to take in their height. Gannets and puffins breed here but as we swim into the first cave, hundreds of seagulls fly screaming out of the darkness. It feels wrong, like we've passed an invisible 'keep out' sign or are trespassing in an aviary so we hurry out.

The next cave is bigger, lighter and more welcoming; a large, round dome with white walls striated with improbably neat bands of

purple, dark green, bright green and grey seaweed, each strip half as tall as me.

We swim on. In the next cave our eyes adjust and we reach a sandy beach at its back scattered with big round rocks. From the beach we can see light is entering the cave from two other places: it's like being in a mermaid's chamber. We climb to the other side of the cliff along a narrow rock channel with a sandy base and turquoise pools of water. There's no exit so we return to the beach. In the few minutes we've been gone the incoming waves have grown in size and we need to get out. We choose the third exit and swim out one by one on outgoing waves.

Feeling intrepid, we drive straight to North Landing to explore further. Michael and I get back into the water. At low tide it's possible to walk into the caves here but the water level is higher now so we swim and wade over underwater pillars and find the place where you can swim through the headland: three tunnels that meet in a cathedral sized dome with a scattered spiral roof, bright green with algae. It's an awe-inspiring place and we swim back and forth under it, then go back so I can I persuade Dom to come and look.

In the excitement we've forgotten about the tide. It's been rising imperceptibly and suddenly makes a very noticeable change: with one extra sluice from the sea the incoming waves are no longer slowed and broken by the underwater pillars but pick us both up and swirl with new force towards hundreds of feet of rock. We look at each other in unbridled panic, put our heads down and swim hard away from the cliff. We swim so close we bump right into each other, which actually doesn't feel too close at all, in the circumstances.

Swim: Advanced. With chalk cliffs, coves, caves and headlands the swim through Flamborough Head is an adventurous swim in an unusual seascape, but should only be undertaken by strong and experienced swimmers, in a group, in good conditions.

Details: From Flamborough village, take the B1255 north along North Marine Road signposted towards North Landing. Thornwick Bay is signposted on the left. There is ample car parking at both Thornwick and North Landing, and a café by each car park. A cliff walk links the two beaches. There are plenty of rock pools and smugglers' caves, and a sandy beach at North Landing. Similar cave swimming is found on parts of the Llyn Peninsular on the west side of Aberdaron Bay. See map ref 110.

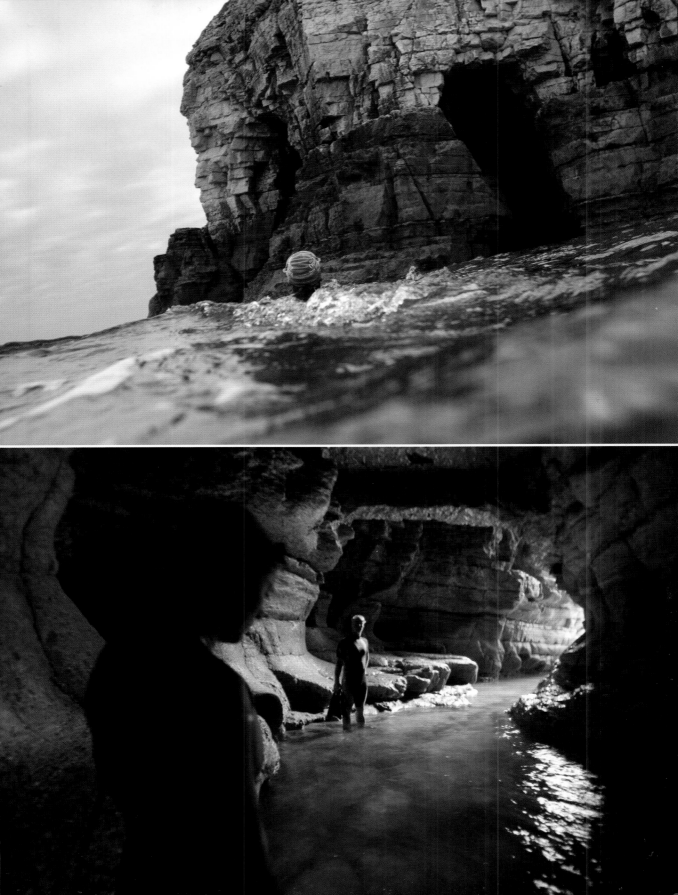

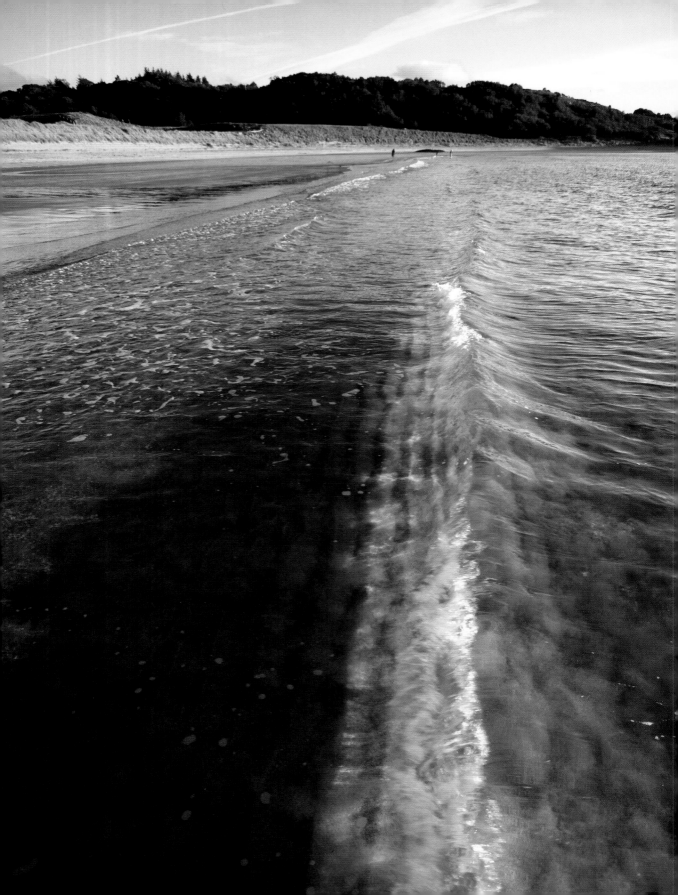

14. GAIRLOCH BEACH, WESTER ROSS, SCOTTISH HIGHLANDS

When we get into the hire car at Inverness airport we all seem to have things on our minds. I've had a double whammy of big bad surprise, one professional and one personal, in the last 24 hours and sit in the passenger seat feeling toxic with leaking eyes. Dom drives quietly, and Kari frets silently in the back about unfinished work she's had to leave behind.

When we arrive at Gairloch Beach three hours later my preoccupations are still not far from the end of my nose. We get into crystal clear water in a soft evening light with the colours of autumn around us – reddish sand, aubergine and bright green seaweed pick up the theme – but the focus is still inward. Kari and I can't seem to see beyond leaking goggles. Scotland's all around us, but we're fiddling with hats and new bits of kit.

Gradually, the swim pulls our attention outwards. First I see barnacles obscuring the black of a rock, white pyramids growing on top of each other. Then I spot a single midge over the sand: the cold must have killed the others. The beach itself is beautiful and improbable: sand rolling right up to a graveyard of Munsters headstones, surrounded by the rich oranges, reds and yellow of a country autumn.

The sea is utterly clear, and Dom calls us to the shallows to see it running over the corrugated sand. The sun is so low it's shining sideways into the top of incoming ripples and refracting below, creating moving pyramids of light and a lightshow on sand. We snorkle back out together, flying over the emptied shells of razor clams, crabs and other sea creatures. We see a fierce sideways crab and Dom dives for it: its pincers go up in angry counter-attack. I swim underwater without goggles and feel the cold taking shock out of my forehead and stress from my eyeballs.

Water has a way of marking the start of a holiday – whether it's jumping into an infinity pool or diving into the sea. It's part of the ritual of being away. We run out of the sea together with feet frozen from the ankle, flexibility chilled out of them so the hard sand seems harder. There's a girl standing waist deep in water in white knickers and a rolled up red T-shirt just looking at the horizon. We talk to her parents and then wade out to join her. 'I'm not much of a swimmer,' she says, 'I just like being in the water.' She's still standing there when we pack up and leave.

We get back into the car, take joint delight in a series of road signs about ice and deer and start imagining whisky, open fires and our first tartan B&B.

Swim: Easy. A sheltered, sandy beach with a long shallow entry and good rocks to swim to.

Details: *Gairloch is in the north west of Wester Ross, on the A832, south west of Poolewe (nearest station: Achnashellach). There is a car park, toilets, a shop and a campsite nearby.*

15. HOLKHAM BEACH, NORFOLK

One of the joys of swimming outdoors is being able to just keep on going: not for the outdoor swimmer the endless turns, the constant interruptions – 16 strokes, turn, 16 strokes, turn. Holkham must be one of the most splendid beaches to do one giant lap: stay close to the waveless shore and your 16 strokes could become 32, 64 and on up to 3 miles. As you breaststroke or crawl along you might see sand dunes and pine forests, beachcombers and sky. The eager-eyed may be able to recognise some of the local birds: in winter, there are hordes of migrating geese, flocks of finches and wading redshank; in summer, oystercatchers and ringed plovers running in and out of the tide line.

We visit in late October. It's Sunday so the car park is full but on the shore people spread out. The sea is a long way out, and all of us are drawn forward to it, walking a mile to the water. We crunch over a graveyard of razor clam shells like giants' toenail clippings.

It's cold, clear and sunny and, like everyone else, we stop at the shoreline like it's a perimeter fence. Then Michael pulls his jacket over his head and Vicky, Dom and I remove scarfs and undo zips. 'Let's show them what the sea's here for,' says Michael.

One of the keys to out-of-season swimming is to make your decision – you are going swimming – and then keep moving forward until you are in. So we run towards the sea, splash through the shallow water, and dive in. It's bracing and we have the whole sea to ourselves.

We swim until our skin burns and then get out and pour hot Ribena into beakers. It steams as we change, laughing and chatting. A big, black Labrador comes racing over. 'BILLY! BILLY!' comes the shout, as Billy runs round us

in a circle, dropping sand into our Ribena and onto our jeans, in a big, bounding, victory lap.

Swim: Easy to moderate. A three-mile stretch of golden sand in a Norfolk nature reserve offers a long, peaceful swim.

Details: Holkham National Nature Reserve is 3 miles west of Wells-next-the-Sea and has a great website – www.holkham.co.uk/naturereserve. It's about half a mile from Lady Ann's Drive (the car park) to the bay, and at low tide another half a mile to the sea – pack light. Look out for seals. Holkham is on National Cycle Route 1 and has plenty of options for walkers. This is an affluent area of Norfolk with pubs such as the nearby Victoria offering upmarket food and accommodation.

16-18. THE ISLES OF SCILLY: ISLAND HOPPING

During the Ice Age, the Isles of Scilly were a single land mass, 28 miles off the coast of Cornwall. When the ice melted and water levels rose, it became a Maldivian archipelago. Only five of the hundred or so islands are inhabited (and only one has roads) and a few times a year the tide drops so low that you can walk between them.

The islands are well known for the subtropical garden on Tresco, with its people-sized forget-me-knots and yuccas like planted octopuses, but the unsung magic of the Scillies is the kelp forests. You can dive all over the world and always have some idea what you might find, but before we swam over the kelp forests in the Scillies I had no idea such things existed. It's rare to experience an 'amazing' thing that is, in fact, amazing. Together with crystal clear water, a shallow sea, dolphins, seals, phosphorescence and weird rock formations, it makes for great, supernatural swimming.

Scillies' swims can be divided into three main types: crossings (from one island to another – the clear shallow sea makes these both approachable and interesting), rock swims (with lots of diving and jumps into perfectly clear water) and swims through kelp forests.

One of the joys of the islands is meeting the people. The limited number of visitors seems to keep islanders spontaneously friendly (if there are more than two visitors per head of the permanent population the island runs out of beds). During our two-day trip we make a whole host of friends. A keen swimmer takes us swimming, his friend paddles us from island to island, and a third says she'll give us a lift to the heliport when we leave. When it comes to it, she can't leave the office. 'Tell you what,' she says, 'take the car,' and starts drawing an outline of a Postman Pat van. 'It's red, windows open, keys are in it. Excuse the mess'. And so after just one day in the Scillies we drive up to the heliport with half of someone else's worldly belongings strewn over the back seat, and leave the van overnight at the heliport, keys in the ignition.

Being fogged in is a monthly occurrence on the Scillies, so plan to leave early if you have to be somewhere. '100 fog-bound passengers' reads a chalkboard outside the Tourist Information Centre on our second day, 'Can you help?' We are delighted to be among those who have to stay the night and, thanks to islanders offering up their spare rooms, every single fog-bound person has a bed.

Peninnis Head, St Mary's

Over poached eggs, slow-roasted tomatoes and field mushrooms at Mincarlo Guest House (www.mincarlo-ios.co.uk) we spread out our OS map. It's 8am and already hot, a promising start to the August Bank Holiday. Sunshine twinkles on the boats of Porthcresso Bay. 'A few days of this and there would be great phosphorescence,' says Nick Lishman, the keen swimmer who runs the guest house. 'Sometimes at night you can see dolphins glowing in the bay, and when you stand up sparkles drip off your body.'

It's such a fine morning that Nick puts his duties off for a few hours to come for a swim, persuading his friend Rob to do the same. Soon the four of us set off across Hugh Town to Peninnis Head.

There's something unreal about the Scillies with their turquoise water and fine white sand. The atmosphere is almost free from dust so there are exceptionally high UV rays which, together with the briny air and warmer soil, encourage masses of wild flowers, out-of-

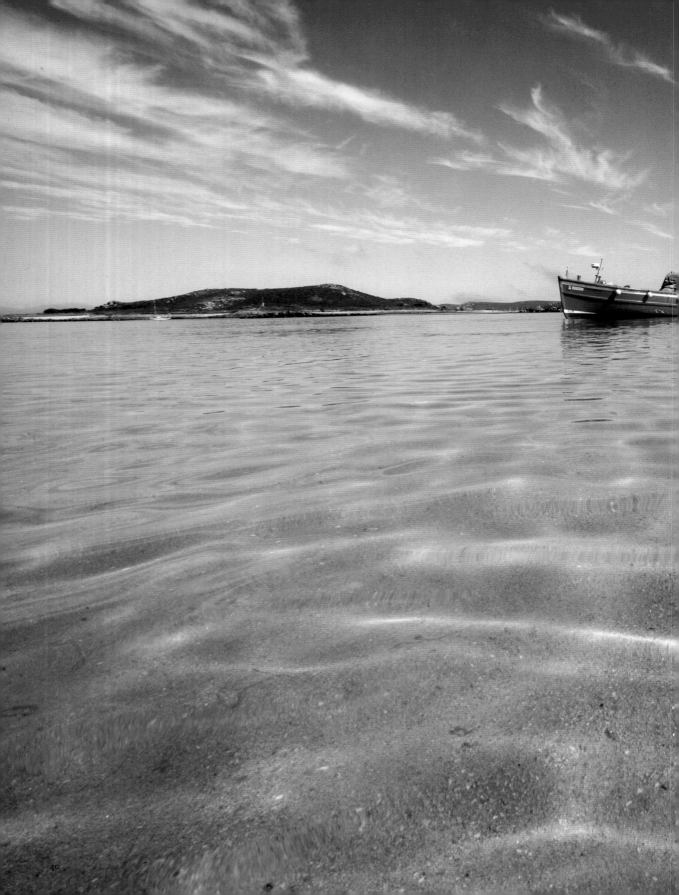

season bulbs and rare mosses and lichens.

Where the west sides of the islands are exposed to the full force of the Atlantic they are worn bare: rugged granite outcrops with only yellow gorse and purple heather for decoration. But just a mile away more sheltered bays offer safe bathing and a profusion of butterflies, bees and wild flowers.

The sea-carved, granite rocks at Peninnis Head – a popular place for an evening stroll as well as scuba diving (one rock face plunges 22 metres almost vertically) – are all suggestive of other things: giant Centurion helmets, sea-smoothed iguanas, the clefts of a hundred bare bottoms. With the confidence of a child who has worked out a route over a long summer holiday Rob leads us down the jumble of granite.

It's a hands, bum and feet scramble, sitting on one rock, arms braced against two others, stretching toes down to the fourth. After a while we get to a dead end, at which point Rob squats down, turns his head to one side, and shimmies sideways through a tall, narrow triangular gap, stretching up to flatten his chest. We follow and soon we're through to the most magical swimming place of all: the sea clear and blue in front of us, smooth jumping rocks all around and complete sunny sheltered privacy from the rest of the world.

We strip off and hurtle in, arms overhead, and gasp – in summer, the sea here is a degree or two colder than round the mainland (13–15°c between June and September) but, being oceanic means it's also warmer in winter (9°c rather than 6°c). The sea is cold, clear, buoyant, fresh – a combination which leads us to jump in again and again, watching the white whirls of bubbles that go down with us. We scale rocks covered in barnacles, bob around looking at kelp underwater and listen to the deep sucky noise

of water between rocks, that sounds as if God were taking the plug out of the ocean. We're shivering quite violently by the time we get out, so sit with backs flat against the hot rocks.

Heat's rising around our legs as we walk back between ferns, gorse and brambles. Thyme and butterflies waft in the air by some allotments and the sound of crashing surf is constant. We pick up some pasties from Hugh Town and head for the St Agnes ferry.

Swim: Moderate – you need to climb to get to this pool, and jump in and climb out once you're there. A magical, sheltered, rocky swim.

Porth Askin, St Agnes

At St Agnes (population: 75) families disembark from the ferry looking like little tribes, with shared mannerisms, clothing and features.

'Every bit of sand you see is a lovely swim,' says Piers, a friend of Nick's who has popped down in his golf buggy to give us a tour (there are no roads for cars). We see Porth Conger (see map ref 125), a busy boat-filled beach right by the ferry, Periglis (see map ref 126), where the local children go after school and where red Venetian glass beads are still found from a 17th-century shipwreck, but settle on Porth Askin, down a footpath past the Coastguards Café (good tea, lunch and cake).

Ferns superheat the air around us and we appear to be walking through something of a Freudian dream, the rocks suggestive of massed bottoms as at Peninnis Head. The coarse sand beach is strewn with round rocks, and a family in thick wetsuits is snorkelling. We put on swim skins (thin wetsuits) to extend our swimming time and get in to discover that the whole beauty of this beach is under the water. I swim over a lawn of Lollo Rosso lettuce, followed by ribbon weed the pattern and

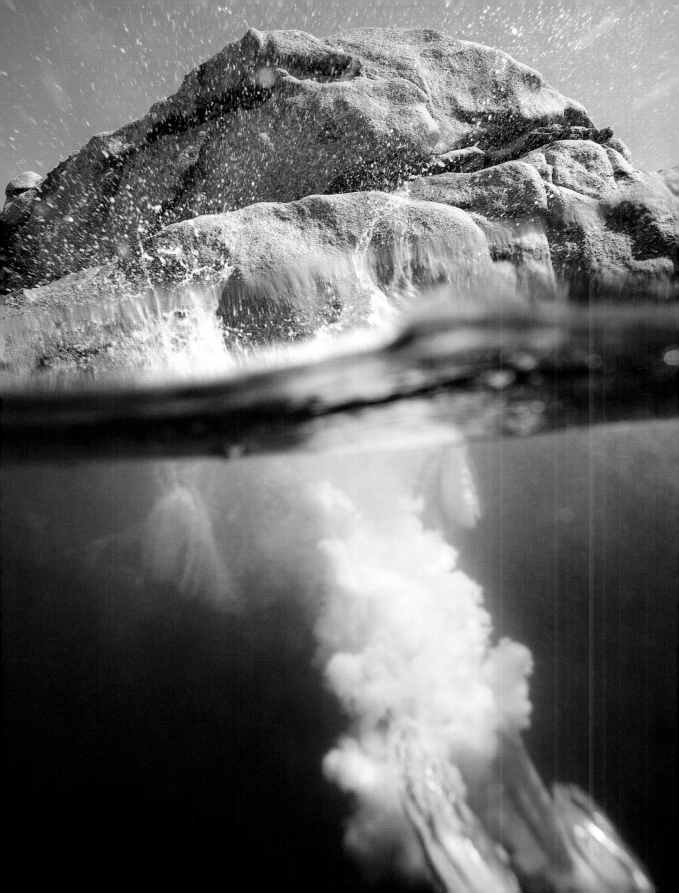

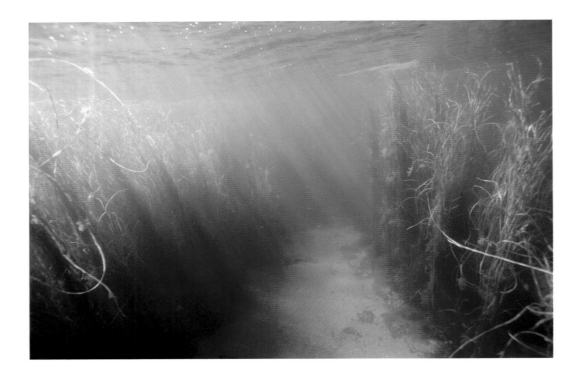

width of truck tyres, lightly sugared with sand. Then I find a patch of 12 feet yellow rope weed like shoelaces with little dandelion clocks on the top. It's an incredible display, unlike anything we have ever seen before.

A lithe, tanned 50-year-old sits on some offshore rocks with his family, and Dom swims up to him. The family have only just got into wild swimming, he says, and new wetsuits helped them realise its potential. The men chat for a bit and then one of them nods towards the horizon and they all head out for a joint aquatic stroll.

Swim: Easy. A great place for admiring the underwater world, with or without a snorkel.

Samson to Bryher

If one of the objectives of a holiday is to 'get away from it all', there is perhaps no speedier route than finding yourself swimming through fog and sunshine such that you are unable to see any 'it' in the first place.

The day starts like many other West Country days: out on a boat with bare legs, blue sky, bright sun and sea spray. We jump off the ferry into the tropical blue water at Samson, and are quickly reminded that it is freezing cold (see picture on page 40).

Samson is an uninhabited island but a couple are already out sunbathing on the white beach, surrounded by heather. We take a swim with them while waiting for Rob to arrive with his kayak – a precaution that seems unnecessary today as the sea is glassy.

There's the vaguest hint of mist over a distant island, clinging to its humps like an aura, but the path is clear to Bryher, and a clump of grey rocks is visible in the middle of the channel, so we set off and swim.

We're soon entranced by the seaweed. It's like flying over a series of meadows. There's a field of succulents, a lawn of short, bright green grass, then a plot of the yellow rope weed, but this time with reddish pompom tops, swishing like horses' tails at 45° to the ground. As we aquaplane over a bed of big unruly ribbon plants with blunt edges, the whole

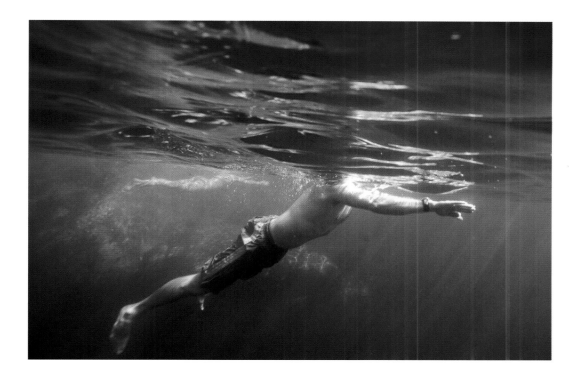

seabed looks as if it's having a stormy pillow fight with itself.

When we stop to pay full attention, it turns out that an increasing mist is not merely inside our goggles, we are completely shrouded in fog. We can't see where we've come from, or where we're going. And the most surreal thing is that we are still in sunshine.

Boats are becalmed, sounds are muffled. It's eerie and otherworldly. We're next to the mid-channel grey rocks now and we either see one heron three times, or three herons once – with the mist gaining and losing density we can't tell. Looking at 'Shipwrecks of the Scillies' in the heliport I'd rather thought the many black and white photos captioned 'Lost in Fog' might indicate laziness on behalf of the researcher. It turns out not: the fog comes in fast, and thick.

We can, however, see each other, and Rob's yellow kayak which has a compass, so flanking him, we carry on. With little to look at our front crawl becomes unbroken, the continual rattle of breath adding to the sense of being in another world.

After a while there's a darker patch on the horizon, then a smudge, then a blur – we're like Walter Raleigh spotting land. Suddenly we can see and we're on a beach, where, improbably, two women lie sunbathing in the fog.

We walk around the island path warming up in our wetsuits heading to our next swim: the Bryher Channel to Tresco. Brambles are festooned with blackberries; after an hour of salt water each little capsule of flavour explodes on the tongue.

Swim: Advanced – this 1000m crossing requires boat cover and knowledge of weather and sea conditions. An idyllic crossing through tropical blue water – if you miss the fog!

Details: Peninnis Head: It is impossible to give directions to this exact spot – even Nick lost the way having not gone for a few months – but there are multiple secluded beaches and jumping spots to discover around Peninnis Head. Take goggles. Be cautious: 'When rocks are submerged just a foot or two, even a gentle swell can

create weird currents and surges,' warns Nick.

Porth Askin is about half a mile south of where the ferry arrives at Porth Conger. Take goggles, and maybe a wetsuit and snorkel.

Motorised boat cover is recommended for all crossings – there are strong currents. The closer the crossings, the bigger the tidal flow, and local boatmen will understand local conditions. SwimTrek does a week-long swimming tour circumnavigating the Scillies (www.swimtrek.com). Some boatmen (www.scillyonline.co.uk/seasafaris) run trips to swim with seals on the Eastern Isles.

There are other possible crossings in the Scillies. Samson to St Agnes is a long swim (3.5km) which can take 3 to 4 hours. St Mary's to St Martin's (3km) is shallow and you can see the bottom all the way across. Tean to Tresco (1.5km) is pretty. The Tresco channel between Bryher and Tresco (500m), is short but has the most boat traffic. See map refs 127-130.

19-22. THE OUTER HEBRIDES: SKINNY DIPPING WITH SEALS

Wild swimming is an elemental thing, and places don't come much wilder or more elemental than the Outer Hebrides, a remote archipelago of islands off the north west coast of Scotland. With a barren landscape of peat bogs, empty white sand beaches and a maze of sea water and fresh water lochans, North Uist, the island we visit first, is not just wild but feral. Beaches are tracked by deer and sheep, and the landscape is littered with stone circles and animal bones. In summer, cattle stand on the shoreline chilling their heels in the surf; in spring loch swimmers can watch eagles displaying – locking their claws and tumbling through the sky.

The Outer Hebrides provide wild swimming at its best, and like the stags roaring on the hillside during rutting season, these wild, beautiful islands emit their own primeval call: 'go skinny dipping'. Clothes seem out of place, an unnecessary impediment between you and the elements, and, besides, you are unlikely to be seen. Forget cosy, whisky-fuelled nights in firelit pubs, the Outer Hebrides are forbiddingly remote. Local swims tips will need to be gleaned from a grocery store, fishery smokehouse or B&B.

The land – sky ratio here is disproportionately balanced in favour of sky. The weather changes fast: fresh Atlantic winds bring forbidding storms and squinting sunshine in quick succession. The white sand makes the sea look blue even on grey days, and when the sun's out the colour's electric. At midsummer there are only two hours of darkness, providing long hours of swimming. All year round, stars seem to multiply under scrutiny in the absence of street lights and in the spring you could be

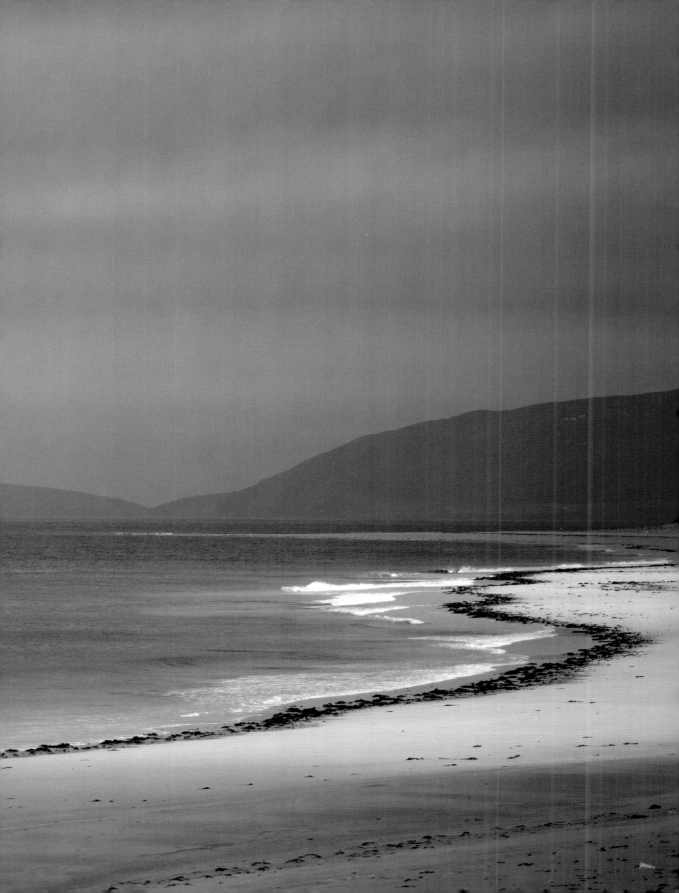

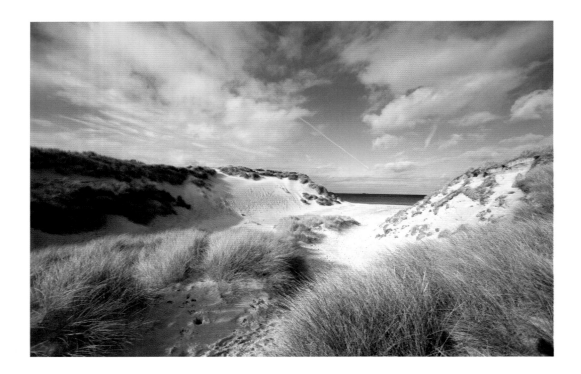

lucky enough to see the Northern Lights.

The sea is not as cold as you might expect, varying between 9°c in winter, and 13°c in summer. Five-metre tides wash the beaches twice a day, and seals, minke whales and porpoises are all frequently spotted in the water.

We visited in October and relished the bittersweet pleasure of cold-water swimming here more than anywhere: the shiver and smack of cold against naked flesh, skin turning reddish purple in the icy salt, rubbing ourselves dry unable to feel the towels. If you take thermoses, thermals, ski jackets and gloves for after your swim, the exposure itself will become an unmitigated pleasure.

There are also great swims in the Inner Hebrides, the line of islands closer to the Scottish mainland which include Skye (see Fairy Pools, Talisker Bay). These include the Gulf of Corryvreckan (see map ref 131), a whirlpool which calms down for one hour a day making it briefly possible to swim across, and an 800 metre crossing from Jura to Islay (see map ref 131).

'Jura is the "island of deer", and this is a migratory route: when deer have had their fill of the pastures here they move on to another island. It's not like the wildebeest flocking, but I've seen them do it – they don't have tide tables so they know how to do it themselves,' says Simon Murie, who rates the Inner Hebrides as some of his favourite British swimming. SwimTrek, his company, organise week-long escorted trips swimming between the islands. (NB Boat cover is essential for crossings. There are strong tidal streams.)

Traigh Ear & Traigh Iar, North Uist

We wash up at the remote island of North Uist on the brink of our 100th swim for this book to find that we're in our wildest place yet. It's late afternoon and Sophie, our host, takes us on the circuit of the 18 mile by 12 mile island by car. The sky rolls with grey clouds and migratory birds and the road dips between brown marsh grass and endless lochans – North Uist is as much water as land. Whooper swans have just started to arrive and spirals of white wire mark

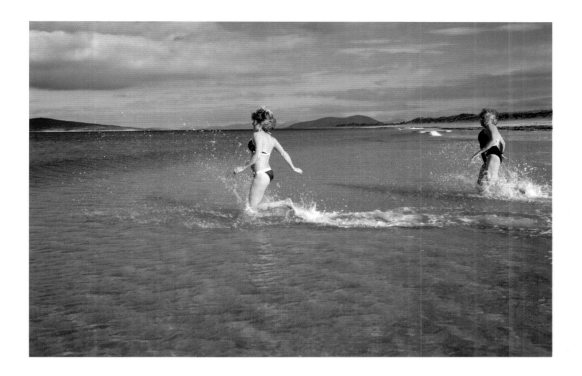

out telegraph wires, protecting the birds from collisions.

When I first started researching wild swims, one swimmer revealed his criterion for a good swim was simply whether the water was 'appealing' or not. What's appealing, I wonder? A raging torrent or a gentle stream? It turns out it was whether he felt 'attracted' enough to it to want to get in. Over the summer this evolved into a joke, but a vital part of any swim trip, we now realise, is the ogle – the checking out of bodies of water.

And so, with Sophie at the wheel, we loop around the island, looking for that 100th swim, surrounded by peaty brown lochans. Sophie rattles off the highlights like the island's madam: 'This one has a mix of fresh and salt water which gives it the best mussels, you could swim then pick some for tea.' 'This one's the longest. It's 13 miles.' Away from each other – at the top of a mountain, at the end of a very long walk – many of the lochs would be irresistible, but lined up next to each other they fail to charm us. It must be how rock stars feel

when faced with far too many groupies.

So we press to the coast and take a long, blustery walk along Traigh Ear, wrapped up in coats. We have been told that yesterday was 'very alluring' – bright blue and sunny, with clean white sand – but an overnight storm has laid out seaweed like a natural history exhibit. We walk along past a stand of brown kelp trees with smooth metre-long trunks and wet rag-mop tops, then a section of bladderwrack constellated with barnacles. A few metres of supernaturally long green beans are followed by thick strips of heavy wet silk. I take one more step and suddenly my feet are surrounded by nothing but clumps of purple-red fur, each looking as if plucked from the head of the Muppets' crazed drummer, Animal.

Next, we walk over the headland to Traigh Iar and earmark the inbetween rocks for a future seal swim – there's a colony of 40,000 seals 4 miles offshore that often visits – then drive home under a darkening sky, passing a Free Church lit up by harsh lines of strip lights, windows damp with condensation

from the breath of the hidden congregation.

Over dinner and a peat fire – the dense sweet smoke so delightful that we wave a peat brick around the house to spread it further – Sophie, an artist, shows us her collection of dead things. She has a dolphin skeleton in a box (minus the skull). There's one vertebra of a pilot whale on the mantelpiece and a cow's pelvis by the dresser. The woman to look for on the island, if you want your own, goes by the name of Mary Bones.

Swim: Easy to moderate. With clear, clean, bright blue sea, white sand and a nearby docking station for seals, these Hebridean beaches are great for swimming.

Berneray Beach, Berneray

The next morning we cross the causeway from North Uist to Berneray (population in March 2007: 128) for our swim. The land is scrubby, brown and full of water. We pass huge pens of black plastic silage rolls, white bungalows with lines of washing blowing horizontal, every second line with an orange work suit fully inflated by wind. It's very David Lynch.

Berneray has a north-westerly beach so today's wind is offshore. We drive through flat fields dotted with scarecrows and then park the car by Highland cattle. We walk towards the dunes, disturbing ground-nesting birds and passing the body of a rabbit decomposing in the arc of a perfect bound and are finally rewarded by a 3 mile stretch of perfect white sand, the sea glinting turquoise.

This beach gets 10 out of 10 for attractiveness: an aquatic Casanova, a watery Lothario. This is it! The 100th swim. Clothes are off and I streak down the beach – sand hard and good for running – taking in lungfuls of the clear pure

air. It's icy and gorgeous and I dive under to feel the cold water against my eyelids. Unimpeded by clothes the water spirals past armpits, chestbone and legs in a continual thread. It's the whole sea and me. I breaststroke parallel to the shore with the white sand beneath me along the surfless beach. Every inch of my skin fresh with cold, contentment spreading right across my frontal lobes. Then I see the grey head of a seal! I look at it and it looks at me. Then there's a splash and a spreading circle of flat water shows that it's submerged right next to me. I've been longing to swim with seals all summer. Now the moment's here and I've got no goggles or pants on. I run out of the water in faint alarm.

After that the three of us stand facing the seal for ten minutes. Kari and Dom eventually get into wetsuits and goggles and get in, but the seal leaves so they swim instead, while I wait on the beach, wearing all four of our jackets to try and get warm. We make tea from a thermos of boiling water and wander off wordlessly. After four days in a Ford Focus we appear to have hit upon the perfect intimacy – separate but together. In this place there's time and space not to think.

Later we drive back to Uist. 'Caution: Otters Crossing' says the sign on the causeway. Kari sits in the back holding some sheep vertebrae and the skull of a gull that she found on the beach, while I hold the map in my ski gloves and look for Scolpaig.

Swim: Easy to moderate. A remote 3 mile white sand beach with crystal clear turquoise water, and few visitors. Ideal for skinny dipping, barefoot running, impromtu beach fires – and you may even see a seal.

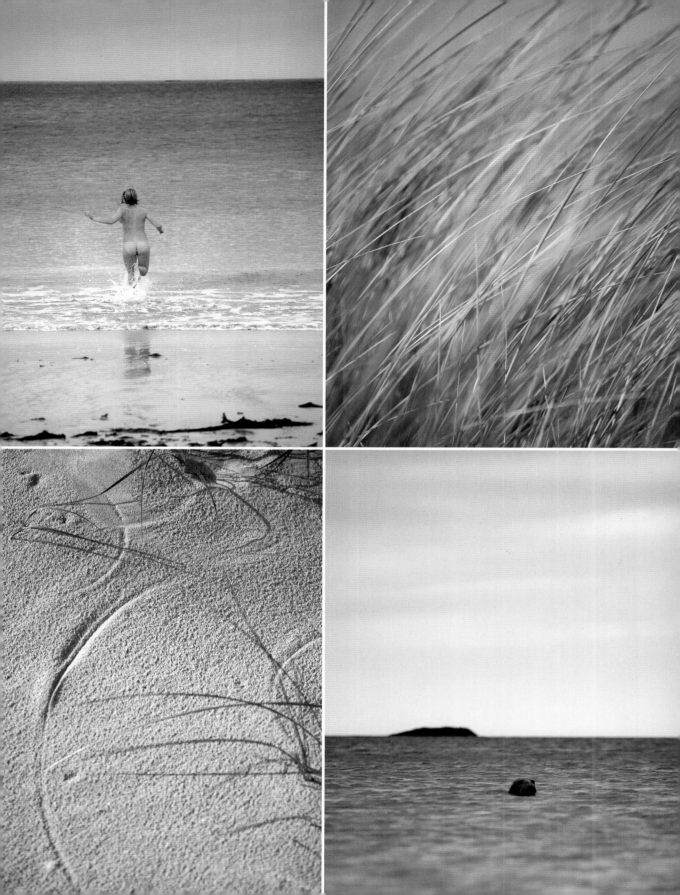

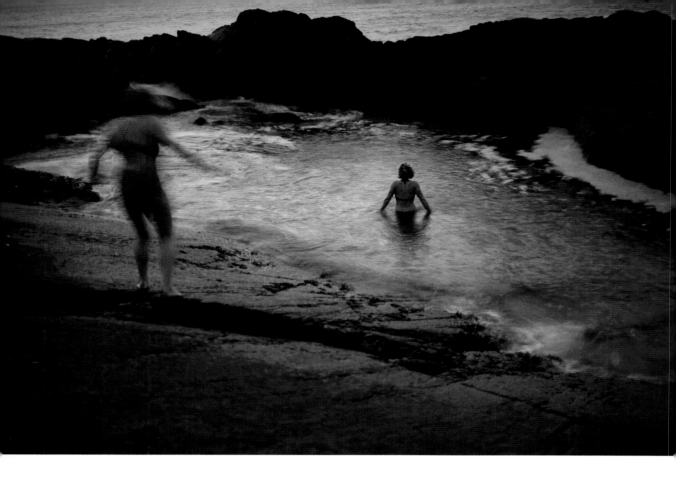

Scolpaig Tidal Pool, North Uist

We approach Scolpaig Farm by a long, undulating road. White stripes on either side mark the dank tarmac out from the surrounding rocks, bog and heather. With the regular bulges of the passing places, the road looks like a snake that's ingested occasional rocks. We pull in for Royal Mail to pass us – out here the post van doubles up as a minibus – and see abandoned white bath tubs sinking into the bog. Barbed wire fences are covered in 'witches' knickers' (black shreds of polythene bags), left by witches fleeing in too much of a hurry.

Following the directions we've been given, we drive past Scolpaig Farm, park on the middle of the headland, following wheel ruts of previous cars, and walk down the rocks towards the sea to find the pool. It's windy and the sea erupts against the rocks with a roar so deep it seems to come from the centre of the

earth. Human beings can only spend so long in relentless wind before it threatens their sanity. After two hours, Dom and I are still stationed on grey rock, hats down over ears, arms crossed over chests, each of us nestled into our own rock groove, waiting for the tide to drop. We decide to beat a retreat, questioning the accuracy of Sophie's kitchen tide-clock.

Kari has been exploring and comes back with news of another pool further on, so we check it out. (It's undoubtedly the right one, like a natural lido, with the rock behind it carrying a curly sweep of black and brown strata, as if from an art deco brush stroke.) We go back to the car and watch the sky darken, still wearing our anoraks. The car rocks slightly in the wind as we drink tea and eat waffles.

By the time we arrive back at the pool the light is fading fast. We make our way down the steep flat rock like crabs then strip off and wade

in. It's cold and dark but we feel reckless and alive. I bang my thigh against an unseen rock in breaststroke, so we scull around on the surface, the light of the moon following us in swirling circles. Once we've learned the underwater topography, we float on our backs, observing the moon. Kari rolls her top down and I throw my bikini out onto the rock – North Uist, we declare, is made for skinny dipping.

When we get out we find that the sea has reclaimed my bikini – and later that evening Dom's photos reveal the bottoms making their way out into the ocean like a spotted manta ray.

Swim: Easy to moderate. A natural tidal pool with a sandy base, art deco swirl embedded in the rock, and protection from the sea.

Details: For Traigh Ear and Traigh Iar beaches go to Grenitote, turn down the road marked by a phone box on the corner, follow it to the car park and walk from there. (Note: There is another Traigh Iar near Port Scolpaig.)

Scolpaig Bay also has a good reputation for swimming. Traigh Stir is beautiful and popular for surfing, but dangerous for swimming because of serious rip tides. We were also advised against Bhalaigh (Valley) Beach – shallow with dangerous tidal pools.

Berneray Beach is clearly marked on OS maps (Nf9381). Scolpaig (NF7375) is at the north west corner of the island, less than a mile off the main road (see map ref 133). Walk along the headland from Scolpaig Farm to Hoster to the point where the rocks are flat and smooth, near Scolpaig Cross on the OS map. From here (although neither the cross nor the pool are clearly visible from the path), walk down the rocks until they shelve into a sandy-bottomed pool.

23. PERRANPORTH TIDAL POOL, CORNWALL

Perranporth pool, on a rocky outcrop in the middle of the 3 mile-long beach, is a wonderful solar-heated pool for children to play in or adults to retreat to on quieter days. By the time we arrive the pink sunset's so vivid it looks air-brushed. The lifeguards have left the beach, along with their flags. A handful of surfers are still out on the waves and a few stragglers are taking evening walks with their dogs. There are a couple of kites in the air and a three-a-side football game is being played.

The pool itself is hidden in Chapel Rock and without a tip-off you wouldn't know it was there. Once in, rocks screen you from what's on the beach, so the view, even on busy days, is just surf and horizon. Seaweed hangs off the rock sides like a balding man's last strands of hair.

Swim: Easy. A small tidal pool hidden between rocks on a popular Cornish beach.

Details: Perranporth is a popular family holiday destination and surfing beach less than 6 miles down the coast from Newquay. The tidal pool is in Chapel Rock and can generate rip tides in the surrounding sea on a falling tide making it unwise to swim to it at this time. (Wait a little longer and you can walk or wade there.)

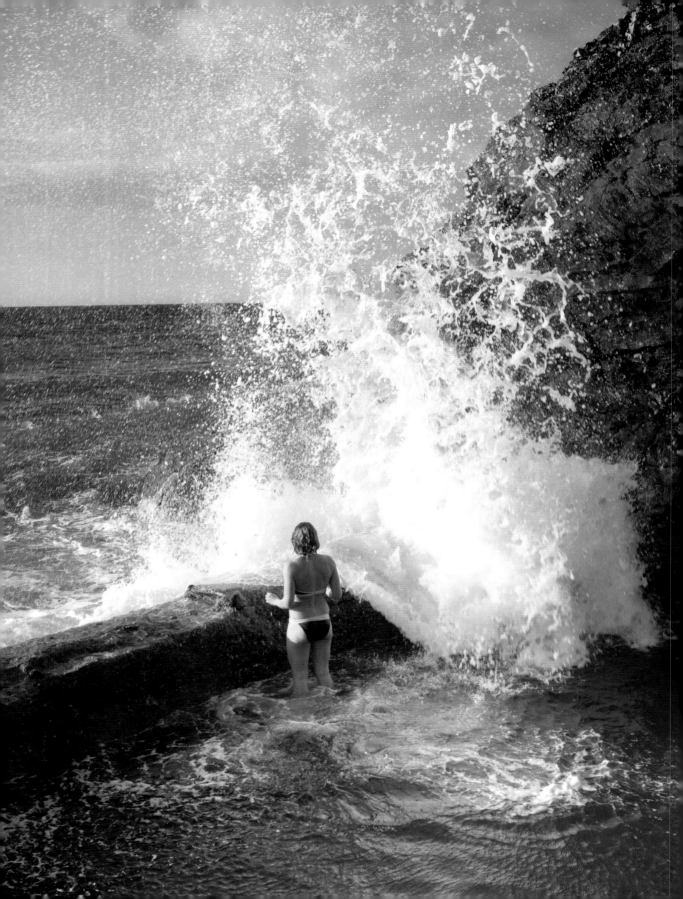

24. PORTHTOWAN TIDAL POOL, CORNWALL

The north coast of Cornwall is dotted with sea pools that give swimmers a chance to bathe safely, away from the waves that make the coast so popular with surfers.

We arrive in Porthtowan at 5pm. It's high summer; the surf shop is having a boom day and the beach is a morass of sun cream, ice cream and bad parenting. Facing the sea we take a right turn up the cliff path closest to the beach, and soon come to some steps down to the empty tidal pool.

The tide is high so we sit and wait for the pool to open – a pleasant change from the normal swimming experience – watching for the point where the pool is no longer part of the sea. Waves crash over the concrete wall that dams the pool, water and white bubbles surging forward over the wall closest to us. There's a sheer dark rock cliff to one side and a jumble of rocks to the left. We see a black shag in the green arc of a wave, perhaps diving for fish.

To pass the time, Dom inspects barnacles and anemones in the jumble of rocks, and I watch the sea lower almost imperceptibly. It reaches a point where the top of the front wall is clearly visible through the clear water and then another where a few centimetres of sea pours over the wall like melted glass.

At this point I get in. It looks like a place where mermaids would swim: purple, turquoise and bright green seaweeds cover the bottom. With goggles I suss out the rocks underneath, then stand on a ledge by the sea wall. Waves are being broken by the wall, hundreds of gallons of water being smashed up into the air. The change in air pressure means I can feel the water coming before it lands, instinctively shying away from the most violent blasts. The water lands on my back with a shocking thump. My heart is pounding in my throat as I swim around the pool but I am soon back waiting for the next wave to fall. It's hard to imagine how any wild pool could beat this as a swimming experience.

Swim: Easy. A wild and exhilarating tidal pool on the Cornish coast.

Details: Porthtowan is about 4 miles north of the A30 at Redruth (nearest station: Redruth). There's a chain of tidal pools along this coast, and a few could be visited at low tide: Portreath tidal pools, Lady Basset's Baths (also Portreath), Millendreath, Polperro and Treyarnon Bay (see also the picture on page 2).

25. TALISKER BAY, SKYE

We arrive at Talisker Bay cheery from a full Scottish breakfast on the North Uist to Uig ferry. We're happy to be back on the mainland but it's a dank grey Scottish morning, the low hills shrouded with mist. We start following signs to Talisker distillery – home of Skye's famous whisky, so full of peat phenols that it tastes of aniseed – and pass a whisky-coloured waterfall. There's one patch of blue in the sky and over time it becomes clear that's where we're headed. We walk down a farm track full of cowpats and sheep droppings for about a mile to reach Talisker Bay in the sunshine.

On first view it looks a bit like a slag heap: big grey pebbles are washed up in a heap at the back of a beach tangled with marine detritus – ropes, fishing nets and empty plastic bottles. But on closer inspection we realise that the sand isn't grey, it's made up of grains that are either totally black or totally white. The whiter sand is lighter and finer, so where streams run down the beach the colours separate in rivulets. Sandworms on the move look as if they've been mapping out the edges of continents in black.

A river runs down the centre of the beach and seagulls congregate over it, and there's a cliff waterfall about a hundred feet tall.

We get in and find that, for the first time in our lives, we're in waves perfect for body surfing. Dom and I catch wave after wave, hands outstretched, kicking our way on to the water, then sliding from the unbroken wave into the white foam as each one breaks. (Goggles and hats transform our body-surfing experience, allowing us to see where we're going.)

Like little kids we stay in for too long, then dress and walk back to the car.

Swim: Moderate. A good swim for body surfing, black and white sand and pockets of sunshine, with an agricultural approach.

Details:Talisker Bay is marked on the OS map (NG3130) about 5 miles due west of Carbost.

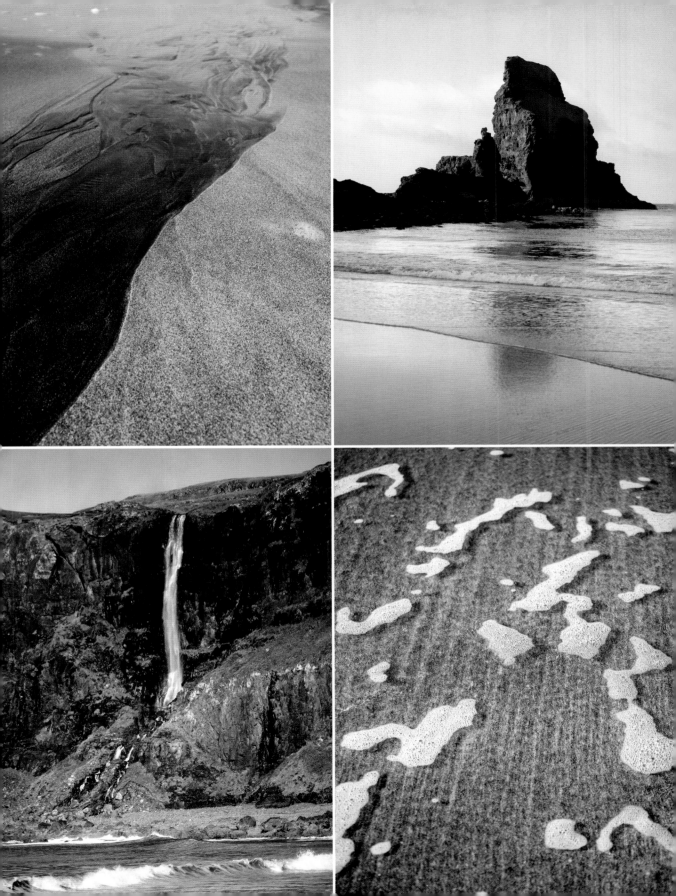

26-27. TINSIDE BATHING AREA & DEVIL'S POINT TIDAL POOL, PLYMOUTH, DEVON

It's a personal dream of mine to live next to my own 'swimming area' – not a man-made natural pool, but a little slice of river or ocean that I can return to daily. 'We might not be millionaires, but we live like them,' says one of the ladies at Tinside Beach, in recognition of the riches 'their' bit of sea brings.

The first bathing houses at Tinside were opened in 1913. The swimming area was so popular at that time that the mayor expressed the hope 'that Tinside might not always or at all times be monopolised by bathers, but that somehow room might be found for those who loved to watch the many twinkling smiles of Father Ocean or to spend a quiet hour in peaceful communion with Nature.' Steps and limestone bathing houses were added in 1928 and still stand today.

Jean Perriam, now 67, used to swim and sleep here during the day after working night shifts as a nurse. In summer, she's one of the regulars who swim three or four times a day, reading and chatting the rest of the afternoon. They used to hang out by the rocks after a swim, but over the years many have acquired beach huts on the cliff, kitted out with tea pots, book shelves and sun loungers.

Out to sea, new yellow buoys, in modern black type, mark out the 'SWIMMING AREA', and a typical swim involves going to the buoy and back – a 700 metre round trip. The council will

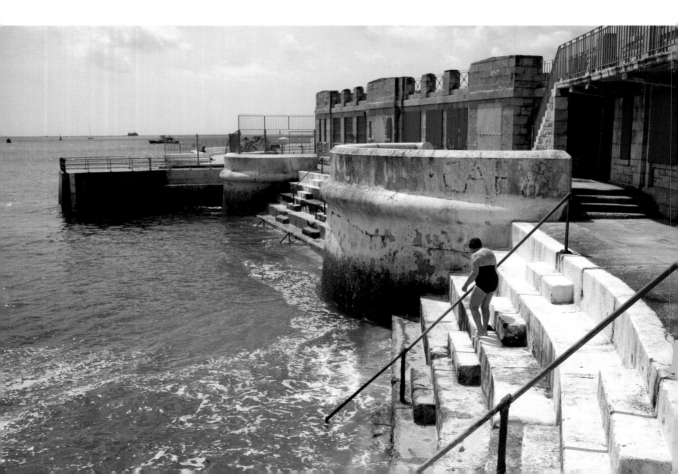

still give changing room keys to anyone who asks, but keeps them locked as protection against vandals. 'They used to have lifeguards here and rafts to swim out to, and a guy in a rowing boat netting seaweed and rubbish, but all the foreshore attention went five or six years ago,' says Jean. The swimmers clear the path out to sea themselves, pulling up a line of bootlace seaweed as they go.

To swim here is a pleasure: descending the giant stone terraces of the Victorian promenade, and surging into the sea, the grey bulk of a battleship going past (the Hoe is next to a naval base). Regulars know the terrain: if the waves come higher than two steps up it's hard to get out (the handrail that used to help them is now covered in barnacles); and if there's a north wind the swim will be both sheltered and clear. 'It doesn't rain on a north wind,' says Muriel

Oatley, 86, statuesque in a blue costume and coral lipstick, 'so rivers aren't bringing down mud.'

A storm out to sea this morning has left the water a little rough, but we follow Muriel and Jean's lead and get in, knowing it's safe. 'When I was younger, in my 50s and 60s, I used to go in whatever the weather, but now I'm more careful,' says Muriel. She learned to swim at nearby Devil's Point Tidal Pool when she was four. 'My grandfather would walk along the edge of the pool holding a stick down to the water and if I started to sink I'd grab it. I swam every day in the tidal pool or sea, nearly everyone I knew did; we were brought up with cold water so it didn't matter.'

Bad weather doesn't put Muriel off. 'I swim when it's snowy. At 6°c it stings, though it feels so good once you're in. I always go right in, I

never hesitate. The sea is my life: I like the exercise and I like the outdoors.'

After our swim at Tinside, we go on to Jubilee Pool, and then pass various tidal pools. Although 'No Swimming' signs are beginning to appear and a few tidal pools have been lost, Plymouth swimmers still have lots of options. By the Hoe there's a very high 'high diving board' that extends into the sea and attracts huge crowds to watch daredevils in summer.

Our last swim is at Mountwise Community Pool, but before that we go to Devil's Point Tidal Pool, at the end of Durnford Street, Stonehouse. This is an elegant shallow pool with a faded lemon base and ribbons of seaweed wrapped around the rusted handrail. Two wetsuited boys, fresh from murdering crabs on the beach at low tide, trade stunt dives with me. The pool is opposite Drake's Island, and the city is further away: we can hear gulls cry and the soothing sound of wind in big oak trees. The pool is shallow – the deep end wouldn't be deep for a lot of children – but it looks a wonderful place to steal a few laps before anyone else is up; great for paddling children and early morning insomniacs.

Swim: Easy to moderate. A popular Victorian bathing area with giant stone steps, an elegant promenade and a view of Plymouth Hoe's battleships.

Details: Tinside is about a mile south of the centre of Plymouth (nearest station: Plymouth). The Tinside Beach bathing area is just to the left of Tinside Lido as you look out to sea.

28. TOMMY'S PIT, BUDE, CORNWALL

Just a few hundred metres of golden sand away from Bude Sea Pool on Summerleaze beach is Tommy's Pit, a sea pool at the end of the sea wall. This narrow sandy-bottomed swimming channel is a hidden treasure, fringed with swaying sea ferns. Look closely at the rocks and you will see the numerals 4, 5, 6, elegantly carved into stones along its edges. It was made by local landowner Sir Thomas Ackland who concreted one end to retain the sea.

The pool is just under 'Barrel Rock', so called as a green barrel on a mast juts from its end. It's improbably tall: a clear demonstration that the Atlantic can swell 9 metres or more on a high tide.

Swim: Easy. A small, elegant tidal pool on a popular Cornish surf beach.

Details: Bude is off the A39 south of Bideford (nearest station: Gunnislake). Walk to the end of the sea wall at Summerleaze Beach and look for the green barrel.

29. WALBERSWICK BEACH, SUFFOLK

A remote village on the Suffolk coast, largely populated by writers and artists, Walberswick looks slightly Dutch, a result of its historic links with The Netherlands, not far across the North Sea.

As we drive towards it, the autumn sunset behind us is so bright that the hedgerows are lit up, bare twigs glowing orange. Over a field gate we see the shell of a silo as thousands of starlings sweep in and land on a ploughed field, then take off in a wave, rising from the back.

It's been a longish drive so we head straight past beach huts and dunes to the beach. There's a long stretch of sand and the sea is brown, busy but not rough. Three fishermen have their rods out. To the right Sizewell B power station looks surprisingly pretty with its pink lights. To the left the black pier of Walberswick has one solitary green light at its end, like a lone firework hovering.

It's a lovely industrial swim, the water somehow more compelling because of the presence of the power station and a tanker on the horizon.

Afterwards we head off to The Anchor for skate wing and capers, apple tart and toffee pudding. The staff at the pub all swim in the sea after their shifts, inspired by a few weeks of phosphorescence over the summer. By the end of the evening our spare wetsuits have takers for the morning's mission: the Blyth Estuary.

Swim: Moderate. Black timber houses, estuary boats, brown sea, sand dunes and Sizewell B power station – there's easy swimming and an out-of-season beauty to this Suffolk beach.

Details: Walberswick is about 2.5 miles from the A12 at Blythburgh (nearest station: Darsham). This area is popular with walkers and it's also a great place for catching crabs. Southwold is just over the estuary.

2 RIVERS & ESTUARIES

Until heated pools were built in the 1950s everyone learned to swim outdoors, many in rivers with sectioned-off learner pools, or at the hands of people who kindly took it upon themselves to chuck children into the village pond until they learned to float. I have a particular fondness for rivers, their silky softness and the experience of floating downstream, looking at clouds while being carried along by the current, then nosing up to tree roots, water lilies, willows and ducks.

River swims are perfect mini-adventures, and a brilliant combination of daring and safety, of being together and apart. You start out walking barefoot together along towpaths in trunks and bikinis, then you're in and immersed in your own experience, until you stop to chat or swing off a rope together.

Waterways are also cleaner than they've been for years, so it's no surprise that more people are getting back into them, enjoying their back-to-nature morning wash by a wild camp or their own stretch of riverbank, meeting friends for a downstream expedition at the weekend or just taking a dip post-festival or mid-walk, wedged into a natural jacuzzi with a few baby trout.

River swims are as various as the people who swim in them: there are waterfalls, sun-warmed paddling pools and swimming superhighways. There are traditional bathing spots where you can join in the splash and chat with children and picnickers, and remote crags and brooks known only to climbers and ramblers where you can swim through underwater arches and plunge off rocks.

This section includes examples of these, from swims suitable for children in armbands to tougher swims for fit triathletes.

Eventually all rivers lead to the sea and so this section also includes some estuary swims. Estuaries are primordial muddy places, alien to most of us, where oak leaves and seaweed bob along together. One of the delights of estuary swimming is getting a free ride: catch the tide in either direction and you can cover more ground and see more scenery than when powering yourself.

River Lugg, Herefordshire.
Previous page: Waveney River, Norfolk

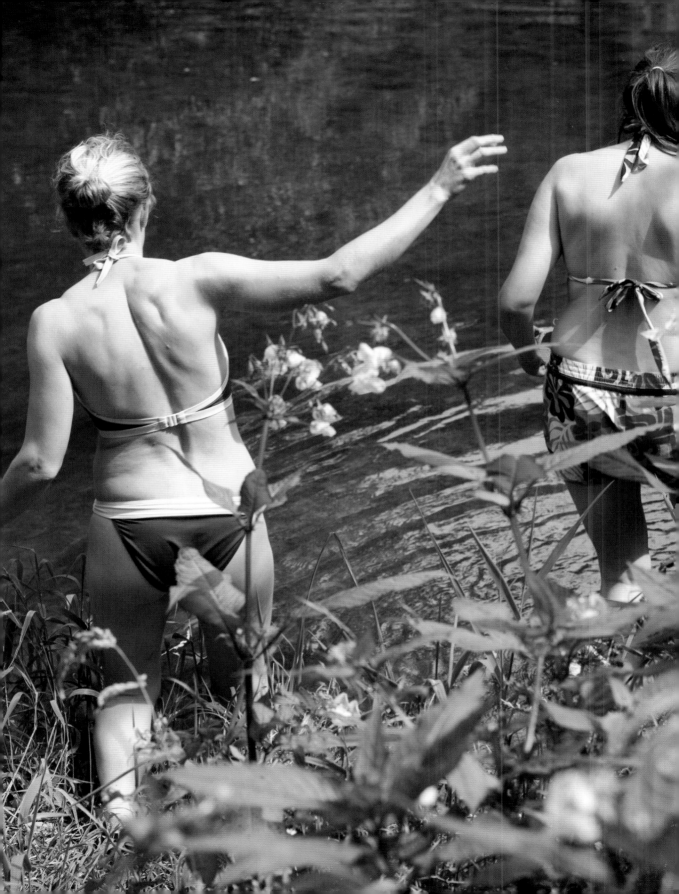

30. BEAULIEU RIVER, NEW FOREST, HAMPSHIRE

We jump into the Beaulieu River on a Sunday afternoon in autumn as the tide's going out. There is low grey cloud and the water is sullen. There's a distinct beauty to overcast autumn swimming. After the hurly burly of summer – the bright pinks, greens, yellows and blues of people, sunshine and boats – there's a restfulness as colour drains from the land. Water appears muddy and bankside grasses and thistles become blackened and ghostlike. The eye is soothed by greys and browns.

We get into the water with an inflatable red canoe, accompanied by some post-Sunday lunch friends and children following us on a path through the wood. The swim is being led by Beatrice, who swam here after a summer wedding. 'The channel was full of old sea dogs tinkering, flags out as they sat on their decks drinking tea, waving and cooking, with lots of birds coming in to land,' she remembers.

The boats now bob deserted, sails taken in. There's the ghostly sound of wind ringing in the masts, like a finger circling the rim of a glass. Pheasants let out occasional squawks and we swim through the water. It looks like river and tastes of sea, with clumps of dark yellow bladderwrack floating alongside fallen oak leaves. The high volume of salt water gives an unusual buoyancy for a swim inland.

The water drains from the creek as we swim, exposing the mudflats that feed the gulls, redshanks and terns. Our progress is slower than expected and, even in wetsuits, we begin to get cold, so we take a short cut, run over some mudflats, and then slide back into the water.

We get out at 'Keeping Trees' jetty, where upturned skiffs sit next to fallen acorns and the first berries of new season holly, and meet the walking party carrying our clothes.

Swim: Advanced. An atmospheric 2.5-3km estuary swim, which requires knowledge of tides and awareness of boats.

Details: Beaulieu is on the B3054 between Hythe and Lymington, 10 miles from Southampton (nearest station: Beaulieu Road). Enter the water from the village green, just downstream of the bridge. Exit at 'Keeping Trees' wooden jetty just before Buckler's Hard marina, which is private. Once you start this swim you are fairly committed, although there are a few places where you can climb out to the footpath. See 'Tips for Wild Swimming' for advice on estuary swimming. This is a busy channel so boat cover is recommended; accompanying kayaks need a permit from the harbour master (01590 616200).

There is an unusual phenomenon of a double high tide on the whole of the Solent, with the second high tide about an hour after the first. Check with local people or the harbour master.

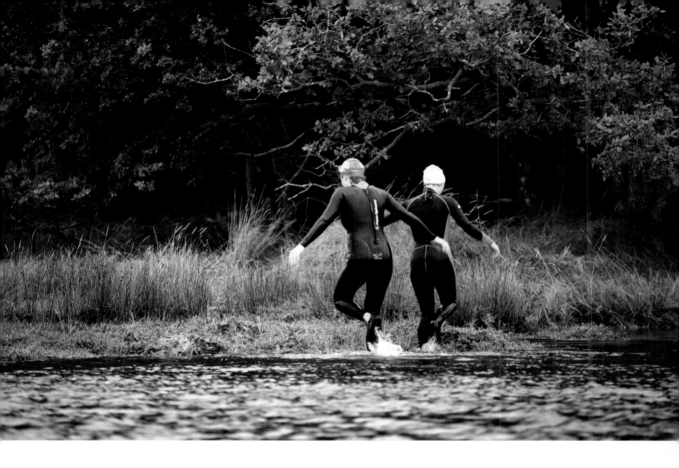

31. BLACKMOSS POT, STONETHWAITE, CUMBRIA

You're never more than six degrees away from a wild swimmer, and in an outdoor shop in Ambleside we are recommended one of our favourite swims of the book. Blackmoss Pot has a magical combination of qualities: a longish walk to a hidden spot, crystal clear water, a waterfall, jumps, a natural jacuzzi and a 20 metre swimming channel between sturdy rocks.

To reach Blackmoss Pot we park near the Langstrath Country Inn, Stonethwaite, where walkers are drying out their boots by the fire and lunching on Goosnargh Chicken and Eskdale Steak & Ale Pie. We start up the Langstrath valley and, after five minutes, pass a wild camping spot that makes us want to buy a stove and stay for the week. A couple of tents and a van are backed up to the river, and there's a painted wooden sign thanking people

for keeping this 'a clean and peaceful place for everyone'.

The Cumbria Way and Dales Way run to the east of the river, which runs clear over grey rocks, but we walk on a footpath on the west. After 10 to 15 minutes we reach Galleny Force, a recommended swim spot with a series of waterfalls in a crevasse with lichen-covered trees hanging overhead, ferns on grassy mounds, and places to sit in natural jacuzzis (see map ref 134).

We continue up the gentle slope and pass an ideal children's section where the river spreads out wide and shallow, with every chance of pockets of water being heated up into little paddling pools by the underwater rocks on sunny days.

A striking tree appears on our right, its trunk split into two boughs that reach upwards like outstretched arms, with a heart-shaped bulge covered in moss in between them.

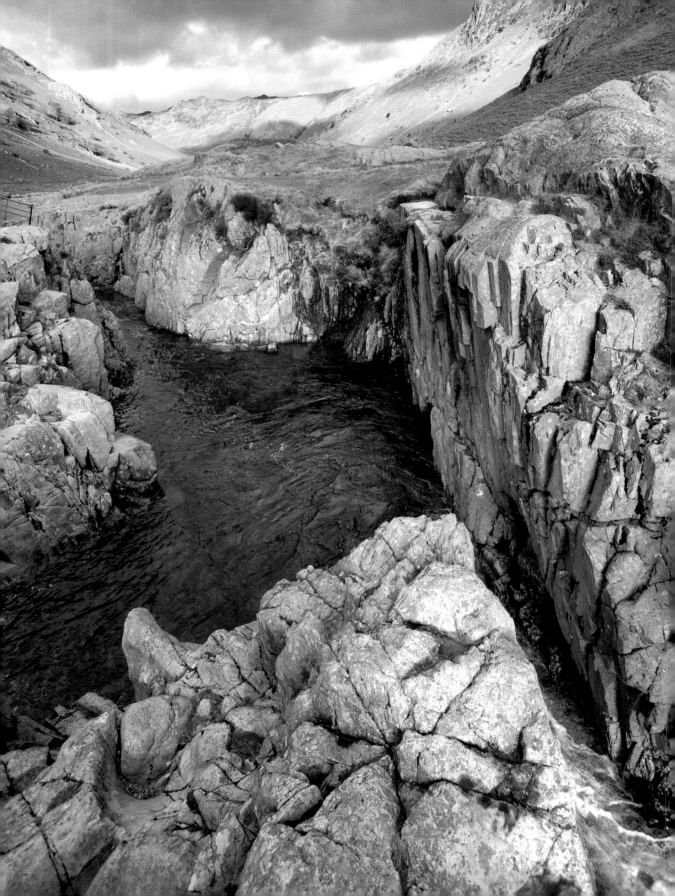

There's no one around so we sneak turns to squeeze our chests against it, bosom to bosom, ribcage to ribcage, and breathe a bit. But the walk and the tree and the vigilance over the creek are all part of what makes this swim. For the first half hour of the ascent our normal lives come with us in the endless noise of our own chat, but gradually we pipe down and the landscape takes over. After an hour we're rewarded by Blackmoss Pot – a deep pool behind a cluster of rocks.

We can't get our clothes off fast enough. There's a big round stone about 6 feet high, the perfect easy jump for landing with a comfortable splash in completely clear water. It is breathtaking, in both senses of the word. We are surrounded by steep walls that climbers play on in summer. It starts to drizzle and I swim upwards to the waterfall. Grey rocks like stepping stones cover its lip. I watch soggy sheep cross the falls one by one while I wedge myself into some bubbles. Then I let go and swim down through the main pool, then up and down the calm 20 metre channel between the two high rocks. It's sheltered, crystal clear, alive with baby brown trout, and – company allowing – the ideal spot for five-star skinny dipping.

Swim: Moderate. Some athleticism is required to walk to this swim, and to jump in and climb out. A climbers' dipping spot in the heart of the Lake District, with child-friendly spots and wild camping sites en route.

Details: Blackmoss Pot is marked on OS maps (NY2611) (nearest station: Windermere). The Langstrath Country Inn or the wild campsite both looked like great locations to base a swim trip. Buttermere, Crummock Water and Scale Force are all nearby, as is Stickle Tarn. See map refs 69, 70, 90 and 145.

32-33. BLYTH ESTUARY, SUFFOLK AND BURNHAM OVERY STAITH, NORFOLK

It's a bright October morning in a landscape of lines: dazzling blue sky, 360° of flat horizon and the Blyth flowing brown between man-made banks. We walk along the raised path between stripes of green grass heavy with dew and sparkling white, the mudflats of the Blyth shining like globular polished rock in the sunshine.

While not part of the Fens, this area of the Suffolk coast shares some of the same history of land reclamation. The boggy marshes of Blythburgh are a mixture of marine silt and freshwater silt carried downstream in rivers. The Blyth used to be a mobile river, entering the sea at Dunwich and then silting up and flooding the flatlands before it broke a new exit at Walberswick, about 2 miles away. But since the 17th century the progress of water has been controlled by an endless process of sluicing and dredging, blocking and pumping.

We pass a Dutch-style pump house that looks like a windmill and stands empty on our way to the lagoon at Blythsburgh Water. Just before our visit the Environment Agency announces it will no longer be maintaining the flood defences in this area; so the sea may soon recapture some of its former territory.

We're headed to the lagoon at Blythburgh Water from where we plan to be swept out to sea by the outgoing tide. This area is famous for breeding and wintering birds, a fact which takes on new meaning as we walk along the brown frothy river, its speed marked out by stray floating feathers. It looks a bit like swimming in the swill of a birdcage.

We arrive at the mouth of the lagoon with the suspicion that our timing is a little off: it's so bright we can only really see reflection ahead but it seems to come from as much mud as water. The Blyth, however, is still making its way out to sea, so the six of us get in – Vicky, Michael, Dom, Sophie from the pub that we're staying at and Annabel, a local friend of Michael's.

The mud is so thick that each step creates a hole that goes up to my ankle, like roomy mud wellingtons. One after the other we take a few steps then do the Walberswick slide: an ungainly wobble-wobble-whoosh into the water. And so our party enters the flow, or what we can find of it – It's over here! No, here! – and begins the downstream journey.

In summer the shallow lagoon heats the outgoing water. Overnight in autumn it acquires a chill. So we are prepared by wearing all the wetsuit gear we own, including, where possible, boots and gloves. I feel a bit like a teddy bear, and Vicky's so buoyant that if you pop her upright she bobs like a cork.

We progress inventing an array of strokes – wetsuits make breaststroke hard, and we have no desire to put our heads in the water, so we are left with variations on trudgen (a kind of front crawl), side stroke and doggy paddle. We have well over a mile to go and it's clear to us that Michael's assurance that we could get out 'at any time' is predicated on the assumption that we won't mind walking home squirming with mud.

But there is a kind of epic drama to it, swimming through this landscape that's utterly flat. We are both blinded by sunshine and frozen, incredibly thirsty yet surrounded by water. All we can see of our surroundings is blue sky and the silhouettes of Annabel's family following us on the bank, including a terrier who occasionally pops up on his hind legs to look over the grass at us in the water.

The poetry of being swept right out to sea is denied to us here, as the boatyard and the

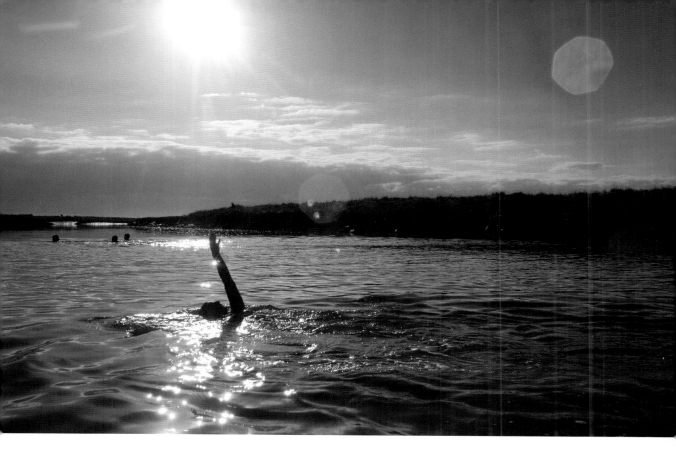

channel to sea are too dangerous, but 50 minutes later we reach our exit point – the boatyard pontoon – and run back to The Anchor at Walberswick.

We wrap up and sit down to one of the world's best breakfasts – fresh coffee, orange juice, perfect poached eggs – with sunshine pouring through the windows. At 7.30am that morning lying in with the Saturday papers was far more appealing than getting straight into a wetsuit but sometimes claiming the day, earning it and staking it out before breakfast ends up as the far bigger treat.

Later that weekend we try an estuary swim in the opposite direction, from sea to land at Burnham Overy Staithe. But a neap tide sees us wading through knee-deep water, while three teenage boys cover themselves head to toe in mud and run around on the bank. 'Wild swimming,' Vicky observes, 'wouldn't really suit the self-conscious.' The swim was

recommended by Michael's friend Alex Hickman, who did it every day while writing a book there. 'Get your timing right, and the incoming tide will race you across the lagoon and up the creek under a towering Norfolk sky. Look out for waders, oyster catchers and Dead Man's Hole, marked by a green buoy, which the locals claim is unfathomably deep.'

Swim: Moderate to advanced. Two epic estuary swims: one through marshlands, the other through sand dunes and mudflats.

Details: Blythburgh is on the A12 between Lowestoft and Ipswich (nearest station: Halesworth). The Anchor has a website (www.anchoratwalberswick.com). We swam during a neap tide, we later discovered, so the water would be higher and faster at other times (see 'Tips for Wild Swimming').

34. CADOVER BRIDGE, DARTMOOR, DEVON

The river under Cadover Bridge is amber and gold the first time I visit. This small peaty pool on Dartmoor looks like a mineral bath, dammed up by round granite rocks and fringed with ferns. But the wonder of this stretch of the River Plym lies upstream, where there is a series of pools and waterfalls.

A local friend has checked it out before we get there. She tells us that the river meanders, creating a lot of 'one person' swimming places deep enough to be worth getting into, with some bigger pools with jumping spaces. Grassy islands with their own trees look perfect for children, and a couple walking a dog report that 'It's like Blackpool in the summer, with people and litter everywhere.' There are a lot of sunbathing rocks where you could lie with a book on a quieter day, with only wagtails and Dartmoor ponies for company.

Kari, my sister Lisa and I arrive in November after an overnight storm. Dartmoor gets more rain than surrounding areas, and the Plym is a 'flashy' river that rises fast in heavy rain. The once-amber water now boils fast over the rocks, moving too rapidly for the eye to keep track of surface swirls. Mid-stream trees are submerged up to their waists, and water laps over the banks, fresh sheep droppings on the green grass still in perfect piles under water, their edges not yet dissolved.

It's not right for swimming, but we walk upstream for about 40 minutes to the cascading waterfalls, now indistinguishable from the rest of the milky brown torrent. This moorland river is fed from run-off (water running off the moors) and today we can see that with unusual clarity: a steep green grassy bank has sprung four impromptu white waterfalls, as rain runs down the field, collects into streams and cascades over the side, pouring through brown bracken onto sodden grass rather than stream beds.

We still can't swim and go on to Spitchwick Common at Deeper Marsh (see map ref 59). It's higher than I've ever seen it, and looks like someone's emptied lorryloads of leaves into the water (standing in some sections they come up to our thighs) but still affords us a quick bracing dip.

Swim: Easy to moderate. A popular stretch on the Dart with a series of small swimming pools. Good for children and warm days sunbathing on the banks.

Details: Cadover Bridge is marked on OS maps (SX554646), not far from Shaugh Prior (nearest station: Bere Ferrers). There's a car park near the bridge, but to get closer to the swimming area take the road to the right-hand side of the river as you go upstream. Opposite a quarry there's a turning and a parking spot right down by the river, making the first pool here readily accessible to children and those with mobility problems. Walk further upstream and things get wilder. There are various local walks that could link to this swim, including a 5-mile circuit around Hen Tor.

35. CRICKHOWELL BRIDGE, POWYS

It's a drizzly dawn when Vicky and I arrive at Crickhowell Bridge. We're on a swimming expedition around Wales, staying at a nearby woodland tipi camp after her hen weekend. It's day five and we've given up showers in favour of a back-to-nature morning dip instead: we don't feel fully awake until we've got in the water.

River smells butt up against wood-smoke, and our car has turned into a mobile cafeteria. Vicky sits knee-deep in empty water bottles in the passenger seat, folding and unfolding maps and carving a loaf of bread into cheese sandwiches. We're happy in a barefoot, three-day-old T-shirt kind of way, spending days outside and nights by the fire. But overnight it rains and the dark dripping wood prods an ogre awake in my subconscious. I wake up in a lucid dream about something best forgotten.

When we arrive at Crickhowell, both the weather and I are in bad humour: I am melancholic (despondent, sleepless, irritable), the weather's phlegmatic (cold, moist), but thankfully the bridge, which has been standing right through temperament theory and into modern genetics, is looking majestic. Some of its proud grey stones have been damp now for a full four centuries but aren't the least out of sorts; they span the Usk wide and proud. There are 12 arches in all, 13 if you count from the upstream side. Below the bridge is a deep pool with shallow entry.

Vicky and I have ogled this water before after the Green Man folk festival but we didn't feel sure enough to get in. But having heard it's a popular swimming spot we jump over a broken stile downstream of the bridge and hover in a slightly drier area under a tree with 'No Juniors' and 'Private Fishing' signs tacked on to it. Vicky sits this one out, and I strip off.

The water is fresh, clean, dark and lovely. Supermarket delivery vans rumble back and forth on the bridge that used to carry kings, chariots, hay stacks and coal lorries, and upstream a family in fluorescent green waterproofs wade at the edge.

Having other people around makes me feel secure. I float on my back and look up: the sky's on my nose, clouds falling down in a constant grey drizzle. Then I look at the horizon bisected by the bridge – sky above, water underneath, swaying green trees frayed by the arches.

And when I get out my melancholy has gone and I am happy. All day. That's the magic of wild swimming. In my experience so far, there is no psychic residue not washed away or made good; no problem that isn't refracted by the water in such a way that looking at it leaves you untroubled.

It's only later, talking to a local swimmer, that we discover we got into the wrong part of the river. Locals have swum for generations in Galvey Pool, upstream of the bridge in Bulpit Meadows (a popular recreation area).

Louis Hurley, 94, is Crickhowell born and bred. He was taught to swim in Galvey Pool by a family friend. He learned to float on his back, then moved on to backstroke then breaststroke. Most locals in his generation learned thanks to 'Mr Gomer Morgan, a chubby jolly man who lived by the bridge, and used to throw boys and girls into the water.'

Louis loved swimming. 'At 6am every morning before school me and my good friend Billy Wilkes would go down to the river. We had great fun: swimming three widths of the river underwater and diving for plates.' The boys swam from April to mid-October, and once a year joined in the local swimming gymkhana held at the same pool. 'There were races, diving for plates, and they erected tall diving

boards over the 15 foot pool.' The competitions stopped before the war, but Louis continued swimming for years afterwards and many locals still swim here. 'Those who know the joy of swimming in live running water, at natural temperatures, will never take easily to manmade swimming baths. I am one of them. I relished swimming in live water, but I've always hated a swimming bath – in a river you can feel the water's alive.'

Swim: Moderate. A popular local swimming spot under a beautiful old bridge.

Details: *Crickhowell is on the A40, between Abergavenny and Brecon (nearest station: Welshpool). Galvey Pool is upstream of Crickhowell Bridge in Bullpit Meadows, a popular local recreation area.*

36. DAY'S LOCK, LITTLE WITTENHAM TO MEADSIDE, OXFORDSHIRE

One hot summer some friends and I went to swim here after work most Wednesdays, driving out of London and parking in a layby at 'Meadside' (near Dorchester on Thames) and then walking across the common land to the river.

This stretch of the Thames is wide enough to pass boats without trouble and the numbers of boats fall off at dusk, which is the ideal time for lazy, hazy summer swimming. Dragonflies and the dandelion seeds blow over the water as crickets set up their choruses in cornfields.

In spring, the river is 70,000 shades of green. In summer, you can picnic in the sunshine on the banks after your swim. At full moon the water shines like mercury as it curves over underwater hands. One night we swim in silence, sculling along with hands and feet not breaking the surface of the water, our surroundings noiseless but for the odd lap against the lush, wet riverbanks. We creep past chub and roach and, hidden in the dark water, they creep past us.

Or you can carry on all the way to Day's Lock, where you can scramble down the banks on the corner, or, should the lockkeeper be feeling generous, step off the Environment Agency ladder above the Day's Lock bridge. The best plan is to identify your exit point, leave your clothes there and then walk upstream in bathers to the place you wish to start and swim back from.

Swim: Advanced. Beautiful downstream swimming in a wide and busy part of the Thames just 60 miles from London. The water is deep and infrequent entry and exit points mean committing to swimming up to 1.5km.

Wetsuits are advisable for all but well-acclimatised swimmers.

Details: The swim is close to Wallingford. From the A4074 between Shillingford and Dorchester on Thames, take a left to Meadside. Soon after the turning there is a layby on the left, used by picnickers and fisherman. Park here and cross the stile to the common land.

From Meadside it is also possible to swim downstream to Shillingford Bridge, or even continue as far as Benson (see page 92).

Between Meadside and Day's Lock there are only three real entry and exit points along this stretch, each about a kilometre apart: you could swim the whole stretch or either section or just have a dip by the shore (be aware it's hard to swim upstream).

The first entry/exit point is downstream: turn left as you hit the river and, after about ten minutes' walk, you reach a small sandy 'beach'. To find the midway entry/exit point turn right as you hit the river. It's by a white hump-backed bridge next to another shallow beach. (Just downstream of this on the opposite bank there is a tree with footboards tacked on which can be climbed and jumped from.)

37-38. FAIRY POOLS, GLEN BRITTLE, & MARBLE BATH, STROLLAMUS, SKYE

If you were a mischievous fairy with eternal life and the power to enthral people, it'd make great sense to live here, bewitching passing walkers to take off all their clothes. The spell of the fairy pools is that they look as if they must be warm – with the kind of vivid blue water associated with the Maldives – but, having come straight down from the Black Cuillins they're anything but. A local swimmer warns us they're on the usual Scottish temperature range: cold, bastard cold or freezing.

The pools are, however, delightful, and few are immune to their charms. We visit them in late autumn, when the Isle of Skye is springy with marsh grass and ablaze with bracken. We approach from the bottom of a wide, smooth glacial basin, the glen marking out a single deep groove like a linocut.

Suspense builds as we pass a series of crystal clear, aqua blue pools, each seemingly more appealing than the last. Under a cliff the grey rock has been carved into a perfect oval bath tub with a view of the waterfalls. Beyond that a grassy island gives access to a high, natural infinity pool, bounded by the natural stone wall.

But our prize today is the two pools higher up the glen. They are separated by a rock buttress and underwater arch so the first is choppy from current and waterfall while the second is preternaturally still. The water is so clear that every pebble and contour can be seen in its depths. Around it are rocks for jumps and dives, and flat rocks on which to sunbathe.

We climb down to the pools and undress in the warmth of the late afternoon sun. There's a grass-lined cubby hole in the cliff just right

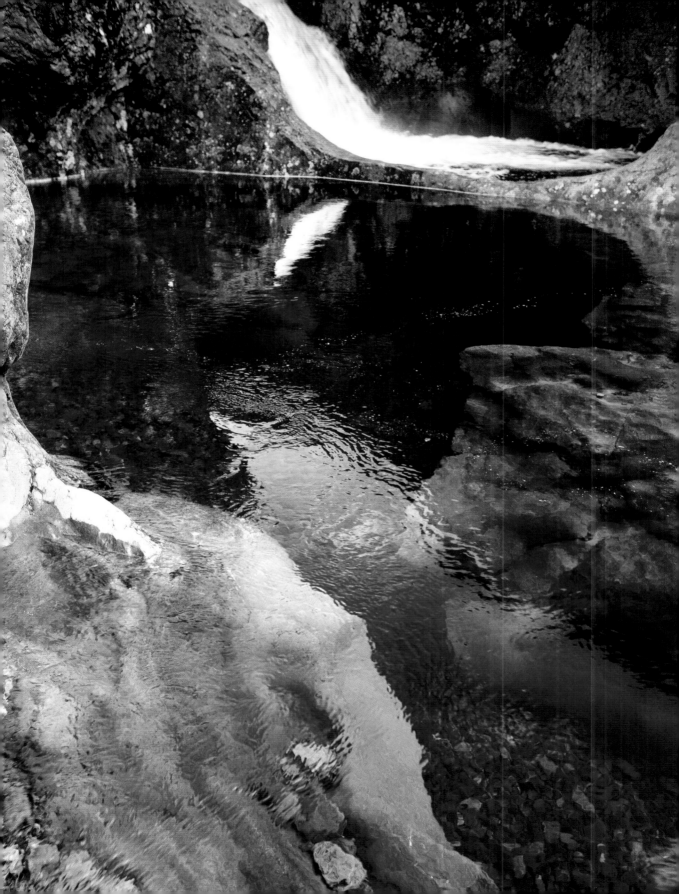

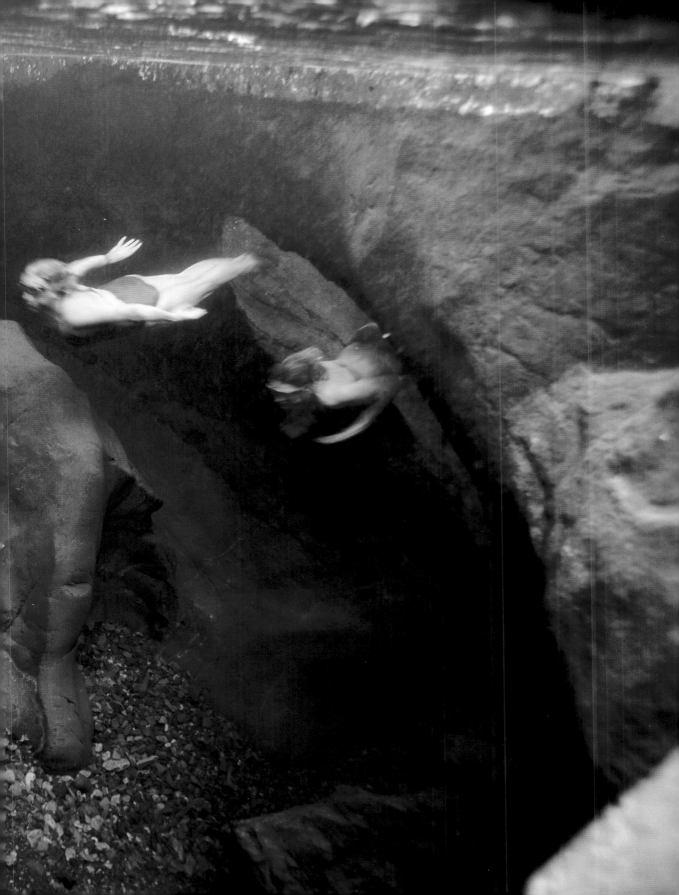

for clothes. White lichen covers a few spritely trees that stand sparse and leafless, and the crags sprout ferns and thin heather.

Perhaps it is fairy mischief that makes us abandon our wetsuits and jump into water that is face-smackingly, lung-contractingly cold (6°c). We clamber back out to catch our breath. The river is at the perfect height for us to haul ourselves out on to the rock buttress and dive in again and again, and then swim under the arch. This is river swimming at its most magical.

There is another fine swim in this area: Loch Coruisk (see map ref 135). It's one of Robert Macfarlane's favourite swims. He describes shooting down a long flume of smooth rock and swimming in the peaty loch early in the morning. 'You can connect up the Fairy Pools and Loch Coruisk, but it is a hard expedition,' he says. 'You'd have to ascend Coir a' Mhadaidh, climb Sgurr Mhadaidh (SM) itself, then drop down to An Dorus (The Door – AD); this bit of descent (from the summit of SM to AD) is pretty awkward. But from there it's easily down into Coir'-uisg. Then back out over Drum Hain and down Glen Sligachan (see map ref 136), with further fine swimming opportunities, to a very well-earned pint in The Sligachan Inn. This could be done in a long day. But the crossing of the ridge should not be underestimated as an exercise – for experienced hill-walkers and scramblers only.'

On Skye we also swam at the natural Marble Bath at Strollamus, not far from Sligachan. Here nature has conspired to create a white marble bath: a curved basin of pure marble in the middle of the riverbed, discovered by Rob Fryer. Most spectacular on sunny days, there's a gentle waterfall at the pool's start, rocks to dive off and sunbathe on, and a rowan tree (loved by white witches for its protective powers) by

its side. We dive off the rocks and sit under the waterfall next to a pool of floating red rowan berries.

Swim: Moderate. Fairy Pools requires some clambering in and out but is a magical river swim with two crystal-clear river pools separated by a rock buttress and underwater arch. Marble Bath is a natural white marble bath.

Details: *For Fairy Pools, park in the car park in Glenbrittle. There is a clear path up to the pools, which may need walking boots – there are streams, stepping stones and boggy bits to cross. A swimming hat and goggles are strongly recommended. There are circular walks that include the Fairy Pools which take you into the Cuillins. Loch Coruisk can be reached by boat or various strenuous walks from Sligachan (see map ref 135). For Marble Bath, take the farm track 300yds before Strollamus on the Broadford road. An easy 5 to 10 minute walk up the track will take you to a stone bridge, to the left of which is the marble bath.*

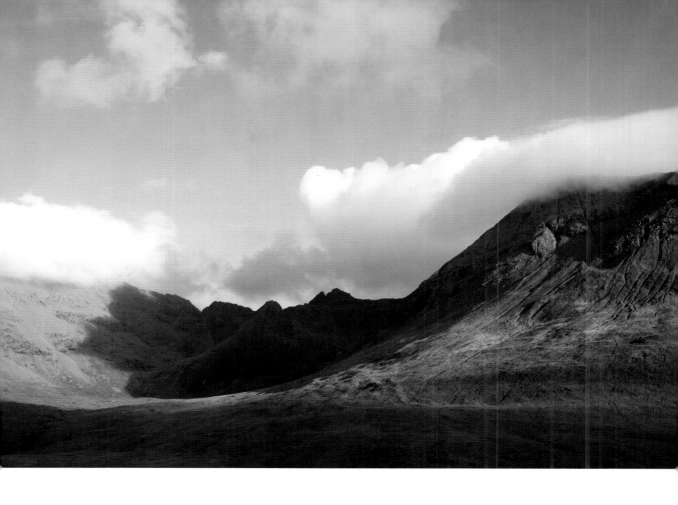

39. FARLEIGH & DISTRICT SWIMMING CLUB, WINGFIELD, WILTSHIRE

In the 1930s there were outdoor swimming clubs in almost every town, with swimmers gathering together for races and competitions. The advent of swimming pools in the 1960s made people 'go soft' says Rob Fryer, so Farleigh & District Swimming Club (which Rob runs with the cooperation of local farmer Peter Bryant) is now the last river swimming club in the country.

Farleigh is a beautiful English spot, with a grassy field for parking and another for lounging about on the sunny side of the river and going for a dip. The river itself is pretty, slow-moving and green. There's a jumping platform covered in hessian matting to get in from, or shallow walk-in walk-out entry by the weir.

We swim in the heat of summer, with a big group of wet-haired teenagers lounging around on the grass, and damsel flies mating in the air next to us as we swim. 'They're always at it,' says Rob, 'sex-mad. For four weeks either side of midsummer you can swim with them mating beside you.' On a hot day here 500 people get in and out of the water, which, thanks to aerating cleaning plants and a constant flow, doesn't need the chlorine of a public swimming pool to stay clean.

The club was started in 1933, and still has as many members now as then – around 2000 a year. You have to become a member to swim here, for insurance reasons, but you can pay by instalments (£1 a swim) or shell out all at once (£5 for over-12s, £10 per adult for annual membership, £16 for families of up to six. Under-12s must be accompanied by an adult). For this you receive one of Britain's most covetable membership cards, bearing the damselfly and waterlily of the club's crest. The club ethos is 'incredibly laid-back,' says Rob, who tries to think of anything else that may define it and eventually says, 'yes, very relaxed'. The club is officially open from 'after the first silage cut' (three quarters of the way through April) till 'it gets too cold' (typically September). Fully paid up members can swim 'anywhen', says the membership card, 'but there might be cows in the field the rest of the time.'

To my mind this is the very best sort of club: open to all comers, in a beautiful place and with only the bare minimum of rules – be decent, pick up litter, no dogs, camping, fires or fishing, and the simple warning 'persons causing a nuisance may have their membership suspended'. After a swim you can amble barefoot up to Peter's farm for a cream tea surrounded by trailing pink roses. 'Sorry, no milk for a few days as the cow's had antibiotics', says a sign on the fridge. Children play swingball on the campsite and, after a chat, Rob drives away listening to fairground music.

Swim: Easy to moderate. A beautiful swim in England's last remaining river swimming club, with a sunbathing field and cream teas close by.

Details: Farleigh & District Swimming Club, Wingfield is 4 miles out of Trowbridge on the A361, 400 yards on the left after a sign saying 'Cream Teas' at Stowford Manor Farm (www.stowfordmanorfarm.co.uk). Trowbridge, Frome, Bath, Bristol, Chippenham and Glastonbury are all within an hour's drive, and the club is well worth a detour from any of those spots. It is also close to footpaths and cycle paths and hot cyclists often drop in for a dip. (Sustrans Regional Route 20 goes from Farleigh to join up with National Cycle Network Route 4, which goes from Bristol to Reading, following the Kennet and Avon Canal.)

40. FESHIEBRIDGE, NEAR AVIEMORE, SCOTTISH HIGHLANDS

Broadford, Muddy Creek, Snowy Mountains… travelling around with just a map and a little imagination you can often have a fair idea what you might find. But it's still a surprise, standing downstream of Feshiebridge, to realise that the strata of an underwater rock aren't strata but fish: lines of big brown trout, noses upstream, perfectly parallel. Every few minutes there's a splash and the pink open mouth and silver underbelly of a muscular trout sweeps through the air. Then they resume their position and our wait – cameras at the ready – begins again.

We came to Aviemore with the hope of finding a great loch-walk combination. With not enough time to walk into the Cairngorms, only the lower lochs are within reach and they are preternaturally still on our visit. A peatiness to the water here gives it a highly mirrored surface, each lake holding a perfect reflection of the red hills, fir forests and bright blue sky above it. It might sound attractive but to us it's not – it seems sterile, as inviting as a show home.

Dom has his first and only strop of the book, standing by one of these Loch Perfects, looking at a landscape that should be on a jigsaw. 'I used to be a photojournalist,' he moans. 'At one point I was seriously considering buying a bullet-proof vest.'

He throws in a stone and for the next five minutes we watch concentric circles expand in and out in eye-popping fashion. It gives us a delightfully trippy feeling, but that's as wild as it gets. And the next minute an American tourist steps out of the forest holding a drink and says, 'Jeez, you guys swimming? Nice place for a sundowner!' and we're back into Truman Show territory.

So we are delighted, before we get our flight the next morning, to come across a river swim at Feshiebridge which has as much spirit and abandon as any wild swimmer could wish, more Betty Blue than Stepford Wives.

Our B&B owners told us about it. The downstream pool is popular with teenagers who work at a local outdoors centre on summer evenings and looks like a perfect place for staying in so long and getting so cold that sitting right up close to the object of your affections afterwards, sharing their body warmth, becomes almost essential.

The fish are hanging out in the pool-size pool, which offers a good swim at most water levels. And there's a grassy area, a big wide fir tree (to change under and hang cossies from) and a picnic bench.

Upstream of the bridge are sections for derring-do. The river's exact appearance will vary greatly with water levels – we jump in somewhere we can go safely down a long, rock channel, and then swim back up to the falls.

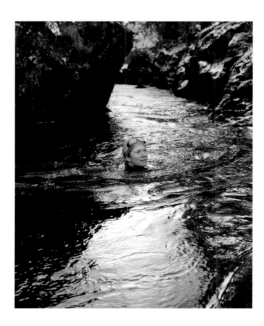

One moment the bubbles are so dense and white that they obscure everything, and the next moment I'm nose-to-nose with a baby trout. On our way downstream we clamber around a riverside rock shaped by the water like a knife through whipped cream; and at one point we need to climb back out on the bank, enjoying the Scottish right to roam as we run past a kayak-cum-plant holder in someone's garden and then get back into the water. Rob Fryer's daughter-in-law enjoyed a 15 feet shoot into a deep pool on her visit, but that's not available when we visit.

When we reach the lower pool the water is clear, brown, clean and delightful, a great place for children paddling and looking for minnows in the shallows. At sundown in autumn you're perfectly placed to hear a stag roar.

Swim: Easy to advanced. Clear, clean water, legions of fish, narrow fast-flowing sections and a big lazy pool: for adrenalin junkies and families alike.

Details: Take the B970 south from Aviemore for about 6 miles to Feshiebridge (nearest station: Aviemore). Park at the bridge. Wetsuits (protection from rocks), aqua shoes, goggles and a good awareness of danger are required for the upper sections. Be careful with jumps: the water here is so reflective it's possible to miss rocks in shallow water directly beneath you, seeing instead just yourself and the sky.

41. FIGHELDEAN, WILTSHIRE

Not far from Salisbury Plain and Stonehenge, we visit Figheldean (pronounced 'filedean') on the advice of Rob Fryer. Pollen fluff floats lazily in the air over this small round pool which is circled by trees and bucolic meadows. It's myriad shades of green: trees, grass, lilies, reeds.

It's the day for cutting river water crowfoot upstream – a slightly controversial practice by fishery managers that creates better conditions for large numbers of fish but reduces the natural braking effect that this plant has on slow rivers. The lower pool is alive with freshly cut plants. The river is funnelled into the pool where clumps of crowfoot have a barn dance: joining hands to gallop down the centre line, then splitting to the left and the right, and returning to the start. We step into a gap between the clumps and are charged around with them.

When we get out of the pool we meet Reg, an ex-MoD gardener. Reg has swum in here since he was a child, when he put a tractor inner tube around a small tin bath and sat on it – 'King of the Castle' – while his friends tried to knock him off. His grandchildren come down now and do the same with big plastic drums. 'It's daft really, but the best things are daft,' he observes.

When the mill was working upstream the pool was 16 feet deep and there was a springboard, but it's still a lovely place for a dip if passing by.

Swim: Easy to moderate. A small, shallow pool surrounded by trees that offers good swimming for children.

Details: Figheldean is about 3 miles north of Amesbury just off the A345 (nearest station: Grateley). Entering from the south, look out for the long stone wall of Figheldean House. Turn left down the cul-de-sac opposite.

42. HELFORD RIVER, HELFORD PASSAGE, CORNWALL

Helford Passage is a peaceful, tinkering kind of place on the Helford estuary with a small beach and pub and a lot of ice cream, sunshine and boats. We arrive in the warmth of summer with a 4hp inflatable boat. We have brought the boat (and bright hats) as protection from other boats and, after paying the ferryman a fee for launching, chug up past an inlet to do a 500 metre crossing.

The swim is a joy; we're at the point where tentacles of river water and sea water are stretching into each other like an aquatic cat's cradle. So we swim through cold patches and warm patches, our tongues registering the change from sea water to fresh. Afterwards we get out and eat ice creams until we're ready to go in again, swimming around to the sub-tropical Trebah Gardens where we walk around under giant rhubarb plants.

When Roger Deakin swam here he did so at lower tide, slithering down oozing mudbanks. 'Feeling deeply primeval, like some fast-track missing link in our evolution from the lugworm, I eventually squirmed into the relative luxury of deeper water,' he said. 'As I left it behind, I thought how much I had enjoyed my communion with the slime.'

Swim: Moderate. Swim at high tide and the water will be 'slack', and watch out for boats. A beautiful, wide stretch of river on the coast surrounded by oak woods.

Details: *We started out from the Ferry Boat Inn, Helford Passage, on the north bank of the Helford River (not to be confused with Helford village – the two places are linked by a pedestrian ferry), about 5.5 miles south of Falmouth (nearest station: Penmere). Daphne du Maurier's*

Frenchman's Creek can be found by walking along a wooded track from the top of Helford village.

43. KIRKHAM PRIORY, YORKSHIRE

A sign on the stile into the field opposite the ruins of Kirkham Priory states: 'It is dangerous to enter the river from these fields. Deep mud on the riverbank. Escape hindered by weeds.' It's the first sign of the spot's popularity as a local swim spot – a 'take care' not a 'don't'.

We came here on the advice of a swimmer who had never actually been but thought it would be romantic to swim past the ruined priory. A friendly guy in the priory shop tells us that children jump off the bridge, and the three couples having a picnic with breastfeeding babies tell us that they have swum here.

It's a pretty spot: the river is sleepy and when we visit the water is the same silvery-grey brown colour as the priory ruins and a tall, leafless tree. I clamber in by the roots of the silvery tree and swim upstream to test the depth of water under the bridge for Michael, a keen jumper, as he peers over its edge. We've chosen the middle arch as the most likely deep spot, and, with hands above head, I test the area, sinking like a plumb-line to check there are no underwater obstacles and it's deeper than us.

A boy passes Michael on a bicycle while I'm underwater and relays the same news that I surface with: 'You don't want to jump from here, that arch over there's deeper.' The moral? Never, assume a river is deep, and never underestimate the importance of local knowledge.

Swim: Moderate. Take care getting in and out. A romantic venue for a swim in a sleepy river, and picnic opposite a ruined priory.

Details: Kirkham is across the River Derwent from the A64, between Pickering and York.

44. LADY FALLS, BRECON BEACONS, POWYS

Lady Falls is situated in Coed Y Rhaeadr which means 'wood of the waterfalls'. The swim is recommended by Rob Fryer. There are a series of pools and waterfalls to swim in on the way through this wooded gorge which carries the Melte, Hapste and Neath rivers, but he particularly recommends Lady Falls, a swim spot just over a mile's walk away through the woods as an 'almost a spiritual experience'.

We approach with some excitement – not quite as much excitement as if sheets of rain hadn't been running down the car windows en route and we weren't being deafened by the relentless swish of our waterproof trousers, but excitement nonetheless. 'Everything about this pool is gentle, and soft, and charming, just like a lovely lady,' said Rob.

It's fair to say that when we visit the lovely lady she appears to be having something of an off day. The round pool is surrounded by trees and steep banks, with the River Neath falling about 40 feet from a huge, flat overhanging ledge. The falls – which pictures reveal as sometimes looking like the fluttering of a white lace petticoat – are thundering over the edge and looking ferocious, enough to give anyone who tried to sneak up underneath them a head injury. Recent rain has brought trees to the edge, and the jagged edges of one tree are rammed over the top of the falls, while another tree languishes broken at the bottom.

But many swims are transformed by getting in so I rip off my clothes in haste – the dim light and curtain of rain providing enough seclusion for skinny dipping – only to find myself trapped in a narrow band of water between the shallow shore and the falls. Not such a successful swim on that occasion, but clearly a magical place in the right weather.

Swim: Easy. There are a multitude of swimmable pools within 'Waterfall Woods'.

Details: *These falls are in 'Waterfall Country'. Park by The Angel pub at Pontneddfechan (on the B4242 on the southern edge of the Brecon Beacons, nearest station: Treherbert) and walk upstream through the woods, following a sign to Lady Falls. The footpath is wide and well maintained and seemed suitable for pushchairs. You will also pass Junction Pool which looks like a special swim – the largest of the pools with cliffs on two sides, beside a footbridge (see map ref 137).*

45-51. LECHLADE TO TADPOLE BRIDGE: SWIMMING DOWN THE THAMES

In some countries people worship their rivers. The same should be true of the Thames.

Its role in the establishment of Britain's capital city, its position as one of the cleanest metropolitan estuaries in the world, its journey from quiet backwaters through sleepy villages into the centre of the city: all these things make the Thames worthy of worship. Or it may just be the fact that if you plunge into Old Father Thames in Lechlade, there are over 150 miles of swimming left to go.

The Thames, outside of the towns it passes through, is like a swimming superhighway: deep, green and enormously wide. You can float downstream from Lechlade to London with no fear of ever grazing your knees (although it will be necessary to walk around a few locks). And, by virtue of the longest riverside walk in Britain (the Thames path is 184 miles long), you can do so with accompanying walkers.

Although the river flows through a tame, well-trodden landscape, once you are in the water, sunk below the paths, roads and signposts, central England looks wild. You are surrounded by thick, green English countryside. 'I looked around at the wooded riverbanks and suddenly realised that I had entered a new and alien world that was on my doorstep,' said my friend Richie on his first proper swim in the Thames, from Shillingford to Benson (see map ref 138).

'The trees reared above us like giant coral fronds. I felt as though the river were carrying us on its shoulders as we flowed with it through a land suddenly made magical. I had just returned to England three weeks before after a long spell in North Africa, but suddenly I was home again. I had caught up with myself at last, and found that there is still wonder to be found at the end of the garden.'

It used to be that people all along the river swam in it frequently, even in London (not recommended now for safety reasons: flow is high and currents are strong). Iris Murdoch was a keen river swimmer and in *Under the Net*, her characters get in on a slack tide at night. 'The sky opened out above me like an unfurled banner, cascading with stars,' says the narrator. 'As I looked up and down stream I could see on one side the dark pools under Blackfriars Bridge, and on the other the pillars of Southwark Bridge glistening with the moon. The whole expanse of water was running with light. It was like swimming in quicksilver.'

This was written in 1954, at a time when hundreds of families would picnic on a sandy beach by Tower Bridge on hot summer days, with children getting stuck into sandcastles and swimming. Swimming races on the river continued until the late 1970s and early 1980s, and were reinstated in 2003 by the South London Swimming Club in Teddington (see map ref 139).

Cleanliness wise, it's a good time to get back in the water. In 1957, a survey on the Thames in London found no sign of life except eels, which can breathe on the surface of the water. (There was so little oxygen in the water that other species had suffocated.) Today, the river is home to 121 species of fish: smelt, bass, flounder, trout, herring, mullet, plaice and sole are among those that cruise through the capital. In 2006, Lewis Gordon Pugh swam the whole river – a tribute to how clean it's become. ('That swim wouldn't have been possible some 15 to 20 years ago,' he says.)

At Port Meadow, in Oxford, townspeople still swim in the Thames after getting in by Wolvercote Bridge (see map ref 140). In

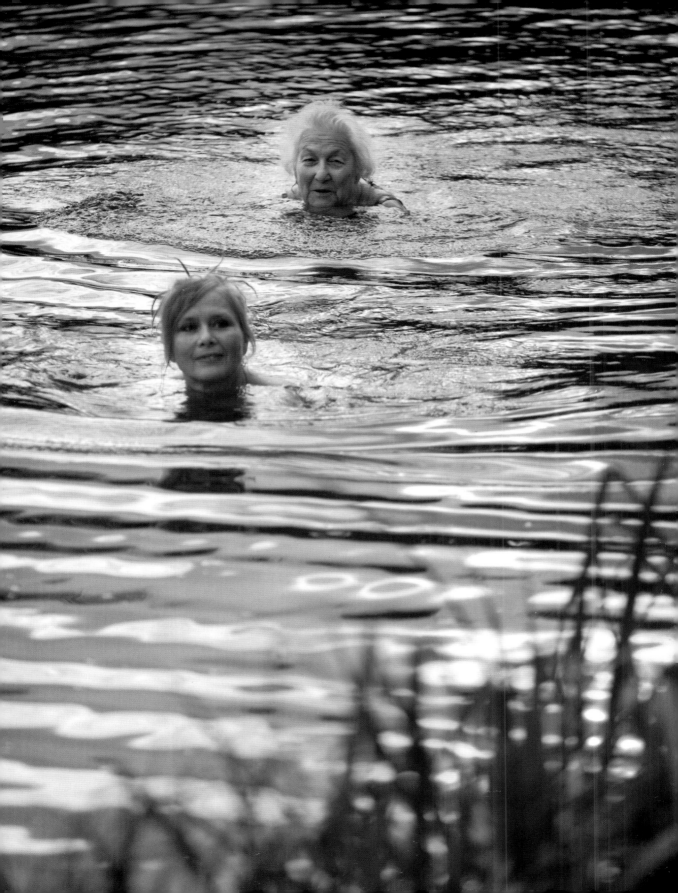

Shepperton (see map ref 141), Sally Fletcher swims every day along a familiar stretch up to a willow. Her sister and mother swim outdoors (pictured on page 93) too, and all the family have taught their children to swim in rivers and lakes, holding babies close to them so they feel body warmth at the same time as the chill of freshwater. Dom and I joined four generations for a dip in the autumn, swimming past a coot's nest, three mermaid statues and a few gin palaces, with the last of the summer's wasps dying twitching on the water. The Fletchers are unusual in swimming close to built up areas in England. But in cities like Zurich, Munich and Stockholm rivers are so clean and wild swimming so accepted, this practice is popular.

There are myriad swims to investigate along the Thames, only some of which are covered here. The Thames is a navigable river so always wear a brightly coloured swimming hat and watch out for boats. Make sure you know where your exits are before getting in – banks are often high and may be a kilometre or more apart, and it's not always possible to swim back upstream. And do not trespass.

Described below is a two-day, 13 kilometre trip down the Thames starting at Buscot (near Lechlade) and finishing at Tadpole Bridge, Gloucestershire. It is possible to do any of the sections as a standalone swim.

Buscot to Kelmscott, 3 km

It's a summer morning when nine of us gather near the source of the Thames at Buscot, for a two-day swim. A sound artist, civil servant, environmentalist, black cab driver and photographer all shed their clothes and step into Speedos and goggles. This is my first distance river swim and, with the butterflies I used to get before school swimming races, I put on my hat and get in.

The banks are lined with oak trees, cow parsley and other wild flowers. The slow swimmers and breaststrokers set off first with the support boat, with the front crawlers bringing up the rear flanked by a kayak. The water is glossy and green and tastes like rain. We alternate putting our heads down in front crawl, alone with our thoughts as we plough through the water, and then drifting downstream on our backs looking at clouds and having a chat.

We swim past buttercups, maize fields and ducks. Our legs brush against waterweeds as we meander around bends. Seven cows line up and look at us from the bank. There's a strong following wind and at one point I stop to listen until my latent arboreal knowledge kicks in and it slowly dawns that I am listening to the sound of the wind in the willows.

I'm at risk of losing my urban cynicism entirely when we chance upon a fisherman. 'Is this the way to London?' shouts one of the swimmers. 'Just round the second bend, mate,' he says. What we actually encounter round the bend is Kelmscott footbridge, which means lunch. There is mooring for boats but not swimmers, so we find a piece of eroded bank to climb out, an uncomfortable (but nettle-free) combination of sharp bricks and thick mud. One of the swimmers is unlucky enough to get cramp half way over it and finds himself hovering on all fours in the muck until it stops. 'Did you enjoy that Rory?' asks Simon Murie from SwimTrek, who's leading the trek, when he finally scrambles out. 'In a very special definition of "enjoy", I did,' says Rory.

Kelmscott to Grafton Lock, 2.5 km

We walk to the Plough Inn at Kelmscott for lunch, and get back in for an afternoon's swimming to the Swan pub at Radcot Bridge.

A few kilometres downstream, on the banks of Grafton Lock, we hunch down on the grass to eat some Victoria sponge cake. There's a sense of childhood about this trip: the day-long uniform of damp Speedos, bare feet, jumpers and towels.

I start getting shivery, even in a full body wetsuit. My companions have more experience and soon the conversation turns to cold water. 'Don't you just hate it when swimming pools don't have cold showers?' asks someone. 'I can't find water cold enough,' agrees Annette, a PhD student. 'In Exeter even the cold tap water's too warm.' Lucy reveals that in February she swam in the Finnish Championships, which entails chiselling a hole into ice four inches thick before getting in. I hunker down and tighten the rug round my shoulders.

Grafton Lock to Radcot, 1.5 km

We hobble across a metal mesh gangplank. I'm first down the steps into the water, picking up an entire spider's web of uneaten flies as I go. Some adult swans hiss at us (we've been instructed not to swim between them and their cygnets) and the boat and kayak form a protective barrier until we get past.

It's a quiet time of day and back out in the open water the light is gentle and the air is soft. We swim past dandelion clocks illuminated by the low sunshine. Salt water has a harshness about it but river water is silky. One of the swimmers has rolled her top down, and Annette says she once swam across Coniston Water in the buff. 'Maybe I'm a desperate sensualist,' says the topless swimmer. 'The cold water on my skin makes me feel alive. A bit of pain can be pleasurable.'

We hang our cossies to dry on our tent ropes at the pub campsite at Radcot and retire for dinner.

Radcot to Tadpole Bridge, 6 km

Waking up to sunshine we emerge from our tents and stand on the towpath drinking coffee and eating bananas and cereal by our support boat. We're joined by a new group of swimmers, most of them actors who hang out at Tooting Bec Lido. 'Other actors move to LA because of the work – we're going so we can do more swimming.'

In the water their daily pool meetings pay off: if yesterday was all about drifting downstream looking at clouds, today is all about progress. This swim could be broken into three sections, stopping at Radcot Lock and Rushey Lock, but we have 6 kilometres to cover before 2pm because one of them needs to be back for a show. Radcot to Radcot Lock, 1 kilometre, Radcot Lock to Rushey Lock, 3.5 kilometres, Rushey Lock to Tadpole Bridge, 1.5 kilometres.

The first few kilometres of the swim is hard work and at one point I get so tired that I weep into my goggles. But despite the tiredness it's not hard to keep swimming: once you're in an open space, swimming's like walking. You find you can just keep on going. We get out to run round Radcot Lock and Rushey Lock and midway we sit on the bank amid the cowpats and thistles and picnic on thermos tea and Digestives. It's sunny and we're still in our swimming hats (very important for warmth). Conversation is easy: on some levels our shared experience means we understand something fundamental about each other. We eat three whole tubes of Pringles and a sticky toffee cake.

When we get back in, we swim past campers – 63 primary school children from Clanfield out on their 'Annual Daniel' – and two men cutting bundles of reeds for weaving. Kayakers paddle past us.

Finally Tadpole Bridge comes into sight. Two men stand on it eating their packed lunches above us, sandwich bags flapping in the wind as they chew on white bread sandwiches. They stand on one side of the bridge and then the other, watching us as if they're playing Pooh sticks. They look at us with bewilderment, as we clamber out onto the bank. 'You doing this for charity?'

Swim: Moderate. This 13km stretch of river at the start of the Thames offers great downstream swimming, surrounded by willows, ducks, cows and fields. The Thames path hugs the river for accompanying walkers and there are frequent pubs. Just watch out for pleasure cruisers.

Details: You need to be aware of boats as you swim these sections, and ideally have a kayak or walkers flanking you – there are a lot of cruisers out during summer. The distances above are not as hard as they might sound – on the Thames swimmers are assisted by the current.

To get to Buscot, take the A419 towards Cirencester and turn right onto the A361, signposted to Highworth and then Lechlade on Thames. Before Lechlade follow signs to Buscot.

The Plough at Clanfield (01367 810222) is a short walk from Kelmscott. We camped at The Swan Inn, Radcot (www.swanhotelradcot.co.uk – no showers or toilets for campers, except in the pub, which also has rooms). The Trout at Tadpole Bridge is a popular local gastropub and you need to book ahead if you want to eat there (01367 870382).

52. RIVER LUGG, AYMESTREY, HEREFORDSHIRE

The Lugg is unusual in that it has free navigation rights but was never made fully suitable for boats (except canoeists) so as a swimmer you have unparalleled access. It's legal to swim anywhere that you can get in and out without trespassing, 'Private Fishing' signs notwithstanding. (The Lugg positively gurgles with trout.)

Vicky, Dom and I decide on a stretch by a public footpath above The Riverside Inn at Aymestrey. It's a hot day and we leave our clothes by a weir and walk upstream in river shoes and bikinis. Two Friesian cows watch our progress from the shade of a tree, flicking their tails idly. We set our sights on a beautiful straight section of the Lugg where the water turns an unnatural whitey-blue, running through an avenue of sparse yellowy trees like a giant Arctic slug.

The basis of the countryside code is respect – for people, plants and animals – but either the water's too cold or our skin's too hot, and wading in creates an immediate noisy panic. We try and quieten down for the sake of the cows, peacefully chewing grass and shuddering flies off their flanks, and after a while the bottom halves of our legs are completely numb, which creates the temporary illusion that we're ready to plunge. So we do, which in turn provokes enough shrieking to light up half of Birmingham with kinetic energy. We swim hectically around a deep corner and under the bough of a tree, spluttering expletives, until it's shallow enough to wade again.

But the key to successful cold-water swimming is to have an objective (see Tips for Wild Swimming) and we do – swimming 'the avenue'. So we press on and soon the fire inside is alive again. We reach the avenue

burning with heat and swim down it with long, silent underwater breaststroke, cold-loving trout no doubt by our sides. We emerge revived and walk quickly back to the car, thawing out in the sunshine.

Swim: Moderate. A bracing swim in a clear, clean trout stream.

Details: Aymestrey is on the A4110, 7 miles north west of Leominster and 11.5 miles south west of Ludlow (nearest station: Leominster). The Riverside Inn (www.riversideinn.org) has an enviable reputation for food. This swim is on many circular walks and is at the mid point of the 30 mile Mortimer Trail, which has views of the Black Mountains and the Malvern Hills.

53. LUMB FALLS, NEAR HEBDEN BRIDGE, YORKSHIRE

If you want to know where to swim, ask the local teenage boys. Geographically constrained and with time on their hands, they are often the most knowledgeable people to ask when you arrive in a new area. I found this place through MySpace, where some girls and boys were arranging to meet. We reach the falls by descending on a footpath, past sheep grazing on a field of cabbages, early morning dew and damp stone walls. Signs of popularity are there to see: a fallen tree is scuffed smooth by boots that have kicked up against it, next to the ash from a small fire.

Beneath the falls is a small semicircular swimming pool overhung by ferns and ivy. We get into the pool and there's a mossy cliff that leads up to a rock ledge which Michael immediately climbs to jump off. I'm not great at heights but the constant roar of the falls seems to drown out normal thought, and after a while I can't hear my own vertigo, so I climb up with him.

It turns out to be a good ledge for jumpers and non-jumpers alike – high enough to be thrilling, not so high that it's terrifying. Always check depth before jumping (see 'Tips for Wild Swimming'). This pool can be shallow; when we visited previous swimmers had dammed it up to keep it deep.

Swim: Easy, but some scrambling is required to get to the falls. A good pool for jumping.

Details: *You will need an OS map to locate this pool (SD993341) on a footpath between Shackleton Moor and Hardcastle Crags.*

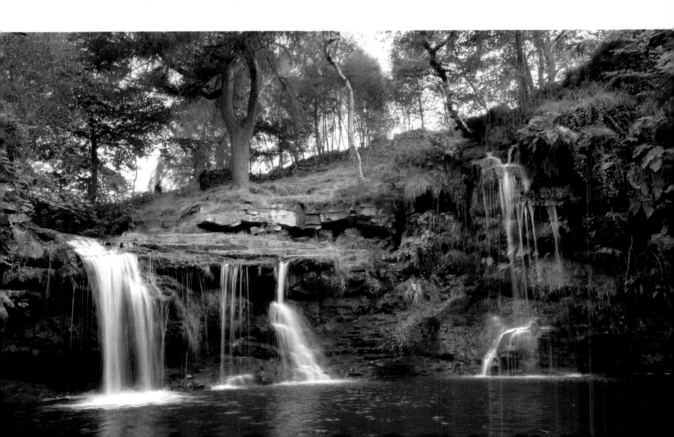

54. MORDIFORD BRIDGE, MORDIFORD, HEREFORDSHIRE

Swimming, sunshine, a picnic and friends: there's a patch of common land at Mordiford that's perfect for an afternoon's lounging. Fifteen of us spend the afternoon here, sharing the green with a group of students (with barbecues) who jump into the river and swim downstream in their underwear.

The swim spot is by the bridge with a view of the church. We walked upstream, then got in and floated around a wide meander, getting back out at the bridge to warm up in the sun. Work out your exit before you get in and stick to it. When we swam, some of us got over-curious about what lay beyond the bridge, ending up trapped between a rapid and nettles.

Swim: Moderate. A perfect hangout for a sunny afternoon.

Details: Park at Mordiford Bridge (on the B4224 from Hereford to Ross on Wye, nearest station: Hereford). Nearby is Woolhope Haugh Wood with a 3 mile butterfly trail. The woods used to be famous for a dragon which drank from the Lugg, breathed fire and ate sheep, but now house 600 species of butterflies and moths.

55-56. NEWNHAM RIVERBANK CLUB, CAMBRIDGE & THE CAM

Newnham Riverbank Club, on the green and dreamy Cam, is an English haven. Just £16 will buy a year's membership for the club grounds, a key to the gate and ready access to the tea and cake that are a frequent fixture on the clipped lawns (if a committee member is present to open the shed).

Elegant steps lead into the water, from where there is delicious swimming up to Grantchester meadows, surrounded by billowy banks, kingfishers and dragonflies. Privet hedges hide most of the club from the view of passing punts, allowing members to pursue their 'clothing optional' policy.

As a swimming place the Cam was made famous by poet Rupert Brooke and his band of friends dubbed the 'Cambridge neo-Pagans' (in contrast to the London Bloomsbury set, of which they were also members). The group, which included John Maynard Keynes, EM Forster and Virginia Woolf, were agnostic free-thinkers, slept outdoors, swam under the stars and went on long unchaperoned walks.

Their friendship predated their fame as writers and thinkers, and was revolutionary stuff in 1911 – as was Brooke and Woolf swimming naked at night in a river smelling of 'mint and mud'. (Ludwig Wittgenstein was also skinny dipping in the Cam during this period, though in less ebullient spirits.)

'Neo-paganism' has been defined as a form of positive existentialism, a sensual, well-meaning love for life in which one is immersed in the present. It's an experience that is at the heart of wild swimming. 'I do not pretend to understand nature, but I get on very well with her,' wrote Brooke. That's certainly easy on the Cam.

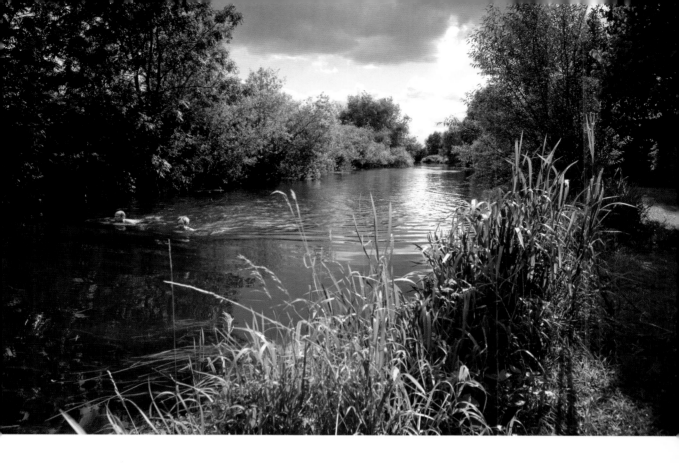

I stay in the water too long, and afterwards take tea with the nut-brown professors and townspeople. I have four jumpers on. They're starkers. In true liberal style, no one minds.

It is not, however, necessary to join the club as there are many swims along the Cam. Local swimmer Andrew Heather recommends the 2km stretch from Grantchester to Newnham. 'Owned by the colleges, there is excellent public access and a great many places to get into the water,' he says.

Grantchester Meadows is popular with families as the river is shallow enough for older children to play in it while their parents picnic. 'Newnham is the busiest section for punts, canoes, swimmers from the club and fishermen with great patience. But users of the river are used to each other and everyone shows respect – swimmers keep clear of boats by moving under overhanging branches to let them past. The general rule is keep an eye on the punts

which are often under the command of a novice. Or a drunk. Or both.

'A great challenge is to swim the whole meadow, which takes about 40 minutes downstream at a steady pace. A little planning – or a helpful non-swimmer – is required to ensure that towel and clothes are not strewn in too many places along the riverbank. It's well worth doing and if it gets too cold then it's easy to get out part-way down.'

Swim: Moderate. A historic stretch of the Cam once loved by Byron, Rupert Brooke and Virginia Woolf. With billowy banks, kingfishers, punts and a meadow, this 2km stretch is great for picnics, dips or a longer swim.

Details: The club can be accessed from Grantchester Street, which heads south from the A603 in Newnham and turns right into a road called Grantchester Meadows. Park where this turns into a gravel dead end, and there's a small path down to a green painted wooden door with a sign saying Newnham Riverbank Club. The club is open all year; to join just show up and hope there's a member to let you in (more likely in summer).

57. SHARRAH POOL, DARTMOOR, DEVON

Upstream of Spitchwick lies a natural swimming pool that is a hidden treasure. For people who orientate their lives on an east-west compass, finding a pool that catches the sun at all times of the day is probably less of a wonder, but for the geographically confused, like me, a pool in a valley where you can be warm in the morning and see the sunset at night seems a magic delight.

I first visited it a few years ago with two sculptors from Devon. To get there we park at New Bridge and walk upstream through the ancient woods. We take the west side (left bank of the river, facing upstream) to reach Sharrah Pool. After about five minutes we reach Horseshoe Falls (see map ref 142), an instantly recognisable horseshoe of falls-cum-natural-jacuzzi where spritzy ions fill the air, and after another 20 minutes Wellsfoot Island (see map ref 143), where the moss, bracken and tall trees of the woods end improbably at the river's edge with a beach of golden sand. Both of these swimming spots are best reached by the path on the east side.

On the west side we continue through Holne Woods. In April the woods are full of bluebells, the enormous beech trees unfurling bright green leaves, still soft as velvet. We have missed lunch and the only food available at New Bridge is Dartmoor Mint Cake from the National Trust trailer in the car park, so we power our shaky legs onwards with this pure sugar snack.

After 40 minutes we reach Sharrah Pool, a 100 metre long swimming channel of sparkling, clear water flanked on either side by large smooth sunbathing rocks. With a clear view of the pebbles beneath us we jump in and swim up to the small waterfall at the start of the pool.

The force of the waterfall depends on volume of water in the river, but we swim up to it and batter our shoulders and backs under the torrent. We let go of the underwater rocks and are swept away round a bend and swirled just clear of the rocks.

Then we swim and bask quietly along the pool's considerable length, looking up through the branches of beech trees to the sky. The water here is deep and plentiful enough to swim laps, should you be so inclined.

Swim: Easy to moderate. A hidden treasure. A natural swimming pool in ancient woodland on the crystal clear River Dart.

Details: For New Bridge take the Dart Valley Country Park exit off the A38. Follow the signs to the Country Park and then continue past the Park and onwards, via Holne Bridge to New Bridge. Follow the road over the bridge and park in the New Bridge car park on the left. Heavy rains can lead to fast and dangerous flow on the Dart. If in doubt, stay out. This swim is on a popular footpath, and there are lots of different routes to combine with your swim.

58. SKENFRITH CASTLE, MONMOUTHSHIRE

The River Monnow below the ruins of Skenfrith Castle, an early 13th-century fortress, provides a great local play area. There are rapids where daring fathers put their children into dinghies at the top and catch them at the end, some big boulders on the lower section where children dive and do backflips, and there's a rope swing hanging from a tree.

When we visit two mothers are lying on the bank, chins on hands, watching their girls muck around in the water. 'She's the main Skenfrith swimmer,' one mother says of her daughter, who is 12. 'She swam in March, and comes every day. The children here keep each other safe; if someone's not ready for something they say so.'

The girls, shivery in wet trainers, shorts and T-shirts, haul the dinghy out, jump on to it and shoot down the end of the rapids, then lie across it and kick their way around the pool, eight legs splashing together. 'I'm not swimming today but it is a communal pool,' says the mum. 'All ages here swim together.'

Swim: Easy to moderate. A river playground for all ages, in a historic spot.

Details: Park at Skenfrith Castle, a Welsh Historic Monument with free admission. Skenfrith is 6 miles north west of Monmouth and 12 miles north east of Abergavenny, on the B4521.

59. SPITCHWICK COMMON, DARTMOOR, DEVON

Dartmoor's awash with legends about spirits that inhabit it and locals being 'pixie-led' by sprites casting mischievous spells. It's also one of the last wildernesses in England, getting its name from the crystal-clear fast-flowing Dart. It all makes for magical swimming.

But it's a 'flashy' river, rising and falling fast with the rain, knee-grazingly shallow one day, a torrent the next. Spitchwick Common has earned its place as a local swim spot thanks to being a reasonably reliable and safe swim: slow when other sections are speedy, deep when they are shallow. The river is clean and clear, holding a perfect reflection of the cliff and mossy boulders that hug its bend. Otters live here, and the deep pool provides a resting place for migrating Atlantic salmon and sea trout as they travel upstream to spawn.

Beside the river is a large clearing, surrounded by an orchard of witchety trees, leafless after all others have blossomed. In spring it is empty, with pale yellow butterflies being blown around above the grass, kept short by wandering Dartmoor ponies. The woods are alive with the chirping of small birds and the clear brown water feels like frosty hands round your body.

But in summer the common is full of families lying on picnic blankets and scorching barbecue marks into the grass (see picture on page 4). The

river organises itself into three swimming areas: at one end of the bend small children sit on rocks in the middle of the river; in the centre of the U swimmers and inflatable rowboats mill about in deeper water full of trout and salmon; and at the other end teenagers do daredevil dives off the cliff in the local tombstoners' uniform of wetsuits, trainers and Hawaiian board-shorts (worn on the outside).

I visit for a picnic with my niece and nephew, five and two, and we spend the afternoon paddling in waterproof sandals and poking sticks under rocks in a shallow offshoot of the river. On the main stretch a teenage boy courts a girl in the time-honoured fashion of splashing her a lot and endangering his safety by jumping from nerve-wracking heights.

Swimming here is a pleasure, whether you're in company or alone. Proximity to the moor keeps the water fresh, verdant and earthy, and its clarity gives a perfect view of the big, round, friendly stones that typify the Dart riverbed as you swim.

Dartmoor National Park is largely privately owned, so people have always swum here thanks to the tolerance and largesse of a private individual. Do bear that in mind and go quietly, lightly and respectfully into this special place. It'd be a great disservice to the landowner and locals to disrupt the balance they've found.

Swim: Easy to moderate. A good picnic and paddling place for children, with crystal clear water.

Details: Although known to all locals as Spitchwick Common, if you want to find this spot on a map look for 'Deeper Marsh' near Ashburton. Park at the car park by New Bridge (see Sharrah Pool page 102). There's a Dartmoor National Park information centre in the car park. Here we discovered that the scrubby trees on the common were alder buckthorn, and the yellow butterflies Brimstone, an early-flying butterfly (it was April). New Bridge is on the Two Moors Way and the Dartmoor Way long-distance paths.

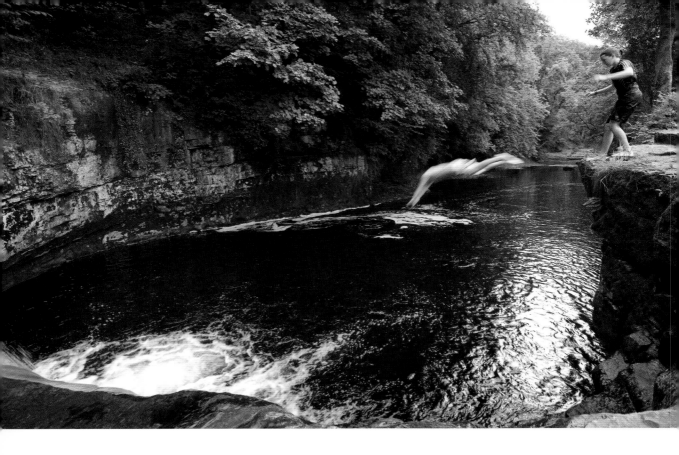

60. STAINFORTH FORCE, YORKSHIRE DALES, NORTH YORKSHIRE

Stainforth Force (pronounced 'foss') lies just below Stainforth packhorse bridge, with some shallow sun-warmed pools suitable for small children, and then a succession of platforms and falls. We approach on an un-sunny Sunday in September, but the banks are full of families eating picnics.

The commotion centres on the deep pool at the end of the falls, where jumpers and divers are gathered on the cliff, peering out from behind tree trunks and scrabbling up slopes.

Children in sports shorts and soggy trainers run down an incline holding a rope-and-wood bar-swing, arcing out over the fall and letting go as they soar over the pool. A sister and brother do tandem dives, backflips and somersaults to the delight of their parents. 'I felt like I was flying for ages,' says the brother, running back from a jump that scared

him. A teenager stands on the highest ledge, shaking. 'Come on then!' shouts a boy of about five, then offers 'I'm not old enough' to the spectators beside him.

It's a riotous human circus that everyone joins, the less confident leaping off lower rocks into the water. Michael tries the rope swing, but his grip slips and he lands on the ledge, jarring his back and then skidding out over the waterfall. It provides the only hush of the afternoon – a collective intake of breath – then the chatter starts up again as he swims to the edge. 'I knew he was holding it wrong,' offers Tom, 11, red-haired and wet beside me. 'You want to hold it like this.' 'Don't tell me,' I say, ushering him forward, 'tell him.'

Swim: Easy to moderate. A popular jumping spot on a lively section of the River Ribble.

Details: Stainforth is on the B6479, about 2 miles north of Settle (which is the nearest railway

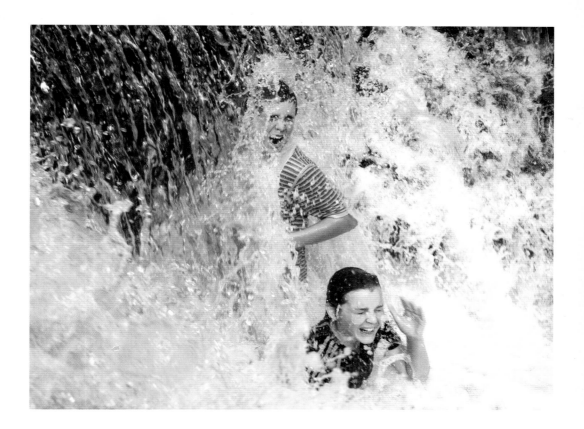

station). The Force is just west of the village. This swim is part of the Ribble Way (a 70 mile footpath) and various circular walks. Stainforth and Little Stainforth are both on National Cycle Routes. The bridge is a short walk from the Stainforth Force car park.

61. TOPSHAM TO THE TURF, DEVON

In the 1930s there was an annual race on the Exe Estuary from The Turf pub upstream to Topsham. There's a foot ferry that runs between this pretty Devon village and the canal bank on the other side, and over the last few years, as sailing boats pass up and down and birds pick things out of the mud, Mike the ferryman used to wonder what it'd be like to swim down the channel.

In 2006 he did it as a personal challenge, and in 2007 17 others joined him on this beautifully brackish part of the River Exe. James Lowe was one who went along. 'It was a great day, the weather was gorgeous, the Morris dancers were in fine fettle and all the swimmers had a wonderful ovation from the crowds gathered. One eager chap passed by and decided he would also 'have a go'. He was helped out of the water at the finish (in a pretty respectable time) in only his cotton boxer shorts and a big smile.'

We did this swim in August with accompanying non-swimmers and children walking down the canal side of the estuary, and cider, crab sandwiches and toffee pudding at The Turf afterwards before walking back to Topsham along the banks (www.turfpub.net – has a large garden play area).

Swim: Moderate – you will need to check tides and take boat cover for this 2.5km swim. A superb swim on a hot day, with a great pub lunch.

Details: Topsham is about 3 miles south east of Exeter, across the M5. Ask Mike the ferryman for local advice and swim on an outgoing tide. The ferry runs full time between April and September, weekends and Bank Holidays the rest of the year taking walkers across the estuary. Boat cover is strongly recommended – some of our party flanked us in kayaks to protect us from other boats. The Turf pub can only be accessed by foot or boat (the nearest car park is about a kilometre away).

62. WARLEIGH WEIR, CLAVERTON, AVON

Dom and I visit Warleigh Weir in Claverton on a slightly sunny Friday afternoon in April. It's before the swimming season has really begun but we walk into the large meadow full of buttercups beside the weir and find two teenage boys face down on a blanket with books beside them (a position they hold, without moving, for the next two hours, before rousing with faces creased).

There is a girl 30 yards away (also stretched out, asleep), then a family of two wet boys, a pregnant woman and a man in a wet T-shirt and trainers holding a chainsaw. 'Is that a regular swimming accessory?' I ask as we get close.

It turns out that Dan, 31, has swum at Warleigh for the last 25 years, and this is his first visit of the year. 'The boys have been saying for months "When can we go to Claverton? When can we go to Claverton?",' says Lorna, his girlfriend. 'And I've been saying "It's cold, the water's high, the weir's covered in trees..."' Today, however, Mark and Dillon, age seven and nine, get their wish. And Dan has brought his chainsaw to start clearing the weir of winter trees, making it safer for other swimmers.

We chat a bit before we get into the river. The weir is long and slippy but, emboldened by the hundreds who walk along it, we cross. The scene upstream is bucolic, the riverbanks thick with lilypads, meadows and occasional oaks. Pollen mists the surface of the green river.

The family are still there when we get out. 'I heard them talking in their bunks last summer,' says Lorna, 'and Dillon said to Mark, "My next lesson in swimming is jumping out of trees".' Dillon points out the place where he and Dan run and jump into the water. 'You have to hurtle through the air, legs pedalling, to get

far enough away from the bank,' he tells us. It's about a 15 foot drop – too high for us – but Dan knows the river. 'My stepfather took me when I was young,' he says. 'I've always preferred swimming in rivers: maybe it's a grubby thing.'

I spoke to Dan again at the end of the summer and April turned out to be their only visit in 2007 because of the summer's extraordinarily high rainfall. 'I can tell by the colour of that river whether it's ready to swim. It's a bit like looking at a tree and waiting for apples to ripen,' he says. 'Clear and green is good, but it was mucky brown for most of the summer from washed-up silt.'

'Up to 500 people come here on hot days,' says Dan. If you become one of them, be respectful and pick up any litter (your own, or other people's). The land is owned by a farmer who allows swimmers access, but could close the land off if there is lack of respect for his property.

Swim: Easy to moderate. A popular summer haunt for families, beside a lazy river.

Details: The weir is just off the A36 to Warminster. Parking is limited on the track to the field, so people park on verges and walk down.

63-64. WASH POOL & WOLF'S LEAP, NEAR LLANWRTYD WELLS, POWYS

Wash Pool is a natural swimming pool in the Abergwesyn valley surrounded by mountains and ancient woodland where the elements seem utterly untouched by time. It's a real dingly dell, where sheep used to be brought for a wash (local pony trekkers now do the same with their ponies). Gnarly old beech trees are covered in moss, rocks are patterned with lichen and there's no trace of footprints on the springy turf.

The only signs of human intervention are rocks that dam up the 20 to 30 metre pool and a tree-hung rope swing. The water is tea-coloured, clean and shallow (a good family swim area), and cascades into the pool via a waterfall and rapids. When Vicky and I arrive the pool has a little foam, more likely to be the result of natural surfactants (from plant lipids and lignins from wood) than domestic or agro-chemicals.

While the view is all natural, you can enjoy it from benches, with a car park yards away – although the remote location makes it unlikely you'll bump in to anyone.

Drive a little further on up the Abergwesyn valley, and you will come to Wolf's Leap. The last wolf in Wales was shot near here around the 13th century. (The history of the name is unknown, but wolves are good swimmers as their slightly webbed feet make great paddles – it's possible they were seen leaping into the water to get away from people, of whom they are scared.)

Not to overdo Wales' reputation as a wet place, but by the time we arrive here there isn't any air, just cubic metres of drizzle. We set off towards the River Irfon wearing wetsuits and walking boots. Sheep baa at our inelegant dress.

We go off-path, feet continually stepping on to what looks like turf and marsh reeds, but is actually bog.

There are two pools here, surrounded by big slabs of striated rock with black lichen, and the upper one captures our imagination – the high walls are surrounded by heather, hanging with ivy, and a rowan tree dripping with red berries. There's a slot canyon and (confident of no sudden flood) we pull our way upstream using hand holds.

The canyon is twisted and sculpted by the flow of the stream, walls thick with green moss, and soon we're deep inside the rock, a crack of daylight above us. The rock emits a very low soothing rumble, like a long, slow breath. It's like being in the ribcage of the mountain. There's a phenomenon where people's breathing and pulse synchronise with one another, and when we emerge from the canyon – floating back down, feet first, with a view of the misty grey green valley between the two rocks – we feel we've taken on the calm, steady state of the mountain.

Swim: Easy. A natural pool and a canyon swim in the remote Abergwesyn valley.

Details: We found these pools thanks to directions from Rob Fryer. Midway between Builth Wells and Llandovery on the A483 is Llanwrtyd Wells. From here take the road to Abergwesyn for 2.5 miles until you reach Wash Pool. For Wolf's Leap, carry on for another 5 miles and take the left turn to Tregaron. This narrow road takes you along the steep valley to Abergwesyn Common. After 2 miles the river becomes hidden between clefts in the rock. Park in a layby on the right. River shoes may improve your enjoyment of both locations.

65. WAVENEY RIVER, NORFOLK

Roger Deakin spoke warmly of swimming on the Waveney, an idyllic English country river that meanders through pastures, irises and willows dipping into its sides. Surrounded by rolling hills and grazing cows, it's Cider with Rosie territory in spirit if not geography, made for cycling up to on bikes and lolling around on picnic blankets in the sunshine.

We visit in late October when it's an English idyll on the turn: the clear blue skies, clover, buttercups and knee-high grass say summer, but the sound of crows and a distant duck-shoot say otherwise.

Another clue to the season is that, after a swim earlier in the day, I have a severe case of cold-water catatonia. This is a condition that afflicts some winter swimmers: you swim, you feel great, you're alive and burning up with the vividness of everything, then about an hour later you are too tired to keep your eyelids open.

On this occasion, as we drive towards our swim on the Waveney, I am so stupefied that every time Dom gets out of the driving seat I slump over the handbrake for a lie down.

We arrive at a meadow beside the river in the afternoon, wander up and down until we find a good entry-exit point, and then Vicky and I have a quick nap on a towel (slightly frozen ground not withstanding) while the boys get the gear together.

We get in without wetsuits (too tired to put them on) and the Waveney is a delight, trees overhanging, muddy-kneed cattle grazing nearby. In summer, you could meander here at leisure down a river that looks like it's found the secret of its own happiness. The water comes right up to the height of the riverbank and the swimming is safe, calm and undisturbed (see picture on page 112-113).

Swim: Easy to moderate – may require clambering in. A lovely, slow meandering river.

Details: The Waveney was Roger Deakin's local river and he regularly swam and paddled here. Canoeists have secured voluntary access agreement to paddle the 33km of river from Brockdish (east of Diss) to Ellingham (east of Bungay). Swimmers who enter and exit the water from public land and footpaths along this stretch are unlikely to be made unwelcome. See www.waveneyvalleycanoeclub.co.uk for further information.

66. WIDGERY TOR, DARTMOOR, DEVON

Widgery Cross, an unusually tall cross made of ten separate slabs of granite (most crosses are hewn from one) is visible for miles around on Dartmoor. It stands at Widgery Tor (also known as Brat Tor) and below it the River Lyd either thunders or tumbles, depending on recent rainfall, through a narrow rock cleft into a small swimming pool.

It's a great spot for a swim after a long hot walk (the Dart's always fresh). We visit it on a breezy day in July; clouds are being blown across the sky, sheep ramble through the granite boulders, gorse, foxgloves and ferns, and the relative seclusion makes the pool perfect for skinny dipping. We keep our goggles on, though, all the better to see the bubbles of the natural jacuzzi lit up by the sunshine, and some tiny trout sharing the water beneath us.

On the riverbank there's a bench and a memorial plaque to Captain Hunter, who was killed in action in the First World War, 1918, aged 23. 'He loved the moors of Devon,' the plaque says, 'and on his last visit to Lydford, he wrote the following lines:

> Are we not like this moorland stream
> Springing none knows where from,
> Tinkling, bubbling, flashing a gleam
> Back at the sun; e'er long
> Gloomy and dull, under a cloud,
> Then rushing onwards again;
> Dashing at rocks with anger loud,
> Roaring and foaming in vain!
> Wandering thus for many a mile,
> Twisting and turning away for a while.
> Then of a sudden over the fall
> And the dark still pool is the end of all.

Is it? I thought, as I turned away,

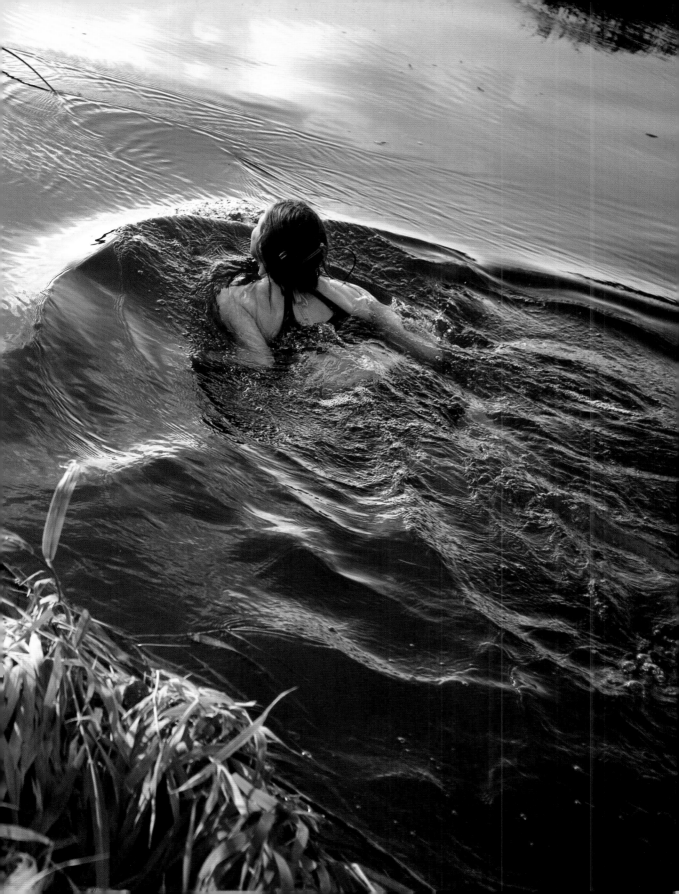

And I turned again to the silent moor.
Is it? I said, and my heart said 'nay'!
As I gazed at the cross on Widgery tor.

Swim: Easy. A perfect pool for a cold plunge after a long walk on Dartmoor.

Details: The Widgery Tor pool is called 'Black Rock Falls'. The car park is some 200yds up a rough unmarked track by The Dartmoor Inn on the A386, 8 miles north of Tavistock. From there follow the track north east for half a mile to the River Lyd. This swim would make an ideal finale to a walk, long or short, on Dartmoor.

67-68. THE RIVER WYE, GLASBURY BRIDGE, HAY ON WYE & TRESSECK CAMPSITE, HOARWITHY, HEREFORDSHIRE

Over the summer of 2007, Mark Sawyer and some Channel swimmers had high hopes of doing a length of the River Wye and invited me to join them. The Wye is a mighty deep river, like the Thames, a treat for swimmers who want to swim for miles between bushy green banks that border pastures, forests, vertical rockfaces and medieval castles.

Mark's plan was to start at Hampton Bishop, have lunch at Hoarwithy, and spend the night in Ross on Wye. Then swim the next day to have lunch at Saracen's Head in Symonds Yat, ending at Bigsweir (see map ref 144).

The Channel swimmers planning the trip are advanced swimmers and were working on swimming about 3 kilometres an hour, with a 3 to 4 kilometres per hour current drift, giving a total of 9 to 12 kilometres an hour. They would therefore cover about 20 kilometres within two hours, before and after lunch – covering a total of 40 kilometres a day. I was going to swim as fast as I could and then catch up by getting into my support canoe to meet them for lunch.

We dreamed of getting carried along in the Wye's clean current, following the course of kings and coracles, enjoying this navigable river's undisputed access and its warmth (the Usk and Wye are warm rivers as they are long, with slow, shallow upstream sections), as it drifts through wide flood plains of unspoilt countryside.

The weather, however, was having none of it. On the date of the first planned trip the river was in 'spate' (flood); 'Trees' texted a friend from its banks 'are floating in it'. On the date of the second, the news came in from one of our

canoeists who lived there: a caravan was floating past his kitchen window. (2007 was atypical with high rainfall and flooding. This swim would have been possible in 2006 when the river was so still it was hard to work out which way it was flowing.)

I do, however, manage two dips over the summer. The first is by Glasbury Bridge in book town, Hay on Wye. There's nothing romantic about the bridge itself, but it's right next to town, there's easy access from a big pebble beach where children can paddle in the shallows and there are endless stones for skimming. It's popular with local swimmers and as a putting in spot for kayakers so you may have the comfort of company. We finish the day with tea and carrot cake at The Granary, then riffle through bookshops and find a beautifully illustrated *Complete Freshwater Fish of the British Isles*, still a treasured companion.

The second is at Tresseck Campsite, Hoarwithy (www.tresseckcampsite.co.uk). Fifteen of us had enjoyed the cider, fine food and friendliness of the New Harp Inn (www.newharpinn.co.uk) the night before, and needed a refresher before breakfast. Vicky and I swim within our depth to test the water, but it is still flowing too fast for a mass dip so we go onto Hoarwithy (see 'Tips for Wild Swimming'). We do, however, meet two young boys from the campsite, who are going downstream later on their surfboards.

Swim: Moderate to advanced. The Wye is a lovely river for dips and long swims, if the weather allows.

Details: Hay on Wye is at the northern tip of the Brecon Beacons on the B4350 (nearest station: Builth Road). It is on the National Cycle Network and the Wye Valley Walk. Hoarwithy is 2 miles

east of the A49 between Hereford and Ross-on-Wye. Canoeing is extremely popular in Wales and Herefordshire, and the Welsh Canoe Association is supportive of swimmers. Commercial operations will hire guides; but you may also find them through the goodwill of local canoe clubs and their internet forums.

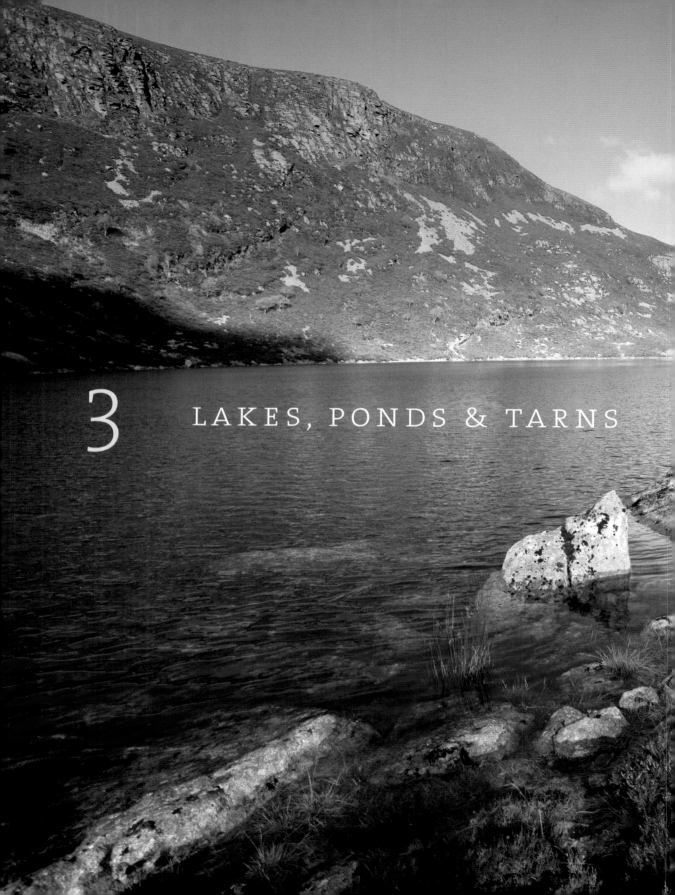

3 LAKES, PONDS & TARNS

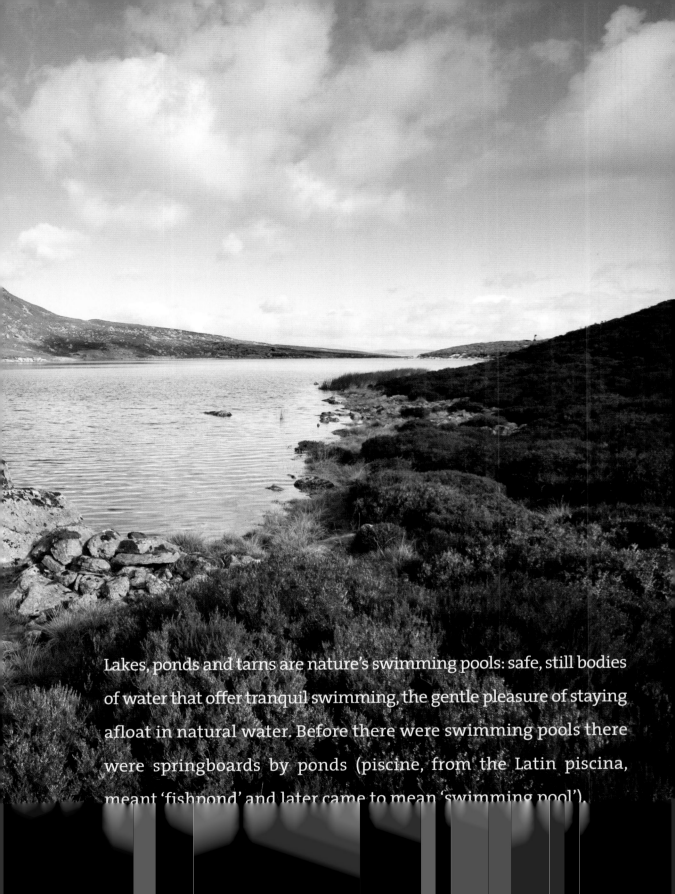

Lakes, ponds and tarns are nature's swimming pools: safe, still bodies of water that offer tranquil swimming, the gentle pleasure of staying afloat in natural water. Before there were swimming pools there were springboards by ponds (piscine, from the Latin piscina, meant 'fishpond' and later came to mean 'swimming pool').

The soft green water in lakes is part of a self-cleaning ecosystem and has a life-giving quality for the swimmer as well as fish, plants and frogs. Swimmers often feel that in water they are truly 'in their element' and in lakes this is somehow enhanced: you emerge as from a freshwater baptism, a rebirth through algae. Lakes also have a timelessness about them, particularly in the early morning when they lie undisturbed by the night, holding a perfect reflection of their surroundings – whether dense woodland or barren crags.

Lake swimming is less daunting than sea or river swimming for many swimmers. Shallow lakes heat up in the summer, becoming warmer than the sea and many rivers. And, while you may have to come to terms with subconscious terror – there is something about lakes that stirs up deep fears of the mysterious monsters that could lie beneath – there are few waves and currents to deal with.

When swimming moved inside it became less an experience than a way of exercising: going to and fro, forward and back in a chlorinated box. Lakes offer the chance for muscles to stretch out and glide for miles, but they also nurture a different kind of wellbeing – that of the heart, soul or psyche. It's not surprising that there's a big demand for 'natural swimming pools' and a waiting list to sign up at the one club in England, Henleaze, by a natural lake with high diving boards, changing rooms, and sunbathing lawns.

Ending a stifling hot day in the city with a dip in the lush surroundings of Hampstead; paddling with children in a shallow lake warmed by the sun; celebrating reaching a summit by slipping hot feet out of hiking boots and skinny dipping in a remote tarn – there is joy, play, emotion and expression in these experiences. We hope that the swims described in this section will encourage you to indulge yourself in these pleasures. It's swimming for life, not swimming for exercise medicine.

Loch Oich, Scottish Highlands.
Previous page: Llyn Arenig Fach, Gwynedd

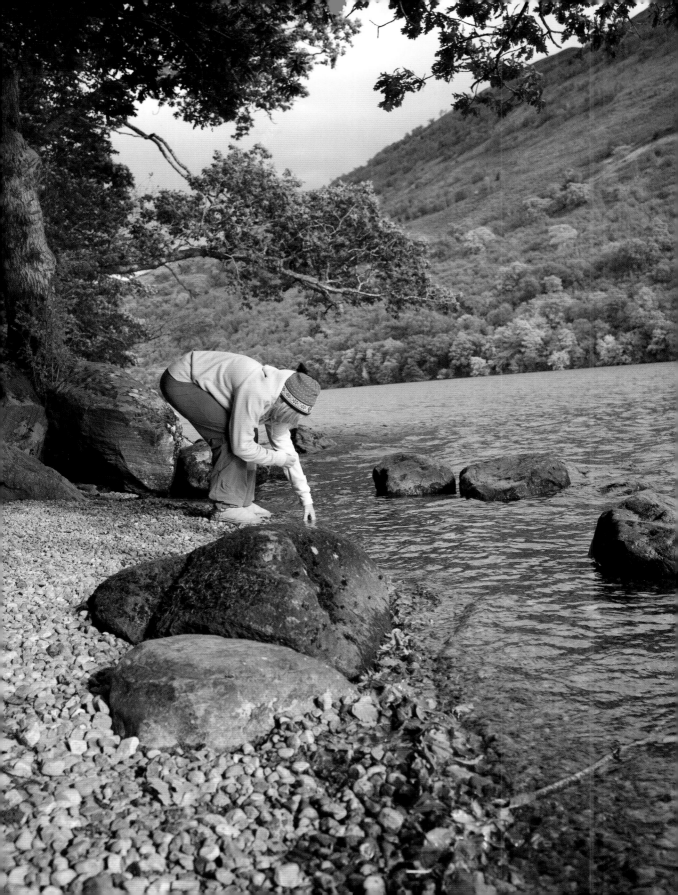

69. BUTTERMERE, LAKE DISTRICT, CUMBRIA

It's the night before Halloween as Kari and I enter our seventh hour of driving to the Lake District. Wind flaps against the wet canvas of a passing lorry and the sky is the colour of wet concrete. There are another 43 miles to go. 'We could go for a swim when we get there?' I venture. 'We could,' says Kari, peering through sheets of rain.

And so it is that while travellers all over the world mark the beginning of a holiday with a ritual swim – diving into a warm sea or infinity pool – Kari and I struggle into our wetsuits by the boot of the car, which we've parked half in a puddle. Water pours from our B&B's scaffolding and every now and then a gust of wind slaps it into our faces.

Wetsuited-up we pick our way through a wood to the shore. The path is dry and springy with pine. We can hear the wind coming in rushes, blowing in such sharp forceful bursts we fear for falling branches. We walk with our arms above our heads as protection.

We both have enough experience to know that while frustration, boredom and tedium can all be taken with you on a trip, they will never outlast a swim. Right now we're all interminable travel, A606 to nowhere. Soon we'll be people on holiday!

We reach the beach and wade in. Cold burns my ankles. The bay is sheltered and dark, clumps of grasses moving like seals in the water. We have to shout to be heard. 'It shelves quickly here!' Kari reports with a splash as she plunges to her waist. We surge forward, gasping, in jolting breaststroke. We swim past a driftwood tree, smoothed of all bark and bleached silvery in the water. Cold numbs my neck and a cruel trickle of water makes its way right down the centre of my breastbone.

We leave the shelter of the bay and go out around the headland. The water looks black until we put our faces in it, at which point round stones shine white underneath. I flip over and swim on my back looking at the outline of undulating hills. When we kick our feet wind picks up the spray and splashes it back into our faces. It's your archetypal dark and stormy night. We stay close to the shore.

Fifteen minutes later we're done, and walking back up the path. Even though it's darker now everything seems brighter and sharper: the pine needles on the forest floor individuated, the curve of the path more delightful. The wind comes at the trees above us in deafening bursts, like surf through shingle.

We get back to the B&B car park and ask a mountain biker whether there's a drying room, as he puts wheels into the back of his van. Two drenched walkers in red Berghaus jackets join us. 'Windsurfing?' they ask. 'No, swimming.' 'Well done,' they say, without surprise.

We tiptoe up to our room, as if that will make us drip less, then go out for beer-battered cod and cider. Later that night, we lie in our £25 twin beds with peach dado rails, damask apricot curtains and pearly headboards. Outside rain pours off the roof, too much for the drains. We have two bright ideas: one to hold a charity swim for breast cancer called Breastrokes; the other to found an Outdoor Swimming Society, to spread the word about wild swimming. (Two years later the swims have raised £150,000 for Cancer Research UK and the Society has 2000 members and is growing.)

Sometimes it takes weeks for a holiday to liberate one's thinking about life. Sometimes, with wild swimming, all it takes is one night.

Swim: Easy to moderate. A small, stunning, boat-free lake that's good for children.

Details: Buttermere and its neighbour Crummock Water are about half a mile apart and make a good focus for a day's swimming, perhaps including a walk to nearby Scale Force, a dramatic 170ft waterfall (see map ref 145) for a dip in-between. Crummock Water, at 4km, is twice the length of Buttermere but both are relatively shallow (which makes them warmer than other lakes in the area) and have frequent and easy entry and exit points and places for paddling with children.

Avid fellwalker and guidebook writer Alfred Wainwright loved Buttermere and there are plenty of walks which include it. A simple circuit of the lakes (4.5 miles) takes a couple of hours, following a path the whole way. There's also a classic Buttermere circuit (8 miles, 6 hours 30 minutes) which takes in the peaks of Red Pike (2479ft), High Stile (2644ft), High Crag (2443ft) and Haystacks (1900ft) – after which your poor feet will be crying out for a dip.

70. CRUMMOCK WATER, LAKE DISTRICT, CUMBRIA

'There is scarcely anything finer than the view from a boat in the centre of Crummock Water. The scene is deep and solemn, and lonely,' wrote Wordsworth. Perhaps one thing finer is the view when in the water rather than on it.

Buttermere and Crummock Water lie next to each other, separated by a narrow, grassy bank. After a morning swimming in Buttermere eight of us divert on foot and walk up to Scale Force waterfall (see map ref 145), and then on to Crummock Water. Scale Force is the highest waterfall in the Lake District, hidden away in a deep, tree-lined gorge, with a single drop of 170 feet, and two shorter falls. The weather is the same as on all my other visits: wet (there is a reason that this area is full of lakes). Sheep hover by grey stone walls, hindquarters to the driving rain, and our legs are covered in goosebumps the second we undress on the shore.

We get into Crummock Water and the 'oohs' that preface this morning's 'ooh it's cold' are slightly more rapturous, the groans closer to pleasurable. There's a long history of sensualist swimmers: for French poet Paul Valéry swimming was a 'fornication avec l'onde', while novelist Gustave Flaubert longed for the sea's 'thousand liquid nipples'. While we're deprived of the full-on sensualist experience by our wetsuits – swimming in a wetsuit is a little like making love with lots of clothes on – there's a sense of aliveness as the blood starts pumping, if not the high that happens at the moment during skin swimming when the body's circulation triumphs over cold in a sudden, searing rush.

We had planned on a 3.5 kilometre length of lake but the wind is blowing straight towards

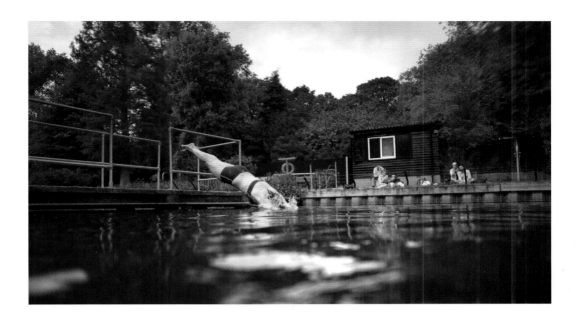

us, so our pleasures are cut short and we divert to a crossing (800 metres) instead. Like Buttermere, this is a great and approachable lake for a swim. On our visit, the surface of the lake is rough with squalls of wind moving first one way and then the other, flattening some patches and whipping others into a white spray, but beneath the surface the rocky bottom means the water is clear. There's a ban on watersports and the water tastes all the sweeter for it.

Swim: Easy to moderate. Another approachable lake, with a glorious view.

Details: Crummock Water is 3.5km long. See Buttermere for some walking suggestions. There is also a walking circuit of Crummock Water taking in Scale Force (8 miles, 4 hours – see map ref 145), which can be extended to take in The Kirkstile Inn in Loweswater. Boats are infrequent on Crummock Water and the only ones allowed have to be carried to the shore by hand (tending to keep them small).

71-73. HAMPSTEAD PONDS, LONDON

Hampstead Ponds are an urban treasure: three open water ponds available for swimming in the rambling expanse of Hampstead Heath close to the centre of London. The men's and women's ponds are unique in Britain; there are few places like this where hot showers and lifeguards are provided around a natural piece of water, and these are the only ones open for swimming all year round.

Hampstead swimming has been a tradition since the 1860s and each pond has its own identity. Kenwood Ladies Pond is particularly pretty. After a hot day in the city, floating in the thick green water, surrounded by old oaks makes a person want to use words like 'divine'. One hot summer, friends and I regularly visited the Pond after work, the sounds of the city overtaken by the nearby rustle of leaves and reeds, and our urban overheating (mental and physical) seeping away in the nourishing water.

The ponds are just as heavenly in the early morning, where many regulars go for their 'constitutional' 365 days of the year, whether rain thrums on the surface or ice stiffens the grass. There is a big sunbathing field which

draws up to 2000 visitors on a hot summer's day, and a strict women-only policy. And all just 4 miles from Piccadilly Circus. It's worth any battles with the tube or the trains to get there.

The Men's Bathing Pond is the largest of the Hampstead ponds and the distance you can cover within it is enviable if, like me, you are female and can only catch a glimpse through the foliage. There are apparently many factional groups within (the gay group, the Jewish group, the chess players, the serious swimmers, the weightlifters, the readers and so on) but it's possible to be so wrapped up in the swimming that the politics go unnoticed.

The Mixed Pond is the least secluded and has the smallest grassy sunbathing area, but the lifeguards are friendly and, because dedicated swimmers tend to go to one of the other ponds, this is the pond with the most free and

easy atmosphere. An additional benefit is that you can go there with friends and children of the opposite sex.

You may, as you swim, wish to say a private thank you to all the swimmers who fought to keep these ponds open. In 2004, the ponds were threatened with closure, when the Corporation of London claimed that it believed it risked prosecution by the Health and Safety Executive if it allowed unsupervised dips.

In 2005, however, Hampstead Heath Winter Swimming Club won a high court victory in favour of their right to swim unsupervised. The judge, Mr Justice Burnton spoke in favour of 'individual freedom' and swimmers' rights to swim at their own risk – adding that by granting permission to the Club, the Corporation would not be liable to prosecution for breaches of health and safety.

This was an important victory for Hampstead

swimmers and wild swimmers everywhere. While the British population has great freedom to engage in all sorts of outdoor activities that could be risky – surfing, climbing, hiking, canoeing, mountain biking – for a number of years landowners and public bodies have been deeply fearful of being prosecuted if something happens to a swimmer. This case has helped redress the balance in favour of swimmers being responsible for their own risks and has given landowners the confidence to let people swim on their property.

Swim: Easy. Three glorious wild swims in the heart of London.

Details: The nearest tube stations to the Hampstead Ponds are Hampstead or Highgate. The nearest overground railway stations are Gospel Oak or Hampstead Heath. Wetsuits are allowed at the discretion of the lifeguards. See www.cityoflondon.gov.uk for opening hours.

74. HATCHMERE, DELAMERE FOREST, CHESHIRE

Hatchmere is a small oval 'sink hole' (a natural depression caused by water erosion) surrounded by reeds and fishing platforms. It's a hugely popular local swim next to The Carriers Inn pub and a road, so swimmers either do a towel dance in front of both, or change in the car. It's empty when we visit but three bins and a log seat on the bank indicate the lake's huge popularity.

As we walk down the grassy bank a lithe, tanned, grey-haired man removes a rake from a tiny red car and starts sweeping leaves and reeds from the shady bay – keeping things tidy for any future comers who may wish to enter the water. 'Hatchmere has been used as a swimming lake by thousands of people from all over the North West for generations, and, together with nearby Pickmere, is not only the best swimming in Cheshire, but practically the only reasonable water open to swimmers,' says Yacov Lev, the man with the rake. 'The lake is particularly popular with families with young children who like to paddle, swim and picnic.'

In 1998 the lake, a site of Special Scientific Interest, was bought by Cheshire Wildlife Trust with the aid of a National Lottery grant. Two years later, the Prince Albert Angling Society were appointed as site managers and trouble began. The sandy bay was fenced off and reeds planted in it (with, it seems, no research on the impact of these reeds on the rare beetles and other wildlife).

There was an angry local protest, joined by a petition of 2000 visitors, which pointed out that the conditions of the lottery grant stated that the Trust has a duty to keep the lake and all its facilities open to the public. Eventually the new owners bowed to public pressure and now the swimmers are back.

Yacov was part of the fight to keep Hatchmere and it led him to co-found the River and Lake Swimming Association (RALSA – www.river-swimming.co.uk), with Rob Fryer, in 2003. Together the two men run a website portal doing much to connect swimmers to each other, and share information about swimming spots with the aim of safeguarding the interests of open-water swimmers all over the UK.

Swim: Easy to moderate. A humble patch of water that is loved by locals and has made a huge contribution to wild swimming across the UK.

Details: Park in the pay and display car park across the road, beside The Carriers Inn pub on the B5152 between Delamere and Frodsham (nearest station: Delamere).

75. HENLEAZE LAKE, BRISTOL, AVON

Henleaze Lake, just north of Bristol, is a 400 metre quarry lake, surrounded by mown lawns and festooned with bunting. It feels wonderfully English. Members spend their afternoons reading, sunbathing and arcing off a high diving board along with kingfishers and swimming in water bobbing with waterlilies and mallard ducks.

A former WW1 military shed forms the women's changing rooms, white wood cubicles hung with gingham curtains and grass matting on the dry wood floor. Swimmers make their way to and from the club house clutching tea bags and cups, sitting in clusters talking in library whispers or reading books in solitude under the shade of a willow tree. Stripy deckchairs are available and barley straw 'sausages' have been sunk around the lake's edges to help control algae growth.

The Lake was set up in 1919 and is fed by spring water. It still has the wartime spring boards and two high diving boards that were once the focus of competitions, come snow or sleet. A constant stream of people climb up the dark green diving tower and jump or dive off the boards, 5 and 7.5 metres tall. (The lake is 3 metres deep, 6 under the boards, allowing the club to keep the boards after EU regulations shut most of the UK diving boards down a few years ago.)

After being signed in by a local member, I spend a lazy afternoon here, lying on the grass in a bikini in the sunshine, idly flicking through a book and looking for four-leaf clovers, taking occasional swims and snoozes. It's a great place to unwind – no surprise that Henleaze Swimming Club has a membership of 1350 and a waiting list of 1500. It takes about two years on the waiting list to become a member according to the website, but members

are allowed to take in up to two guests, so you may be able to get in before then.

I leave as a 17 year-old boy – a guest – is made to take the 50 metre swimming test required for membership. Major Badock, the lessee of the lake when the Club was founded, was emphatic that only good swimmers should be admitted. 'It is no place for non-swimmers or beginners and I wish this to be strictly enforced.' And to this day, it is.

Swim: Easy. A members-only lake swimming club that's a paradise for the wild swimmers of Bristol.

Details: Henleaze Lake is on Lake Road in the Henleaze area of Bristol (nearest station: Redland). Henleaze Swimming Club: www.henleazeswimmingclub.org

76. LLYN ARENIG FACH, SNOWDONIA, GWYNEDD

Llyn Arenig Fach (see picture on page 116-117) lies deep in Snowdonia National Park and local legend has it that if you put your ear to the rocks on the far side of the lake you can hear the heartbeat of the mountain. 'What more magical motivation for crossing a lake can there be?' says Dom, who visited this lake alone.

'I set out for it on a hot August morning, just a few small clouds hurrying across a blue sky. It is a hilly 45 minute walk from the car park, the fresh wind providing a welcome relief from the heat of the sun. There are some terrific views on the way up with some old farm buildings nestled in the lee of the hill that the sheep seem to enjoy visiting like tourists at historic ruins. But I can't see the lake as I climb, and reach a series of false horizons that sap my energy. Then, sweat on my brow, I reach a ridge that provides my first glimpse of Llyn Arenig Fach, its cool blue waters promising refreshment. It looks a good size for swimming, about 250 metres across to the stark cliff of Arenig Fach, a 2260 feet (689 metre) peak on the furthest shore.

'I pick my way down to the water's edge through dense hillocks of heather and bilberries, helping myself on the way to handfuls of sun-warmed berries. I make my base on a set of flat rocks on the shoreline and begin to wander about photographing the patterns of sunlight on rust-stained water.

'I deliberate whether to swim across without my wetsuit but in the end decide to wear it for safety because I'm on my own. Buzzards on the cliffs above send their cries echoing down as I ease myself into the cold water and start to swim directly across. Reaching the middle of the lake I lie back and take in the soundscape of noises collected by the cliffs: crows

squabbling above, sheep calling hopefully, the lap of the water and papery buzz of a dragonfly – but no heartbeat, yet.

'As I set off again I begin to scare myself with thoughts of blind monstrous creatures in the inky black below, roused from cold sleep by my splashing on the surface. I dive down a metre or two to challenge my imagination to put up or shut up. Uneaten and more or less reassured I reach the base of the cliff on the opposite bank. I listen to several rocks like a safe-cracker at a bank vault, ear against stone, willing a faint thud to vibrate from the mountain, but it never does. Perhaps I didn't find the right rock or perhaps I was listening for the wrong sound – what does a mountain's heartbeat sound like?

'I am disappointed as I start the swim back, but by the time I get to my thermos and towel I feel rewarded enough by the swim. As I leave over the hill I turn to look back at the lake, and watch a single cloud almost the exact size and shape of the lake hang over the blue water a second longer than it should, as though pausing to admire itself.'

By chance Dom was looking for the heartbeat of the mountain in Llyn Arenig Fach the same week Vicky and I found something similar in Wolf's Leap in the Brecon Beacons, a hundred miles away (see page 109).

Another possible swimming spot nearby is at the base of this route by the car park. At 4 kilometres long Llyn Celyn is less charming than the smaller lakes in the area but is very accessible (see map ref 146). The reservoir has a bitter history, with its construction in the 1960s necessitating the flooding of the village of Capel Celyn. It is used as a swim spot now.

Swim: Moderate. A good-sized llyn, well worth the hill walk to get there.

Details: Llyn Arenig Fach is at the eastern foot of Arenig Fach. The easiest place to begin the hour or so walk is at the car park off the A4212 as it loops around the north shore of Llyn Celyn. An OS map is essential – head for SH8276 4176, the centre of the lake.

77. LLYN HYWEL, SNOWDONIA, GWYNEDD

Lakes and tarns are never more spectacular than when hidden away, and this very wild, very high tarn can only be reached after about an hour's walk. 'It's a weird atmospheric place, there is rock all around and it feels very ancient,' said Kari, in recommendation. 'Often you get up there and there's cloud cover when it's sunny down below: it's like going up into the gods really.'

The llyn is nestled between two of the highest peaks in the Rhinog mountains (Rhinog Fach and Y Llethr), one of the remotest areas of England and Wales, and was swum by Dom. 'I take the shortest and easiest route up but even so it is an hour's walk at a brisk pace and needs a large scale OS map,' he says. 'The path peters out and I clamber over a ridge rather than walking around it, following sheep tracks across a jumble of small bracken and gorse-covered hills and dips, before climbing up a hill almost to the edge of Llyn Hywel.

'The place has a presence, even on a dull grey day. It is eerily beautiful. I've been told that the low oxygen levels in the lake have made the resident trout almost jet black. Whatever the reason their coloration seems well suited to the dark waters, which reflect the light like a worn pewter dish.

'As I start to get my gear together a couple of walkers arrive. Seeing my towel they tell me that they've been in just 20 minutes before. I explain I'm photographing a book on wild swimming, and they are very enthusiastic, but not enough to swim again for the photos. We say our goodbyes and I am left to make do on my own.

'There has to be at least one person in the water for the images so I rig the camera up on self-timer and strip off. Anyone unfortunate enough to have arrived during the next 15 minutes would have been greeted with the following bizarre scene: a naked man crouches beside an apparatus that may or may not be a camera balanced shakily on a rock between a stick and a thermos. After some brief tinkering the man leaps to his feet and runs, as if fearing an explosion, into the lake, with all the grace of a drunken camel. After about ten seconds, when the water has reached his knees the man turns back to shore with slightly less haste but no more grace, whereupon the sequence is repeated, several times. Thankfully no one arrives and once I've got a frame that works I am free to have a proper, though short, swim.

'This is a gruff, rugged spot, high and treeless, rocky and cold but magical for all that. I have the fleeting thought that swimming here is too playful a thing to do in such an austere place, like whistling in church. As I adjust to the cold, my gasps slowing to more regular breaths, I feel more at ease and accepted. Once properly in the lake I can look north to the scree-banked summit of Rhinog Fach and south to the slightly gentler slopes of Y Llethr, feeling both exposed and protected in the nook of these two mountains. I can see Rhinog Fawr in the distance and with my eyes on the surface of the water the llyn becomes a natural infinity pool.

'Once out and dried I forage for bilberries and find plenty growing on the eastern shore, including one bush, too small for fruit, that has taken root in the fissure of a rock standing out in the water.'

Swim: Moderate. It's at least an hour's walk to this remote llyn. A gruff, rugged spot in hiking country.

Details: The whole area is well loved by walkers,

*hikers and wild campers and there are any
number of routes that will take you to Llyn Hywel
(SH663266). The most direct route is to turn off
the A496 at Llanbedr, drive up the single track
road that follows the Cwm Nantcol valley into
the mountains, park near Cil-cychwyn and
take the track from there. It's about an hour's
walk. There are jagged rocks at the edge of the
lake so river shoes are advisable.*

78. LLYN GWYNANT, SNOWDONIA, GWYNEDD

The large, grey rock on the far side of Llyn
Gwynant looks like an elephant, making it an
obvious target for a swim. 'The rock gets the sun
in the morning and is good for jumping,' says
local swimmer Ross, who recommended it. Both
ends of the lake are very shallow so it warms
up quickly in summer.

Lulu and I park on the beach across from the
elephant rock, just off the A498, which runs
along the south side of the lake and gets the
sun all day. The water here is shallow and looks
good for paddling children, but I set off for the
rock, about 400 metres away. The water is dark,
the valley is pretty and the elephant seems to
gain ears and trunk as I draw closer. I make it
there in comfort and sprint back – all the

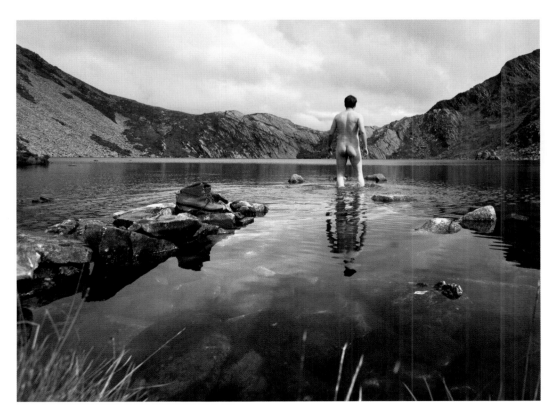

quicker to escape deep water fear.

Wetsuits are recommended if you are going to commit to this swim: it would be possible to hobble back from the elephant around the shore if you got too cold to swim, but the warmth and buoyancy of a wetsuit improves safety. As always, check the depth before jumping off anything (see 'Tips for Wild Swimming') – the depth below the elephant rock varies from 80 feet to shallow.

Swim: Easy to advanced. A relatively warm llyn with shallow edges for children, and a good destination swim to 'elephant rock' for more advanced swimmers.

Details: There is a campsite (www.gwynant.com) at the end of the lake from which you can walk up Snowdon. Gwynant is a popular lake for kayaking and canoes, and they can be hired by the hour if you want to use them for cover.

79. LLYN IDWAL, SNOWDONIA, GWYNEDD

There are lakes all over Wales that are good for swimming in, and, while this llyn is good for walkers, wild campers and climbers (particularly beginners who can have a go at the 'Idwal slabs'), the wide stepping stone path to it also makes it a great family option.

Lulu finishes chatting with the handsome young guide in the visitor centre ('so which part are you in charge of?' she says, stroking a map of Snowdonia National Park in his private office), and then we start the walk up, through a wrought iron gate. This topographical representation of the Cwm reflected in the llyn also conjures up an eagle's wingspan and concentric ripples on water at the same time. We pass a few people pushing babies in off-road pushchairs, and young children skipping up the ten minute walk without obvious signs of fatigue or boredom.

Idwal is one of the best examples of a glacial valley in Wales, a wide open basin in the shadow of Twll Du (known as Devil's Kitchen), with the dark cliffs and waterfall of Clogwyn y Geifr (the Cliff of the Goat) behind it. There's a big shingle beach that looks ripe for an afternoon's picnic, playing and snoozing on a sunny day, and there's a low-lying walk right round the lake. Pictures in the visitor centre show Llyn Idwal in various seasons: eerily beautiful on misty mornings, intensely coloured in autumn sunshine.

But some strange confluence of weather fronts and our travel plans means that, during my trip to North Wales, it rains as we approach each and every llyn. And now, 50 steps from the beach it begins to pour and everything looks grey. Lulu finds somewhere to crouch, towel at the ready, while I swim.

The only drawback of this lake for children

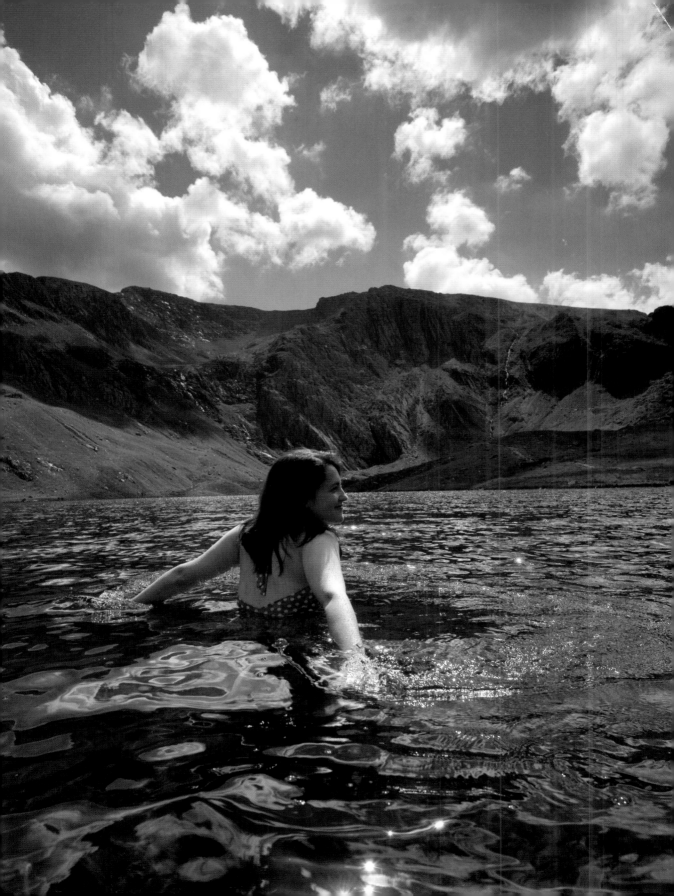

is that it's north-facing which, combined with its altitude, means that it's a little bit colder than the others. But the deep-sided cwm (rock basin) is stunning from the water. And minerals washed down from Devil's Kitchen would have made the grass beneath it supernaturally green, if the light hadn't been too flat to see it.

This is one of the most popular lakes in Wales (300,000 people visit each year) so tread lightly. This is the furthest south that some Arctic alpine plants can survive, and grazing has been excluded in different areas to allow heather to regrow.

From Idwal there is also a steep walk up to Llyn y Cwm (Lake of the Dogs), a swim recommended by local wild swimmer Ross (see map ref 147). 'It's a small, beautiful lake on a popular footpath where you can easily spend an afternoon.' He has swum in over 50 of the llyns around Snowdonia and says the natural ones are clearer. 'The man-made ones tend to silt up and collect about three foot of mud in the bottom – you can swim in them but it's not pleasant, walking up to your knees in mud.'

Swim: Easy. A good lake for walkers, climbers and families

Details: Llyn Idwal is 800m long and 300m wide. There is a car park by the Cwm Idwal visitor centre (and café), off the A5 on the south side of Llyn Ogwen. The beach gets the sun all day in summer. Dom visited with his wife Sarah (pictured) with one-year-old Martha on his back. If wreck-swimming is your thing, we heard afterwards there are a few old rowing boats that can be seen under the water, on the right hand side of the lake as you stand on the beach.

80. LLYN MORWYNION, SNOWDONIA, GWYNEDD

It's drizzling and Lulu is sweating mojitos from a cocktail party in London the night before as we follow a path into the Rhinog mountains that climbs along the side of a boggy pine forest, past a waterfall, and onto open moorland. 'I am never doing this again, Rewy. The driest part of me is inside my nostril.'

Lulu's previous experience of rambling has been limited to trips to Waitrose on the King's Road, but in the spirit of friendship (and in recognition that this may be a once in a lifetime encounter with the uninhabited, rather than uninhibited, version of 'wild') she has caught a train up to North Wales, one of the wildest places in Britain, to accompany me.

Some of our route is in crow land – no paths, just open country. Neither of us have really done this kind of map reading before. 'My geography 'O' level is coming back to me,' says Lulu, as we crane our heads over the map to identify enough features – peak, Roman steps, gradients, waterfalls – to be sure we're headed in the right direction.

There's a tinkle on the hillside and a father and daughter team comes bouncing down the mountain, bikes over their shoulders, rattling like mountain goats. Then there's a squelch. 'I've become a dowser,' says Lulu as her borrowed walking boots – slightly undone at the ankle – scoop up another boot-tongue's worth of bog. She is indeed showing an uncanny ability to step on all the bits of grass that sink.

Roman steps identified, I walk (and Lulu squelches) up a dry stream bed where we catch our first sight of Llyn Morwynion, sparkling a few hundred feet below us. It's all the more special for having been out of sight until now.

Then God hits the dimmer switch and it starts to pour. We descend to the lake, picking

our way between rocks and heather roots that act like tripwire. We straddle an impressive Roman wall but Lulu's foot slips. Pinioned there, khaki trousers translucent and stuck to her legs, water running off her dark hair and obscuring her face, it's not entirely clear whether she's having fun yet.

A few minutes later we're at the shore edge. We have been told that there's a rock jetty that heats up in summer from which you can walk into the water, and we make our way to it. It would be a lovely place to sunbathe and rest on a hot summer's day, looking out at the crags opposite. But right now rain thrums across the lake in diagonal sheets, fast and repetitive. The water is black, Ophelia weeds waving by the shore.

In the time it takes to remove my anorak and give it to Lulu my clothes are drenched. A bikini seems beside the point so I launch myself over the weeds naked while Lulu points to a stone and says 'swim round that' definitively. Her job, as she's undertaken it, is to make it possible for me to swim remote swims. Until this point, I hadn't appreciated that she was going to do this without getting in.

The water is soft and clean and cold and bracing. Despite the weather, this instantly becomes one of my favourite swims in Wales: the sense of discovery and remoteness is intoxicating.

Soon I'm out, towel held aloft for me by Lulu like a boxing trainer for a champ, and we're off back the way we came, up the hill, over the Roman wall, across the open moor, back past the waterfall, with a few more topples for Lulu into a bog, guppying more peat on to her bright yellow socks. We reach the car at 7pm, stripping in the deserted car park and getting into dry Ugg boots and trackies with relish. Hot chocolate has never tasted so good.

In an outdoor shop in Betswy y Loed we meet Ross, who has swum in about fifty llyns in North Wales, 90 per cent of them naked. He recommends Llyn Edno (see map ref 148), a similarly remote lake. 'It's a one and a half hour walk. You won't see anyone up there and it is hidden until you are virtually at its shore.'

Swim: Moderate. A remote and rewarding llyn found after a good hike across countryside.

Details: Llyn Morwynion is so remote you will need an OS map OL18 (SH658303). Take a left off the A470 between Dolgellau and Trawsfynydd before Bronaber. A track leads to a parking place in a forest from where it's about a 1.5 mile/90 minute walk to the llyn. There is a reservoir of the same name in this area.

For Llyn Edno there is parking available in a small layby (OS map OL17 SH631483) which is reached by taking the minor road that leaves the A498 at Bethania.

81-83. LLYN TERYN, LLYN LLYDAW AND GLASLYN: SWIMMING UP SNOWDON

The base of Snowdon is littered with lakes and the Miners' Track, Snowdon's easiest ascent, (if ascending to 1085 metres falls within your concept of easy) passes Llyn Teryn, Llyn Lllydaw and Glaslyn. All three are perfectly clear, and a startling bluey-green because of the presence of copper (hence the Miner's Track).

On our way up we work out a plan for a future visit, combining all three with a walk up Snowdon. Setting out very early, we could take a morning wash in Llyn Teryn or Llyn Llydaw on the way up to the summit with a thermos of coffee and breakfast by the banks, and then have a cooling dip and lunch by Glaslyn on the way down. The round-trip is 8 miles (about six hours' walking) and the path doesn't get truly steep till after Glaslyn.

As it is, Lulu and I visit in the afternoon and don't have time to swim in all three. A big part of wild swimming is eating. Cold water makes you ravenous, so after a morning's swimming we retire to Pete's Eats in Llanberis, a Snowdonia institution.

The café is full of happy, fit people in fleeces who were up really, really early and have already come down a mountain, strong hands wrapped around pint mugs of tea. We find ourselves sharing a table with a soft-faced climber who turns out to have swum around most of the coast of Cornwall, and leave a few hours later with a hand-drawn map of Llydaw on a napkin. ('Avoid the power station which sucks water out' it says on one side of the long thin lake; 'v safe for children' it says beside the beach opposite.)

Apparently, only the early birds will find a parking space at Pen-y-Pass at the base of the Miners' Track – but we come so late that everyone else is leaving. We put on our newly acquired gaiters in an attempt to blend in, not realising that this is the kind of sturdy path where we won't need them.

First we pass Llyn Teryn which shimmers at us, a silent, atmospheric and awe-inspiring place. It's tiny and looks good for a swim but we walk on to Llyn Llydaw, where the Miners' Track bisects the lake. The water is bright blue and exceptionally clear. It's a stunning-looking swim currently only being enjoyed by two mallard ducks. The grassy sides all around would make it easy to feel happy and free here, with the comfort of knowing that if you tired of swimming you could get out in many places and walk back to your clothes. There are big stone slabs to sit on, and rocks with quartz streaks and stripes.

Britain's pioneering cold swimmer, Lewis Gordon Pugh, trained for a swim off Antarctica at Llyn Llydaw, which he calls 'The Lake of Pain' (he started off with 'Lake Misery' but decided the view was too fine to feel truly downcast). 'It was the coldest I could find in England,' he says, 'four or five degrees in October. I used to run up to the lake first to get warm, swim, then run back down'. 'The llyn,' he says, 'appeals to adventurers: towering above you is Mount Snowdon, and about a kilometre away is a small B&B where Sir Edmund Hillary and Brigadier Sir John Hunt stayed when they did all the training for their Everest ascent.'

But we carry on, on round the bend to Glaslyn, arriving at 5.40pm. The temperature drops and it starts to rain, so we arrive with waterproof trousers flapping in the wind. Two people are setting up a wild camp.

The water of Glaslyn is an extraordinary colour even in cloud cover, slipping between aqua, Arctic blue and the emerald green of a box of paints. It's a compelling invitation to swim.

Lulu adopts her North Wales swimming position, hunkered down by an old brick building for shelter from rain, and I get in. It's so cold it feels like I've clamped a neck brace made of ice to my throat. I fwaw fwaw fwaw into the centre. The water riffles look like they're on fast forward, as if giant shoals of fish were dashing about under water. I'm so entranced that it's not until I turn and choke on a windblown mouthful of water that I realise that the return journey will be swimming right into the wind. Coughing hard and slightly panicked, I swim to the bank to walk back instead. Lulu keeps spirits high, running towards me, beach towel held aloft – 'Well done, Rewy!' My skin is the bright red-orange mottled colour I haven't seen since double hockey in the sleet at school.

We walk back, euphoric, with our hearts set on finding a drying room. The light changes so quickly on the return journey it feels a bit trippy, foreground and background snapping in and our of colour palates and focus. Rock lichen is so yellow it's almost neon and the mountain tops look purple above, their velvety sides carrying British racing green veins along streams. The walk goes on just that bit too long. We spot a hydroelectric pipe that runs from Llydaw into the valley: 'Don't you wish we could just slide down it?' says Lulu.

From the top of Snowdon it's also possible to walk down the Watkin Path. 'About 20 minutes from the bottom there's a lovely waterfall and a little jacuzzi pool so cold it'll drive your testicles into your throat,' says local swimmer Ross.

Swim: Easy to moderate. Three surreally, aqua-blue lakes on the Miner's track up to Snowdon, which could be swum individually or together as part of a longer day.

Details: Take an OS map, walking boots, provisions and good outdoor gear – temperatures drop as you climb, weather changes rapidly and these lakes are cold. The car park at Pen-y-Pass fills up early. Another option is to park at Nant Peris Picnic Area car park and catch the bus to the Pen-y-Pass Youth Hostel. The Miners' Track is pretty level until Llyn Llydaw, then starts to rise steadily, not getting really steep until it has rounded Glaslyn.

Pete's Eats in Llanberis (www.petes-eats.co.uk) has post-swimming hunger-sized portions completely sorted, with giant cooked breakfasts, spaghetti bolognaise and homemade veggie curries and brown rice for five pounds. It's a place that is made for people to smile, swap stories and chat, with pictures of climbers dangling from overhangs and ascending glaciers in crampons adorning the walls. There's a map room upstairs that now has 400 laminated maps where you can go in search of more big wet places to swim.

84-86. LOCH NESS, LOCH OICH AND LOCH LOCHY: THE GREAT GLEN

It's a bright, crisp autumn morning as Dom, Kari and I stand on the banks of Loch Ness putting on wetsuits, booties and gloves. The sky is blue, and the dark water is in sharp contrast to the trees ablaze on the far shore: yellow and green by the water, rising to oranges and reds on the hills.

We stand at the water's edge of the pine forest primed to experience the first mass sighting of the Loch Ness Monster since 1961, when 30 hotel visitors saw a pair of humps break the surface and travel for about half a mile without submerging. We're keen to identify the wave pattern against the sharp stones on the shore as 'unusual', but that seems unlikely so Kari fashions a Nessie out of a tree, moss and bracken and carries that into the water with us instead.

Today we are swimming in each of the three lochs of the Great Glen, the 60 mile long rift valley that runs from Scotland's east to west shore and is home to the long narrow forms of Loch Ness, Loch Oich and Loch Lochy.

We run a sweepstake on the temperatures of the three lochs as we enter. The Great Glen can be cycled in a day in the summer, with refreshing, not-wetsuit-required swims along the way. But this is the season where grouse are fattening and clouds of mist hover over grass before the sun falls; where stags roar at night as dead thistles grow silvery with frost. Water temperatures are rapidly dropping. A cold trickle of water makes its way down my breastbone. We guess temperatures from 9 to 13°c, with the lochs becoming warmer as we move west.

The water is black as space. In our wetsuits we are weightless, and bob about doing somersaults like aquatic astronauts. Swimming's ability to restore the magic to over-familiar landscapes works again here: Scotland becomes epic now we're actually in it. Roads, cars and people have dematerialised. We abandon Nessie to the depths and head out like great explorers, breaststroking together towards the horizon. To our surprise the loch tastes of salt.

We swim around a moss-coloured rock, all the time staying close to the shore (we're in colder water than we're used to and don't know how our bodies will respond, even in wetsuits) and get out an hour later feeling invigorated and alive. Kari and I dress in alpine hats, thermals, ski gloves and down jackets, sipping hot chocolate while looking fondly back at Loch Ness. Our new wetsuits, boots and gloves have worked – the thermometer tells us that it's 9.5°c.

After a pub lunch by a fire at Fort Augustus we move on to Loch Oich, a small loch that – currently deserted – looks both wild and approachable. We know we haven't got much daylight left so we go for a quick crossing.

We select a bright orange tree on the opposite bank – easy to keep track of – and head for that. It's a wonderful swim: yellow leaves hang suspended in the black water, illuminated by sunshine. The loch is flat and empty so we feel safe. We stroke out in a smooth, rhythmic front crawl: seven minutes to the bank opposite, seven minutes back. Every now and then we come across a straight line of fallen leaves on the surface blown into formation by the wind. We get back in the car and set off for our final swim of the day: Loch Lochy, which empties the water that started at the North Sea, gathering Highland rivers and rain en route, into the Atlantic.

Loch Ness was a playful swim; Loch Oich a

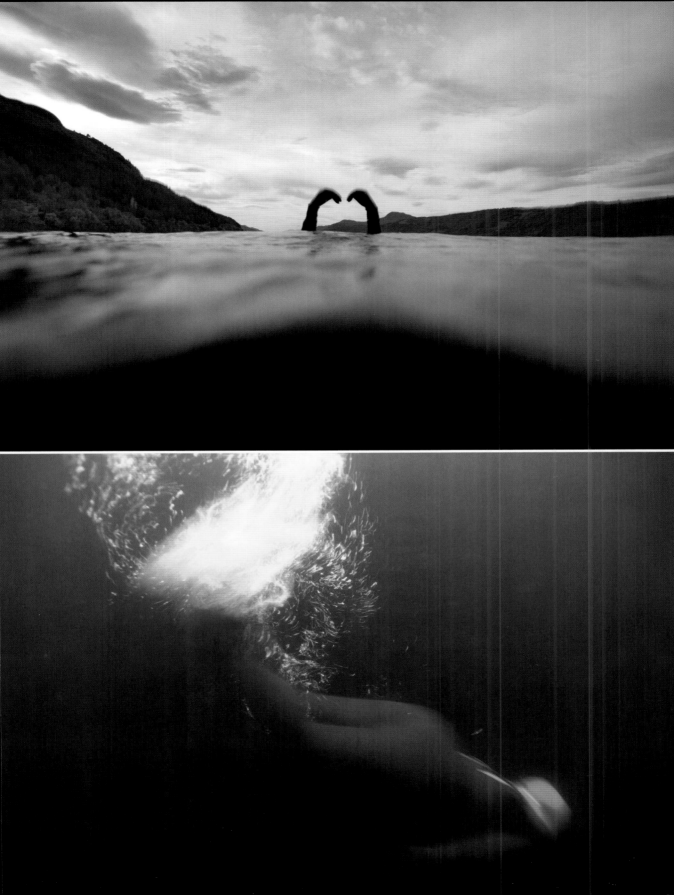

short, wild crossing; Loch Lochy is different again – surreal and stilling.

The loch has corrugated sides with hidden bays to discover, and the landscape seems richer and softer: felted hills and pillowy forests. We park in a pine wood and walk down to the shore. Up close nothing seems quite as it should be. A brown frog the size of half a thumb is making its way down to water from the car park – an improbable distance – and the forest floor is so dry it seems unlikely to make it. Three acid yellow mushrooms nestle in the moss. Every few minutes a fish leaps out of the water.

We reach the shore, and a few hundred metres across the bay there appears to be a mangrove swamp: a waterlogged forest of black, truncated tree stumps.

We spread our clothes on rocks for later, throw our towels high into the trees to sway and dry in the breeze and swim across. There is grass under the water, and we can see the submerged perfect three-pronged prints of large wading birds. Every now and then we hear the slap of another jumping fish.

The sky turns pink and a cloud like a giant tadpole snags on a mountain. We get out and wade about on the shoreline with towels wrapped over shoulders, looking at the untouched footprints and blackened trees under the clear water, unable to deduce how everything got here. It's stilling, calming, transfixing. We drive away as the light is fading, heading off to the Isle of Skye, our next swim destination. Elegant birches with silver trunks and yellow leaves pick up the last of the light. In the dark the lochs shine like tin foil.

The temperatures on our visit were 9.5°c, 10°c and 11°c: Dom won the sweepstake.

Swim: Moderate to advanced. A swim across

Scotland in three beautiful, contrasting lochs.

Details: *We drove along Loch Ness on the B862, which gives greater access to the lake than the opposite shore and got in opposite Castle Urquart, where we were advised there was good shallow access. Invergarry or Laggan Locks would be a good base for (a walk and) a swim at Loch Oich and at Loch Lochy. The Great Glen Way is a footpath linking all the lochs (73 miles) and you could cycle and swim them all in an active day. There are shallow entry and exit points along their shore; temperature, not access, will be the issue with children.*

87. MALHAM TARN, YORKSHIRE

This tarn could easily be made part of the 'classic' eight mile walk that takes in all three of Malham's charms. Malham Cove and Gordale Scar, are both 'impressive' limestone cliffs, and Janet's Foss, 'a gem of a waterfall'. Dom, Michael and I just went there because Michael saw blue on the map and said it was 'quite clearly a big wet place that, in the spirit of the weekend, has to be investigated'.

We arrive in a grey, flat light, wind shooting across the water's surface and blowing right through our jeans. It's the end of a long day's swimming in cold water and I am by now wearing all of the boys' jumpers on top of my own, as well as an anorak, hoodie and hat. We stand there, us and the grass growing damp with drizzle. It's a condition of this book that each swim is swum, but there's a general sense of refusal.

Then Dom is off – stripping down to his trunks and bounding, as much as the sharp stones allow, into the grey-brown water. Michael and I are now off the hook, and yet... 'Have you got the feeling we're missing out?' asks Michael. So we strip off too (not as instant as it may sound when wearing six over-the-head layers) and the three of us head out together towards the centre of the lake, chins upwards to avoid the wind slapping waves into our faces.

Once we're in, the water is surprisingly warm, perhaps because it's a shallow lake (the average depth is approximately 8 feet). Yorkshire looks gratifyingly wild from the water: the top of the open moorland obscured by grey cloud, a forest on the bank, a small stone boat house. It's a lovely swim.

We get out and hurry back to the car dreaming of tea...and then down the wet tarmac we see a white and red snack van has pulled in next to the cattle grid and put his hatch up. Crisps and big polystyrene cups of tea later we're on our way back to London, warmer than when we began.

Swim: Easy. A slice of Yorkshire wildness, promising for picnics and paddling on sunny days.

Details: It is possible to access the tarn from many points along the shore. One option is to park at 'Street Gate' (SD904656), about 2 miles north of Malham, where there is adequate parking on the grass. Head west back along the road and take the first track on your right. This leads you to the shores of the tarn. There are lots of good walks in the area.

88. PICKMERE, CHESHIRE

There's a No Swimming sign when we arrive on the banks of Pickmere, towels in hand. 'Danger: Deep water' it says. 'No bathing, no paddling'.

At one point there were No Swimming signs on the banks of all the most popular wild swimming spots in the UK and even today all the best triathlons take place next to forbidding notices, with hundreds of bionic swimmers filing past 'Danger: Deep water' with line drawings of people in aquatic peril. It's hard to know what the signs mean. Is it 'Leave now! You are trespassing and have no right to swim in this private water'? Is it 'We'd really rather you didn't swim here – the fishermen don't like it/we think outdoor swimmers are crazy people/we fear getting sued?' Or is it 'No swimming. It's dangerous and you might drown?'

The sign at Pickmere, a popular local lake, is apparently of the 'No Swimming, because we'd rather you didn't' kind. The 'Hatchmere Campaign' (Hatchmere is a local lake that had access issues of its own, see Hatchmere Lake) challenged Pickmere Parish Council, who apparently admitted they have no legal basis on which to enforce it. But the sign remains, and local swimmers walk past it, right to their little rope and wood swing on the shoreline.

The lake is big and blowy when we arrive. Some gulls are drinking on the wing and a heap of ducks and geese are sheltering under the boughs of a tree. Look the right way and you could imagine Mr Darcy galloping across the open meadow; look the wrong way and a few mock-Tudor houses threaten to ruin it. There are walking paths along its edge, and signs helping visitors identify pike, bream, rowan and cowslip.

The beach is slightly boggy and covered in goose feathers, as lake beaches can be, but it's a beach nonetheless. 'It's a great swim any time during the summer,' says Yacov Lev from RALSA. 'Many people prefer it to nearby Hatchmere because there is more space along the shore, many entry points to the water, clearer water and no conflict with local fishermen.' Like Hatchmere, it is probably a local, rather than destination, swim.

Swim: Easy to moderate. A locally popular swim in the Cheshire countryside.

Details: Pickmere is on the B3591 north east of Northwich, south west of Knutsford (nearest railway station: Knutsford; nearest tram stop: Altrincham). You need to go through Pickmere village to get to the mere. There is parking and there are cycle racks in Mere Lane, which is near the shore. Entering the water is only allowed from land owned by the parish council or a public footpath which runs along the shore (not through private farming land). Be aware of power boats and water skiers who may come close to the shore. RALSA has been informed that skiing is not allowed before 10am on any day except Thursday.

89. SERPENTINE LIDO, LONDON

The Serpentine Lido, a 100 metre swimming area marked out in the lake in the centre of Hyde Park, is one of London's finest surprises: there's something so lovely about bobbing around in the city surrounded by 4000 trees and a clear view of high-rise buildings that it can make even jaded urbanites want to rush out and buy 'I ❤ London' T-shirts.

The lido is open during the summer, when a few pounds will buy you one of London's top days out: a stripy deckchair parked on the tarmac 'beach' or the grassy area above to sunbathe on between dips. The water is green and when the sun comes out it can look as thick as pea soup, with floating algae collecting in your costume as you swim. It is worth remembering that this is water's natural state: green (plants have been keeping water clean far longer than chlorine).

Many first-timers start out terrified of its colour and the 'centuries of goose crap' that may lie beneath, but leave converted by the silkiness of fresh water. 'The fact that it isn't a chemical experience definitely gives it a bit of an uplift,' said one swimmer after his inaugural dip.

'It's completely clean,' says Alan Titmus, Secretary of the Serpentine Swimming Club. 'It's healthier than a lot of beaches. It just looks dirty. The Environment Agency check it daily throughout the summer and they've never had to shut it.' The water apparently comes from an artesian well near the Italian gardens (the original stream from Hampstead got too dirty). 'There are pike in there, and crayfish – and they'll only survive in clean water.'

While the lido is only open during the summer, keen swimmers can swim all year around between 6.30am and 9.30am by joining the Serpentine Swimming Club which has the run of the swimming area (save a few moorhens) 365 days of the year. Membership is £20 a year (including communal tea, coffee and biscuits).

Club members share a tiny windowless changing room full of damp towels and bonhomie. The done thing is to continue your happy chat, averting your gaze from others' bare bottoms. There is a cold shower on the banks (no shampoos or shower gel allowed as the water runs straight back into the lake).

And after a good swim you can always pop next door to the Lido café for scrambled eggs and coffee, or a cooling ice cream.

Swim: Easy. A lake swim in the heart of London.

Details: The nearest tube station is Knightsbridge. There is a car park by the Lido (www.serpentinelido.com) See also The London Lidothon (page 117) www.serpentineswimmingclub.com

90. STICKLE TARN AND OTHER TARNS, LAKE DISTRICT, CUMBRIA

After staying a night at the classic walker's pub The Old Dungeon Gyhll (in Great Langdale) Kari and I head out early for a breathtaking dip in nearby Stickle Tarn. The old school hotel is attached to the Hiker's Bar, cherished by walkers for its giant hearth and flagstone floor, perfect for muddy walking boots and seized-up calves to tramp over. It has an easy charm, and proves a good place to drink bitter, eat chips and rest up (still in full outdoor clothes) before bed.

Kari has swum in Stickle Tarn before so 'knows the way' and we set off map-less, waterproof-less and provision-less for an 'about 40 minute' walk with the sun breaking through mountain-top clouds, planning to make it back in time for breakfast. We start by

a river, the climb littered with fallen rocks and a fallen sheep, its back broken at an unnatural angle. Crow caws and the moos of a few cows echo off the mountain.

Then the clouds lower and wind blows in mist and sheets of fog. Our clothes grow damp and bright green lichen on rocks by our feet becomes the most distinct thing in our vision. We walk on, following clear tracks but with no clear idea where we are going – 'this way', 'no this way'.

This goes on for two and a half hours. Eventually the wind blows the fog apart for long enough for us to see two other walkers, whom we sprint after so we can look at their map.

Soon visions of ourselves being branded money-wasting life-endangering idiots by mountain rescue recede and we're looking down on the small dark shape of Stickle Tarn

instead, the shore surrounded by sharp grey scree stones.

It's perhaps not the prettiest tarn in the Lakes, but its location by the pub and Scafell Pike make it perfect for a dip. I swim across and get out to the applause of four student walkers sat on a wall relacing their boots. A lovely venture; particularly, I imagine, if we had made it up and back in time for breakfast.

There is nothing to stop the keen walker and swimmer dipping into tarns all over Cumbria. Local swimmer John Hunston recommends all the higher tarns, such as Styhead, Sprinkling and Angle Tarns. 'It is perfectly feasible to do all three in a day,' he says. 'Bowscale Tarn is also a favourite (see map refs 149-152). It's less of a walk but in a relatively quiet area "back o' Skiddaw", and it seems to warm up quite quickly.' Bowscale is reputed to contain a pair of immortal fish, which Wordsworth refers to in his poem, 'Song at the Feast of Brougham Castle': 'And both the undying fish that swim/Through Bowscale Tarn did wait on him/The pair were servants of his eye/In their immortality/And glancing, gleaming, dark or bright/Moved to and fro, for his delight'.

When exploring tarns, be aware that some can be muddy. 'My most idiotic swim was breaking the skim ice on a shallow tarn at 2000 feet on Raven Crag in the Lake District in winter, and dipping there,' says Robert Macfarlane. 'The guy I was with, Mike Brown, had summitted Everest three times, so was familiar with discomfort. But it turned out not to be the cold that was the problem (though naturally it was exceedingly cold), but the 5 feet of soft dark mud-sludge that the tarn had concocted on its bottom, and that had been undisturbed since, presumably, the last Ice Age. We pelted in, and the sludge rose up around us, coating our skins, and releasing gouts of vile

methanous gas. If you'd lit the air above the tarn, it would have burnt, there was that much gas coming off. We went in fancying ourselves to be water babies, but hauled ourselves out looking like mudlarks, and stinking like sewer rats.'

Swim: Easy to moderate. A great place for a hike and dip in the heart of Langdale.

Details: *There's a National Trust car park beside The Old Dungeon Ghyll (NY 286060), from which the path up to Stickle Tarn follows a large, built path just behind the pub, which starts on the left bank but crosses soon to the right bank of the gill (or river) and climbs steeply up to the tarn. For other tarns see Windermere page 151.*

91. WASTWATER, LAKE DISTRICT, CUMBRIA

At some point all swimmers experience deep water fear. One moment you're swimming along, thinking of ice creams, and then the next a voice in your head is screaming 'WHAT IS DOWN THERE?' From the banks you can see it, a swimmer's steady progress broken as they get spooked and scuttle away from invisible objects, or do an about turn and thrash back to shore.

Swimmers develop all sorts of rituals to cope with deep water fear. I sometimes focus on a point about 12 inches from my nose, which seems to limit the imagination to that aquatic area. Counting strokes also helps – a loud and insistent 1 to 20 can drown out most thoughts. Whatever your method it's wise to have one before swimming in Wastwater as, at 258 feet it's the deepest lake in England.

Kari and I swim in Wastwater on our first autumn trip. We drive along the single track road as it winds past grassy knolls and over cattle grids to a dead end. The morning's heavy rains have cleared and our surroundings are rugged. A scree slope drops directly into the water on the east side of the lake and the highest mountains in England, including Scafell Pike, inspire awe around it. In contrast to the bright oranges and reds of the hills around, the water is black – a sign of its cleanliness and depth, because there is nothing for light to bounce off.

We chat to two men putting on dry suits and talking about the scuba-divers' gnome park on the bottom of the lake and then park by a fine shingle beach and walk past five shaggy sheep with tubby knees that, for sheep, seem unusually relaxed. We wade in just as the sun comes out and reaches the beach beside me. The water is decorated with white caps and we swim towards the scree slope on the other side. It's a joy to set off across boat-free lakes: you don't have to look out for vehicles. Water generally has a taste and a smell but here we register nothing – it's that clean and pure. Then I kick a twig and get spooked: what *is* down there? I try Kari's 'feel the fear and do it anyway' approach: duck dive and swim back up with eyes on the surface. From above the black was impenetrable but underwater I can see shafts of light illuminating it green. A multitude of small waves slosh against each other on the surface, and bubbles trace my finger tips as I pull back up towards it.

We reach the halfway point and stop and look around: 360° of water, mountains and rocks. We can't see a car, a road, a pylon, a path or even a walker. I cannot think of a better way to experience the remoteness of Wastwater. Wild, remote and epic in scope, Wastwater is, for us, the Lake District's prize. We swim fast back to shore, our heads down in front crawl. The sudden appearance of sediment-covered rocks and fallen leaves still yellow under the water announces the shore.

As we step out, everything has snapped back into focus. The greens look greener, the oranges and reds more acute. As if, while we were out in the water, someone coloured the landscape in. The air smells of pine and distant bonfires.

Swim: Moderate. The wildest and deepest lake in the Lake District.

Details: Wastwater is 5km long and about 600m wide. A single track dead end road runs along the lake's western shore from Nether Wasdale. The Bridge Inn, Stanton Bridge holds a 'Biggest Liar in the World' competition every November – a good place, perhaps, to tell people that deep water doesn't scare you. At all. Ever.

92-94. WINDERMERE, LAKE DISTRICT, CUMBRIA

Lakes are often the home of legends, their placid surfaces stirring up fears of strange beasts beneath. In the 1900s a Windermere boatman told tourists stories about 'Tizzie Wizzie', a winged hedgehog-like creature on the banks, and it inspired many sightings. Over the last century the monster appears to have submerged and mutated: Windermere's 'monster' is now something large and slippery, more like Nessie (see page 138, The Great Glen).

In 2005, Dom set off to Windermere to photograph an expedition to find the monster by a bunch of cryptozoologists from the Centre for Fortean Zoology. Their previous missions had been unsuccessful – they had failed to find the death worm of Mongolia ('perhaps just as well,' says Dom, 'as one glance over a crowded desert and that's apparently it for you') and had no luck tracking Bigfoot or the yeti.

'They had decided to change direction from mythical animals that certainly don't exist to strange creatures that might,' says Dom. 'We weren't sure exactly what we were looking for but they had heard reports of people seeing "something" – enough to warrant headlines in a local paper about the "Monster of Windermere".

'We met in a B&B to spend a weekend looking. There were lots of plans that got changed, but the first change was that it quickly transpired that you had to have special permission to scuba dive in Windermere, so they decided to look for the monster of Windermere in Coniston Water instead (see map ref 153).

'We bought a whole load of fish from Morrisons, some strange gunk which is supposed to attract big fish, and with the help of a local diver bundled it up in hessian sacks and put it in a rocky outcrop where eels might appear. The diver had seen eels around there and we were hoping to find an unusually large one.

'When we returned three or four hours later the sun had set and the diver went down with a borrowed underwater camera, and there was a long, long wait as we watched his light move around in the dark water. There were occasional camera flashes now and then and it all got quite exciting. Then he surfaced and we all said, "What did you see?" "I couldn't find the sacks," he said. He hadn't seen any eels either and he'd just been taking pictures by accident.

'One of the most bizarre things was that this result was taken positively by the cryptozoologists: "At least we haven't disproved it!" they reasoned. Someone even pointed out that the sacks might have been carried off, perhaps by the very creature we were seeking. We did see one eel that weekend but we had to go to the Aquarium of the Lakes to find it. Far from being monstrous in size or demeanour it took fright at the uncommon attention we gave it and hid away in its fibreglass "lake-bed", eyeing us with blank suspicion and refusing to emerge for photos.'

Monster or no monster, Windermere is a popular swimming lake, with two beaches that draw crowds of picnicking families over summer: Miller Ground Landing and Red Nab. This 'ribbon' lake was formed by glaciers bulldozing down a valley and is the largest natural lake in England, 10.5 miles long and a mile deep. It's surrounded by the wild fells, forested banks, bracken and peaks that make the Lake District so popular. 'None of the other Lakes unfold so many fresh beauties,' said Wordsworth, a sentiment that has, in fact, led

to Windermere being slightly less fresh than the others because it's the one we've all heard of – and the cruisers, ferries, gin palaces and tourist infrastructure have moved in.

For family days, the beaches above are a joy, but for me the best times to swim in Windermere are when it's pelting down with rain or in the very early morning. It rains a lot in the Lake District, so luckily there are plenty of opportunities to enjoy a drenching from the water. I swam there one summer with friends Vicky and Emma, when it was bucketing so hard not even the walkers were out. Our male companions went shopping (for anoraks) and then moved into a flash hotel for a sauna and spa, while we picked our way up the swollen banks in wetsuits and bare feet, rain streaming down our faces and mud squeezing between our toes.

We walk from 'The Brows' to Grubbins Point, Emma outwardly contemplating whether my swimming fixations are going to migrate to the Caribbean anytime soon, and inwardly, I've no doubt, experiencing enjoyment. We step off the stony outcrop at Grubbins Point, swimming past Silver Holme Island and back to base, staying close to the bank. It rains the whole way (about 2 kilometres), the force of the percussion on our bodies varying as we go.

It's a swim I've repeated a number of times, sometimes with a group, sometimes actually in sunshine.

Early morning swims win points for different reasons. Lakes seem particularly timeless in the early morning. At Windermere, there is less boat traffic at the southern end of the lake (but still a few criss-crossing ferries and pleasure cruisers) and even less at dawn, making it safer for the vigilant, experienced groups of swimmers in brightly coloured hats to make their crossings.

I swim one narrow section from YMCA South campsite on a summer morning with four new-found swimming friends. Fresh out of our tents, it takes 40 minutes, the water fresh on our faces and a gentle mist on the hills. There is a 6 to 10mph speed limit for boats but few boat owners even think of looking for people in the water so the vigilance may be all on your side. Stay close to the shore unless you have boat cover. Winds here can whip up waves in the middle of the lake and make it less approachable. (Note that 'mere' means 'lake', making 'Lake Windermere' a tautology.) The lake can reach temperatures of 20°c to 22°c in summer (quite warm!).

Swim: Easy to advanced, depending on distance. A great place for family swims, long swims, early morning swims – and to experience a downpour while in the water.

Details: Windermere town has a railway station but the nearest station to the YMCA Lakeside and southern end of the lake is Grange-over-Sands. Windermere is on the A591 from Kendal to Keswick.

Grasmere, Rydal Water and Easedale Tarn (see map refs 154-156) lie to the north of Windermere, and all three bodies of water have central islands where swimmers can rest on a crossing. Simon Murie describes them as 'picturesque as any spot that you are likely to find in the lakes' and includes them on SwimTrek's 'Lakes Weekender'. Grasmere is a 2.5km crossing, Rydal Water 1.5km and Easedale Tarn 1km.

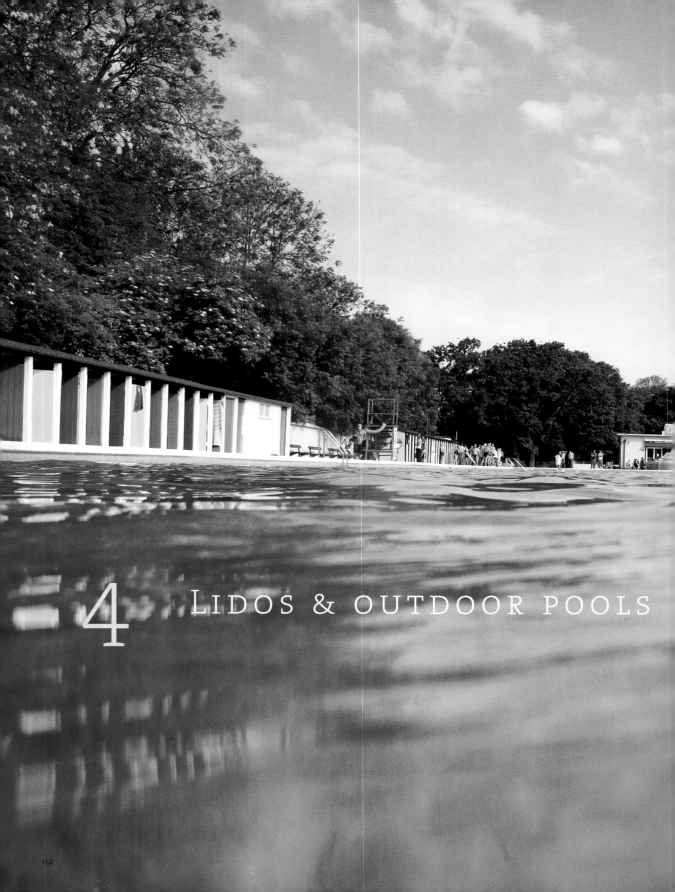

4 LIDOS & OUTDOOR POOLS

There's an expansiveness to public outdoor pools rarely seen elsewhere: lidos are places of goosebumps, coincidental friendships, shared habits and smiles. People move to be near to their lidos. You needn't go often to become part of a lido's community; just a few trips and there'll be a nod, an upward tip of the chin in recognition, a 'hi' from the lifeguard. Swimmers understand something very fundamental about each other, which is why one can often see deep mutual fondness in people's eyes, just behind the sheen of their goggles. The bond cuts across age, gender, politics, personalities and class: you share the same routine or passion.

For first-timers at unheated pools the chill can come as a shock, but generally all it takes is a few dips for the sensation to be relished: the cooler water is invigorating, rejuvenating, something that makes you feel alive. Water needs no roof! In an outdoor pool you can breath open air, get pounded by rain, feel the warmth of the sun or watch clouds roll by. In outdoor pools there is mist, sunrise, a midday sun, the chance to be the first person to leave footsteps across dry paving stones, dew or ice. There are the sounds of birds, trees, and shouts of children – all happily floating up to the sky, not bouncing back from hard walls.

There is less chlorine in outdoor pools and some are filled with natural water from nearby rivers or the sea. These pools seem to encourage the rest of nature to join in, with swallows nesting in changing rooms and dive bombing 'morning dippers', or the tides flipping a few fish and crabs into the water.

The safety and accessibility of lidos, and the availability of hot showers, make them fertile ground for winter swimming addictions. Often only a few months or years pass between screaming 'It's cold!' and forming the desire to swim all year round. Winter swimmers become addicted to the high of cold water – that moment when the body triumphs over cold in a searing rush. It's hard to think of many things one can immerse oneself in and emerge minutes later feeling so complete, euphoric and alive.

This section contains a random selection of outdoor pools around Britain, from elegant 1930s lidos to new community pools. They're all worth a visit, but since location is generally key to selecting a lido to visit, there's also a directory of every lido and outdoor pool in the country at the back of the book. Lucky are the people who have a local lido that they can make part of their daily routine.

Jubilee Pool, Penzance.
Previous page: Tooting Bec Lido, London

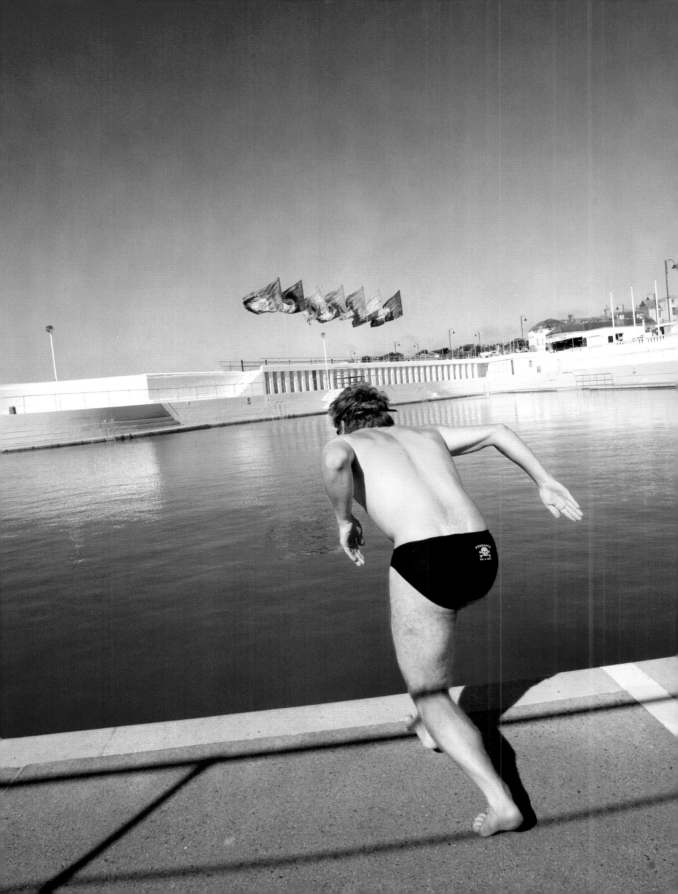

95. BUDE SEA POOL, BUDE, CORNWALL

Bude Sea Pool is as much wild swim as lido, with a steep black cliff on one edge, a rocky base and a tide that sweeps right over it and laps up against the lifeguards' huts 20 days of the month. The swell brings in fish, sand and surfers. Seagulls squawk overhead and the 'Sea Pool Lifeguard', in red shorts and a red vest, job title in yellow, wages a daily battle against seaweed with his broom. A solitary lane divider is used to keep swimmers away from falling rocks rather than marshal them into swimming order.

The sunbathing area around the pool gives a clear view of the surf that swimmers seek refuge from, and the 'No Diving' sign is there to be obeyed – the daily swell moves sand bars around in the pool, sometimes just a few feet under the cloudy sea water.

When Bude gets an attack of weaver fish, which bury themselves under sand on the shoreline and cause painful stings, the pool is inundated with swimmers at low tide, but early in the morning you can be the only one in the water. A rising tide is a special time to swim – the Atlantic lapping and slapping against the pool edge.

Bude Sea Pool was almost shut a couple of years ago, but a vigorous local campaign saved the day. 'We have four generations of the same families coming down here. It's part of Bude and people love it.' Thanks to them, the pool remains free to all swimmers.

The pool is 88 metres long and 50 metres deep, with an irregular shape – a big breezy pleasure to swim in. 'We tell people it's "solar-heated",' jokes Mini the lifeguard, 'but the sun only penetrates about 4cm, so it never gets hotter than 17 to 18 degrees.'

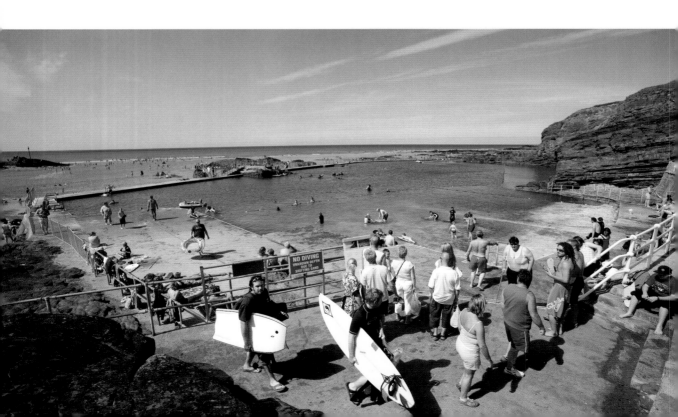

Swim: Easy. As much tidal pool as lido, with sand banks at its base and cliff on one side. A breezy pleasure to swim in.

Details: Bude Sea Pool, Summerleaze Beach, Bude, Devon. Tel: 01208 262822. See the North Cornwall District Council website (www.ncdc.gov.uk) under Leisure and Sport/Bude Sea Pool.

96. CHAGFORD SWIMMING POOL, DEVON

This 30 metre by 13 metre pool on the edge of Dartmoor can't be that far from Heaven. Swallows nest in the changing room and divebomb the swimmers, and tea is ever present in 'Chagford Swimming Pool' mugs. With the sound of the river Teign running past stepping stones and the sun-warmed decking inviting a long afternoon lie-down, it's as relaxed as a swimming pool gets.

We arrive in the late afternoon. The pool looks like a faded David Hockney, wavy white lines stretched over its surface like a distorted fishing net. Big oaks with acorns rustle in the summer breeze above a man who lies reading. There's a shelf of second-hand books outside the changing room ('Pay Pam or the lifeguards' says a handwritten sign – Pam has run the teashop for 30 years and her father was among those who first dug the pool) and we sit swinging our legs on the raised decking. Children are experts at swinging – out of trees, in playground parks – but it's not often adults get a seat tall enough to reconnect with the art.

The pool is riverfed, and the Teign water feels wonderfully soft. It's topped up when it evaporates. It's lovely swimming, with a dolphin painted on the pool base and it feels just as appropriate to meander around as to get busy with laps.

The pool was originally dug out by locals in 1934 to stop children in the river disturbing the fishing. (A black and white postcard depicts hundreds of people in dresses and cricket whites watching an opening race.) For years the leat (a channel that provides water to a watermill) was blocked so the river literally spilled over into the pool, and the mud bottom had newts nesting in it.

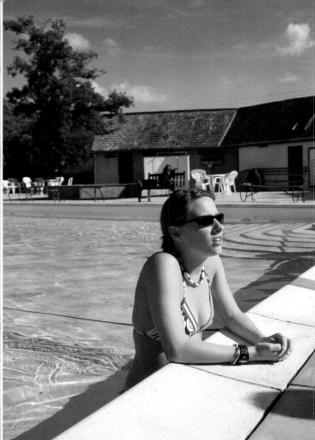

The pool was given in trust to the people of Chagford in a will, but reverts to farm land if it goes unused for a year. So far this has never happened and, in 2000, locals raised £180,000 to meet new health and safety requirements. The amount of local love that has gone into this pool may explain why it leaves the swimmer with such a sense of allrightness.

The pool now attracts people from Exeter, Tavistock and the south coast. It's just a few minutes from the A30 that runs from Exeter to Launceston and well worth a detour on your way down; if it makes you late for your final destination you can always blame the West Country traffic.

Swim: Easy. An idyllic riverfed village pool on the edge of Dartmoor, where swallows divebomb the water.

Details: *Chagford Swimming Pool, Chagford. Tel: 01647 432929 www.roundash.com/pool.htm*

97. ILKLEY LIDO, YORKSHIRE

Part of the charm of a lido can be the contrast between the pool and its wild surroundings – the juxtaposition of a bright blue square of pool water and the rough grey sea at Gourock, the unruly swell of the English Channel set against the neat art deco lines of Tinside. The contrast between safe and dangerous, groomed and feral, somehow enhances our appreciation of each.

Sometimes the contrast is just between the wildness of the weather and the neatness of a pool. Some of my favourite swims at my local lido, on Parliament Hill, are when the rain pelts and batters the water, drumming on the surface, shattering the calm, bouncing up in reverse droplets as swimmers nose along. Nature can give you all it has when you're in an outdoor pool, and you're safe to enjoy it. (The exception to this is lightning. Lifeguards marshal a speedy exit from pools at the first clap of thunder.)

At Ilkley the juxtaposition is between a mushroom-shaped play pool and the weathered, windswept rocks of the Yorkshire Moors. The looming shape of Ilkley Moor and the greyness of a Yorkshire town seems to have encouraged a profusion of primary-coloured plastic around the pool. With yellow plastic steps, red markers, lane dividers, a mishmash of signage, a consistent aesthetic is clearly not the owners' top priority. There are at least two types of hedge (fir, privet), many different floorings (grass, pebble, paving) and there's a wooden café serving burgers at the back of an old cricket pavilion.

But none of this matters when in the water. Swim lengths and your eye will come back again and again to Ilkley Moor, huge and powerful beside you. And on hot days happy families obscure the mismatched signs and the noticeboards: 2000 people a day come to swim here.

The wild swimmer won't, however, enjoy Yorkshire's wild weather here. The pool shuts in bad weather, so ring ahead to check.

Swim: Easy. A lively, colourful lido on the edge of the Yorkshire moors.

Details: Ilkley Pool and Lido, Denton Road, Ilkley LS29 0BD. Tel: 01943 600453 www.ilkley.yorks.com/ilkley-pool.html

98. JESUS GREEN POOL, CAMBRIDGE

It seems almost obligatory for lidos to have a record (biggest, longest, deepest, largest, coldest). Jesus Green claims to be the longest (92.5 metres) beating Tooting Bec ('the largest') by a metre. Aldershot claims to have the biggest volume (1.5 million gallons) but the lifeguards at Jubilee contest that claim. Chudleigh is the newest (built 1997), if you discount London Fields (reopened 2006). Hilsea's the deepest (15 feet), until Broomhill is saved, anyway. The most northerly (Stonehaven), the most popular (Finchley – 11,972 visitors on one hot 1971 day) – the claims seem endless. But every lido in Britain has one undisputed best: the (b)est lido in the world to its locals.

Jesus Green – a long, narrow pool – is a delight. The engineers here have spread the gallons out lengthwise so swimming here is an unbroken joy. It's surrounded by the calming presence of trees, with sycamore leaves floating in the turquoise water and the rustle of elms, firs and plum trees.

In hot summers you can't see the paving slabs for people, but when we visit it's quiet. A girl is inspecting the wrinkles in her fingers at one end and Mike Ashby, a regular, is drying his feet on a bench at the other. 'I come every day, twice a day sometimes,' he says. 'It just makes you feel so good,' he says, 'Cold water's refreshing.'

Spiders have spun cobwebs between the changing room doors in the quiet and they sparkle in the sunshine. I have a good swim and then change in the open air changing block, birds singing overhead and the breeze joining in on the drying-off process. For once I am free to enjoy the elements without the need for a towel dance.

Swim: Easy. A long, narrow lido in the heart of Cambridge, surrounded by trees.

Details: Jesus Green Outdoor Pool, Cambridge. Tel: 01223 302579. See the Cambridge City Council website (www.cambridge.gov.uk) under leisure and entertainment.

99. JUBILEE POOL, PENZANCE, CORNWALL

We arrive at Jubilee Pool on Penzance promenade at the end of a hot summer day. Men with handsome chests and strong jaws are playing water polo in old-fashioned polo bonnets, bows under chins. It's a scene straight out of the 1930s, their pastel-coloured hats and tans set against a pale pink and blue sunset and the sweeping white lines of one of the country's finest art deco lidos.

The pool, triangular but with gentle curves, was built on a traditional bathing spot on the Penzance coastline, providing a sheltered swimming and sunbathing area just metres away from ferocious Cornish seas. (It's still possible to buy sunbathing-only tickets.) Jubilee is massive (100 metres along one of its uneven, triangular sides, 73 metres on the other) with an unpainted creamy base. They abandoned the idea of painting it when they realised how many litres of paint it would take. When the pool is emptied mid-season it takes two to three days to refill with sea water.

The pool is home to a lively group of sea swimmers. We bump into the polo players later at the Yacht Inn opposite and they have a 'swim for every occasion', celebrating birthdays with night swims and getting dropped off at rocks in 'one hell of a sea' to swim back to shore. That day's Cornishman is on the bar heralding their latest achievement: a Newlyn to Penzance charity swim completed by 237 swimmers and Bilbo the dog, who beat 100 people back to shore. (Bilbo is the nation's only canine lifeguard, patrolling the beach at nearby Sennen Cove.)

Swim: Easy. One of the country's finest art deco lidos just metres away from ferocious Cornish seas.

Details: Jubilee Pool, The Promenade, Penzance, Tel: 01736 369224. Open May to September. www.jubileepool.co.uk. There is a baby pool within the main pool for children. The Poolside Café next door serves coffee, lunch and suppers.

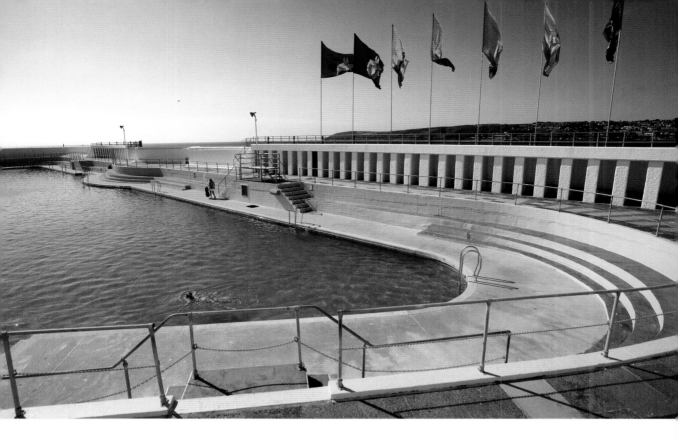

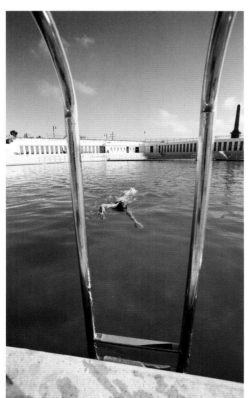

100. PELLS POOL, LEWES, SUSSEX

Pells Pool is a restful treat of a swim: an elegant 46 metres by 23 metres rectangle with mosaic tile floor, surrounded by a sturdy flint wall. It's the oldest pool in England (1860) and fed from a natural spring. The water is soft and the laps are easy; they can take 300 people in the water but 'generally don't' says the lifeguard. In fact, it's just me and Adam Smith, another day-tripper from London, when I visit.

I've never met Adam before but we say hello and get chatting. Adam's been 'getting wet' since the year 2000 with an annual 'Great Swim', setting off with friends and a minibus for a one- or two-day aquatic adventure. They've been to Cambridge, Hertfordshire, Norfolk and Berkshire and today he's checking out a swim journey to Brighton.

'I like finding places where people don't generally get in,' says Adam. 'It's about showing people that there are these places, away from chlorine-infested indoor municipal pools. It's a stand against health clubs where you have to pay £60 a month to go for a swim.' Adam also likes to show people about 'swimming as fun, not as a mechanism to tone your body, but something to enjoy just for the feeling of water, the sensual experience.'

We do laps in the surrounding calm, with tall firs on one side of the pool and the quacking of ducks somewhere out of sight. In 2000, the lease for the pool was taken by locals. We leave in convoy, so I can join him for a 'not mainstream' river swim he wants to check out on the way back to London.

Swim: Easy. This pool is fed by a natural spring and has a tree-lined bathing lawn.

Details: Pells Pool, Brook Street, Lewes BN7 2PQ. Tel: 01273 472334. www.pellspool.org.uk.

101. SALTDEAN LIDO, BRIGHTON, EAST SUSSEX

I'd heard Tracey Emin swam at Saltdean and so was expecting something quite glamorous. In photographs the lido looks like the prow of an ocean liner, elegant art deco curves dressed in pale lemon – all aboard that gaggle of Brighton media types! I imagined them chatting in sunglasses on the sundecks.

I call before leaving London to check that it's open and a few hours later pull into a puddle in a derelict-looking car park. I follow signs into an old-school weights room with a bungalow ceiling; it has a scratchy blue carpet and smells of sweat and grimace.

'The pool's closed because of poor weather,' says a smiley woman.

'Oh! I was looking forward to it! I've driven up from London.'

'Ah, it was you on the phone!' she beams. 'Come in! You can swim at your own risk. Let me show you.'

I follow her to the changing block. 'Er, out of curiosity, what happens to other people when you close?'

'Well, we tend to let parents with children in. Children don't really understand when we say it's shut.' And so, while not a child, ('But I wanna! You said!') I am allowed in.

There's no gloss or glamour here; this is everyday suburban reality, where grass sprouts between paving stones and concrete walls leak rust. The pool now sits by the A259, its elegant shape hacked in two and the letter T of 'Saltdean Lido' replaced in a different blue. Dirty fabric hangs in shreds from a pole. 'It's a "sail" to protect people from the sun,' says the attendant, 'but there isn't any this year, so we haven't put the new one up.'

The swim itself is divine: the sun comes out and dazzles from the pool's white bottom, so

I swim up and down with my eyes closed. I have come here to escape work; no one knows where I am and my phone is off. The anonymity of this rundown place is perfect. I am free from expectation. It's just me and swimming. The A259 whistles by in clear view, the endless thrum of tyres on tarmac, and to both sides 1950s houses with PVC windows and mock tudor facades look on.

The pool attendant makes me a cup of tea afterwards. So what about Tracey Emin? 'I've worked here eight years, and I've never seen her.' We chat a while, then I drive off to Pells Pool in Lewes (the previous entry), and run into another Londoner playing hookey from his life for the day.

Swim: Easy. This rundown but still elegant art deco lido in Brighton is a faded glory.

Details: Saltdean Lido, Shape Health Studios, Saltdean Park Road, Brighton BN2 8SP. Tel: 01273 888308. www.saltdean.info/lido.htm

102. SANDFORD PARKS LIDO, CHELTENHAM, GLOUCESTERSHIRE

Sandford Parks Lido (see picture above) feels almost colonial, the 50 metres by 27 metres blue pool bordered by well-pruned rose bushes and ornamental flower beds. There's a colonnaded tuck shop at the end of the pool, a large ice cream-shaped fountain at the other end, and the layout of the grounds is symmetrical and well-ordered.

I swim up and down between bright red lane markers, past the beating legs of a group of pre-pubescent girls and boys, treading water and having a chat. Small children scoot down a slide, little bodies shooting their way into the pool in a plume of bubbles.

Swim: Easy. A handsome Cotswold lido with a colonial feel.

Details: Sandford Parks Lido, Keynsham Road, Cheltenham GL53 7PU. Tel: 01242 524430 www.sandfordparkslido.org.uk

103. SHOALSTONE POOL, BRIXHAM, DEVON

This cheery, seawater pool on the English Riviera is kept alive by community spirit, with reinforcements courtesy of the Home Office. Torquay sparkles across the bay, seagulls peck at the red sea walls and ten men with nut-brown coastal tans stand in the bottom of the empty pool in hi-vis jackets doing their community service. Eight different types of handwriting mark out 'Deep End' around the pool edges. A supervisor inspects their work in the sunshine, and, rather disappointingly, decides the Hammer House of Horror version of 'Deep End' must be painted over.

Rowan Molesworth, chair of the Friends of Shoalstone Pool, has masterminded the annual recovery effort since August 2004. The council provides materials while tombolas and the local Co-op raise money for luxuries like cement mixers. Community service provides most of the labour. 'Tides bring in rocks and sand as well as the odd fish, and they bash against the walls,' he says. 'It takes its toll.'

The 30 metres by 80 metres flipper-shaped pool looks as if it would be a lovely swim if it wasn't empty. 'Early in the morning you can be alone, except for a friendly seal basking outside in the bay, but on hot days in summer the sundecks are crammed with bodies,' says Julie Bevan, vice chair of the Friends of Shoalstone. She runs the Water's Edge kiosk next to the pool, a small shack festooned with ice cream signs, crab lines and beach badminton rackets. We buy tea and pasties full of ripe cheese. 'When it's hot, Mum and I race each other to get in,' she says.

The pool was built on a natural rock pool in 1890, and converted into the lido in the 1920s – its shape determined by the rock underneath. Twice-daily tides bring water in over the wall for about ten days a month (from new moon to half moon), with the whole pool being emptied and refilled with sea water every ten days over summer (a small amount of chlorine is added to keep algae at bay).

The pool is lifeguarded between 10am and 6pm, and on summer nights hundreds of locals swim in the pool and some – like Julie and Rowan – swim every day of the year. Park at the car park on Berry Head Road and your fee will go towards subsidising the pool lifeguards. Amazingly that is the only price you'll pay – courtesy of Rowan and his bands of local workers, swimming here is totally free.

Swim: Easy. A flipper-shaped seawater pool with a view of the English Riviera that receives regular dousings at high tide.

Details: Shoalstone Pool, Berry Head Road, Brixham, Devon. Tel: 01803 851806. See Torbay Council website (www.torbay.gov.uk) under Leisure & Culture/Beaches.

104. TINSIDE LIDO, PLYMOUTH, DEVON

Opened in 1935 and described at the time as 'one of the finest open-sea bathing centres in the country,' the recently refurbished Tinside Lido (see picture on page 170) is stunning. Built in art deco style, this semicircular pool has a fountain at its centre and beach-towel stripes on the pool bottom. On scorching days the pool is packed; sit on deck chairs watching the ships in Plymouth Hoe and children hurling themselves off high diving boards into the sea.

The pool was built over a rock pool locals used to swim in, and up to 1000 people come here on good days, with ambient lighting and 10pm opening on hot summer nights. We arrive in July, a strong wind roughing up the sea and whipping at our towels, just the time when seaside-dwellers need a safe pool to swim in. The central fountain is set in a whale jet and the wind carries it across the pool, pelting onto my back like a hailstorm.

The pool is designed so that it seems natural to swim across the stripes on its bottom rather than within them – a nice counter-cultural, relaxing touch. From one side to the other feels such a long way that I could be crossing a curved ocean.

Swim: Easy. A stunning art deco lido on Plymouth Hoe.

Details: Tinside Lido, Hoe Road, Plymouth PL1 3DE. Tel: 0870 3000042. See the Plymouth City Council website (www.plymouth.gov.uk) under Leisure and Tourism/Sport and Recreation/Swimming Pools.

105-108. TOOTING BEC TO HAMPSTEAD PONDS: THE LONDON LIDOTHON

'The day was beautiful and it seemed to him that a long swim might enlarge and celebrate its beauty.' This sentiment lies at the heart of John Cheever's famous short story *The Swimmer*, and in the hearts of most swimmers.

The idea of an aquatic journey and the desire to plot 'with a cartographer's eye, that string of swimming pools, that quasi-subterranean stream that curved across the country' takes hold of swimmers some time soon after experiencing swimming as 'less a pleasure, than the resumption of a natural condition'.

Before you start outdoor swimming, water in this country can appear to be negative space. On maps we are drawn to the roads, the towns and the junctions or else the high ground and the green spaces. Outdoor swimmers look at maps in negative. All we see is lines of blue, the trace of lakes and rivers and streams and shoreline, lochs and llyns and pools and tarns, and the rest is just geographic dead space.

In June, Vicky, Dom and I decided to trace our way around London, picking off outdoor swims as we went – our ultimate day out in the capital. The previous summer, friends in Devon had attempted the same – a pool crawl, they called it, 'like a pub crawl, but with the fluid on the outside'. Setting off early, they swam in Tinside Lido, Buckfastleigh Swimming Pool and Ashburton Swimming Pool and then drove over the moors where they had a picnic and ended in Chagford Swimming Pool. 'We were planning to finish by going on to Bovey Tracey Swimming Pool and complete the tour back to Plymouth by taking in Shoalstone Pool at Brixham, but we felt soggy enough by then.'

This is what happened to Dom, Vicky and me when we attempted a similar feat around London.

Setting off

When John Cheever's character Neddy Merrill sets out on his journey home in 'The Swimmer', he has only swimming in mind. Neddy is suffocating in misery and suburbia. Swimming, it seems, is the one thing that washes all that away. He stalks water like an animal in black trunks, running barefoot across lawns and through woods, plunging into pools and doing a length of each as he journeys home.

When Dom, Vicky and I set out on our London version of the same, we have little more on our minds than the vagaries of London transport, Neddy's bather-clad sprint being replaced by tube, bus and train. It's 6.44am and we're on the platform at Kensal Rise, waiting for the first London overground train of the morning. We're wearing matching pale blue Outdoor Swimming Society sweatshirts and clutching towels. There's a rattle on the line and then the yellow, purple and green beast hoves into view. Misery and suburbia can wait: our train is on time.

Richmond Pools on the Park, 7.37am

We bypass the footbridge and run across six lanes of traffic on the A315, so keen are we to get to our first swim.

Richmond pool is part of a 1970s prefab sports centre and is half lido, half gym pool, steaming with workers getting on with their laps. It's surrounded by palm trees and pampas grass, with a heavy planting of swimming signs amongst the shrubbery. The belly of a plane looms overhead every few minutes. It's A315-on-holiday.

We swim up and down and up and down and up, which is what you do in these kinds of pools and then a woman talks to us! And there it is: half gym pool, half lido. Merrill was suffocating in the smallness of his life, the private pools and manicured lawns made ugly by the hangover from his human life around them. In contrast, lido life is brilliant and expansive.

Next we're off on the 493 bus to Tooting Bec, which has a higher density of people in a good mood than anywhere else in London.

Tooting Bec Lido, 10ish

We're only just through the pearly blue gates of Tooting Bec Lido when we get our first beaming smiles. Mark Sawyer, a local, challenges us to 'The Plunge', a South London Swimming Club 'feat': you dive in and see how far you can float. Lucie Petrie, a member, can apparently travel a full 50 metres. We line up, take off and stop after about two. Then we stretch out and do some swimming over the top of Tooting's bright new blue pool liner, a few neatly serrated leaves lie like sea sediment on the bottom.

Tooting Bec is the jewel in London's crown, the reflective sheen on your best pair of mirrored goggles: 91 metres by 33 metres – a bright blue inner city ocean (see picture opposite and on pages 152-153). The sun is out, the water is dazzling and the pool is surrounded by bright changing room doors in primary colours. We're sad to leave.

Serpentine Lido, midday

'At what point had this prank, this joke, this piece of horseplay become serious?' asks Merrill late on in his journey. We ask ourselves the same as we sit on the Central Line to the Serpentine. In contrast to the bright sunshiney Tooting Bec, the tube is unbearable. I feel so nauseous that we get off at Green Park and sprint up the escalators, towels flapping, into the sunshine.

We celebrate with a taxi to Serpentine Lido in the heart of Hyde Park. Lidos need less chlorine than indoor pools because of their colder temperature but the chlorine still makes the water slightly harsh. The Serpentine, being freshwater by contrast, is regenerative. There's a softness to it, a life-giving quality. We get dressed by a bank full of daisies and the odd goosefeather and a woman with a pushchair stops for a chat. She swims at Hampstead Ponds but never the Serpentine.

Try it, we say, it's a freshwater baptism – rebirth through algae. We meet the first Russian woman to attempt the Channel having a photocall and then walk across the tree-filled park to Marble Arch.

Our faces are radiant now. Freshwater has the same effect on the complexion as being hugged for a long time: all the discordant little molecules are soothed back into line.

London Fields, Hackney, 1.35pm

Two young girls in wet costumes stand around smoking outside London Fields in damp towels. We pass a spot where Dom was mugged a few years back. Wiry women with white bruised legs, shorts and a Rottweiler sit by a bin overflowing with Red Bull bottles. An electric fence tops the lido wall.

Then we're in and there's bunting and blue water and shrieking children and sun umbrellas bearing the legend 'I ❤ Hackney'. After ten lengths so do we – London Fields is a glory! There's an odd density of children considering it's term time, but no wonder there are constant queues outside its door.

Parliament Hill Fields Lido, 3.45pm

We get back on the overground at Hackney Wick and travel to Gospel Oak, the stop for my regular lido. It's not summer yet and four long chilly swims have taken me to the point that I baulk at the water but I dive in and the silver-bottomed pool sparkles its magic. One guy does butterfly and suddenly half the pool are at it, weaving and curling through the water in rhythmic moving Ss. We plough up and down and then set off across the heath barefoot in bathers. All very Neddy Merrill until we pass a group of football players. There's heckling. It's not pleasant but we're going swimming! It's soon forgotten.

Hampstead Mixed Ponds, 5.30pm

At last, the end of our journey. After this there's just one more train home. The sun is soft and low, the water is green, wasps are pollinating pink flowers and the lifeguards are chatty. Canada geese paddle in formation around one of the lifebuoys and we change by yellow irises and fluffs of pollen.

The natural water is a peaceful green haven after the lido, like coming to rest in an English country garden. A man comes in with his 11-year-old son, who has learning difficulties. His dad monkeys about on the jetty and the son laughs and splash-jumps in. 'What's it like?' says another regular. 'Quite nice actually,' the boy replies.

We join them. The water has warm patches and cold patches. A couple come in with a terrier which they are asked to tie up outside. The lifeguard fetches a blue rope the width of a forearm. 'My god! He's not an elephant,' say the owners, and we all laugh. A couple frolic on a life ring and ducklings race for cover under a tree.

And then we get back onto the overground and go home. Merrill finished his trip 'so stupefied with exhaustion that the triumph seems vague'. Ours just seems like a triumph, a celebration of the quasi-subterranean stream that traverses the capital, of all the open air pools we have access to across London.

Next time, we agree, we'll swim more of them.

Swim: Easy. The lidos featured in here have further references in the list of lidos in the resources section. The two lakes both have separate entries in the chapter on lakes.

Details: A complete list of London pools is contained in the resources section and there is more information about the Serpentine Lido and Hampstead Heath ponds in the section on Lakes, Ponds and Tarns.

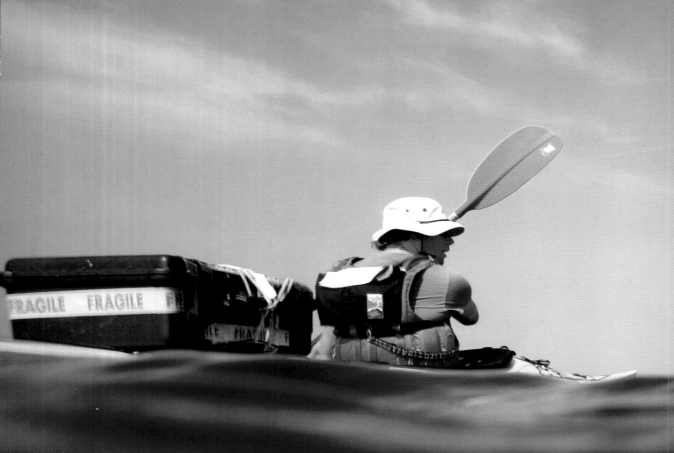

RESOURCES

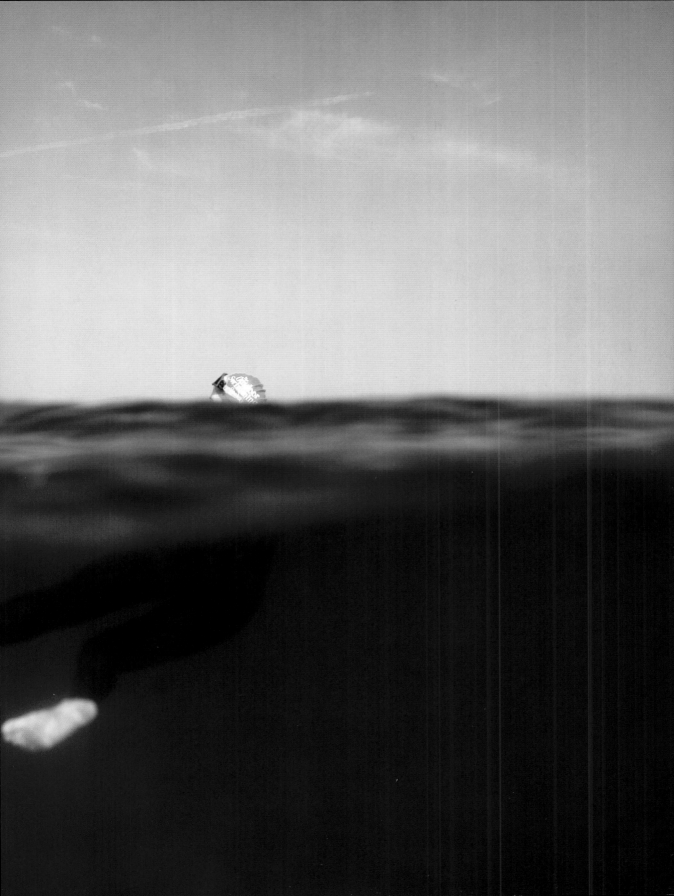

106 LIDOS AND OUTDOOR POOLS

I get my inspiration in the swimming pool, mostly,' says Ralph Steadman. 'I swim every morning come rain or shine. I get my best ideas in a thunderstorm – the power and majesty of nature on my side.'

Whether you're the first person to step across the dew on a poolside paving in the early morning, swimming as snowflakes or raindrops land on your nose, or joining the busy summer throng to bag your own patch of poolside sunbathing terrace, outdoor pools offer a very special swimming experience. All over Britain swimmers are leaving the hot chlorined captivity of indoor pools and embracing the joys of swimming under an open sky.

There are currently 106 public outdoor pools in Britain, some freshwater, some seawater – and one or two river water. Outdoor pools are generally cooler than indoor pools, which means they contain less chlorine (and make for a more invigorating swim). The spirit of the pools listed here differs massively – unheated 1930s lidos tend to have an art deco grandeur and attract devoted year-round swimmers, while heated pools that are part of leisure centres or have an indoor pool often retain a 'gym' feel, with swimmers ploughing up and down. Village-maintained pools range from noisy exuberant playpens full of inflatables, to quieter unheated pools in beautiful natural settings.

Lido (pronounced lee-doh or lie-doh) was originally a term for an outdoor pool with other recreational facilities attached, but we're using it, as it's more frequently used today, to mean an outdoor pool.

Most outdoor pools are open from May to September. Winter opening is mentioned where available. Few pools have dedicated websites so efforts have been made to refer the reader to the nearest website source in each case (often a page on the local council website or the website of the leisure company that manages the pool). Pools are listed alphabetically by county and all can be located on the map by number.

This list was created by Kathryn Hall (Kate's mum) with reference to, among other sources, Oliver Merrington's site www.lidos.org.uk and Liquid Assets, a book about the lidos and open air pools of Britain, by Janet Smith (English Heritage, £14.99).

● *sea or tidal pool* ● *lake, pond or tarn*
● *river or estuary* ● *lido*

ALL SWIMS LISTED BY MAP NUMBER

ENGLAND

BEDFORDSHIRE
157 Eversholt Swimming Pool,
Church End MK17 7DU
Tel: 01525 290168
www.eversholtvillage.co.uk
23m x 7.3m freshwater heated pool in Eversholt village. Originally built as a facility for its workers on the Woburn Estate.

158 Woburn Lido,
Crawley Road, Woburn MK17 9QB
Tel: 01525 290168
www.prstubbs.btinternet.co.uk/woburn.htm
22m x 10m freshwater heated pool was built as part of the Woburn Estate but now lies just outside the boundary wall. Elephants can sometimes be seen and heard on the other side. Private hire available.

BERKSHIRE
159 Northcroft Leisure Centre,
Newbury RG14 1RS
Tel: 01635 31199
www.leisure-centre.com under Centres/West Berkshire.
Heated 70m x 14m lido set in one acre of mature grounds and built in the 1930s.

160 Theale Green Recreation Centre,
Theale Green School, Church Road, Theale, Reading RG7 5DA
Tel: 0118 932 3725
25m heated pool with floats and inflatables for children.

BUCKINGHAMSHIRE
161 Aqua Vale,
Park Street,
Aylesbury HP20 1DS
Tel: 01296 488555
www.aquavale.com
20m x 12m heated pool linked to an indoor pool. Open all year round.

162 Chesham Town Swimming Pool,
Moor Road, Chesham HP5 1SE
Tel: 01394 776975
www.chesham.gov.uk under Services.
The 19th-century custom of bathing in a stream on
the local moor, in the Chilterns, stopped when this
freshwater heated pool, 26m x12m, was built in 1964.

163 Holywell Mead Outdoor Pool,
Bassetbury Lane, High Wycombe HP11 1QX
Tel: 01494 514 265
www.wll.co.uk under Wycome District.
Built over the remains of a Roman Villa, with some of
the recovered Roman walling used in the entrance.
30m heated pool and adjacent 20m teaching pool,
surrounded by sun terraces.

164 Wolverton Pool,
Aylesbury Street West, Wolverton, Milton Keynes
MK12 5BS
Tel: 01908 322200
Three freshwater heated pools, one 33m, and a
children and toddler pool.

CAMBRIDGESHIRE
165 Cottenham Outdoor Pool,
High Street, Cambridge CB4 8UA
Tel: 01954 288751
www.cottenhampool.org.uk
23m x 9m freshwater heated pool, relined in 2000.
Unusually, the pool was built entirely above ground
and so there are steps to climb up and steps to climb
down into the water. It is run by a village pool
association.

98 Jesus Green Outdoor Pool,
off Chesterton Road, Cambridge
Tel: 01223 302579
www.cambridge.gov.uk under Leisure and
Entertainment/Swimming Pools.
Very long freshwater pool surrounded by trees and
grassy sunbathing areas, 92m x 14m.
MAIN TEXT ENTRY P.162

166 Peterborough Lido,
Bishops Road, Peterborough PE1 5BW
Tel: 01733 343618
www.dcleisurecentres.co.uk and choose
Peterborough Lido from the drop-down list.
Freshwater heated lido 50m x 18m with eight lanes
in the main pool. There are separate teaching and
paddling pools, and sunbathing and terraced areas.

CHESHIRE
167 Nantwich Outdoor Pool,
Wall Lane, Nantwich CW5 5LS
Tel: 01270 610606
www.crewe-nantwich.gov.uk under Leisure and
Tourism/Leisure Centres and Pools.
Popular local brine pool fed from an underground
source nearby and heated to a minimum of 23°c.
Possibly the only one of its kind in the UK. 30.5m x
15m. An indoor pool was built alongside it in 1976.

168 Marbury Park Open Air Pool,
Marbury,
Northwich CW9 6AT
www.marburypool
30m pool in Marbury Country Park. Swimmers are
asked to become members of 'Marbury Park
Swimming Club' and join for a 'season' (£25 for adults
in 2007).

CORNWALL
95 Bude Sea Pool,
Summerleaze Beach, Bude
Tel: 01208 262822
www.ncdc.gov.uk under Leisure and Sport/Bude Sea
Pool. 88m long x 50m deep, irregular-shaped sea pool.
MAIN TEXT ENTRY P.156

170 Hayle Swimming Pool,
King George Memorial Walk, Phillack,
Hayle TR27 5AA
Tel: 01736 755005
www.penwith.gov.uk under Sport and
Leisure/Leisure Centres and Pools.
25m x 12.5m unheated freshwater pool that overlooks
Hayle Harbour and is set in a lawned garden.
Copperhouse Pool, a man-made tidal pool, is nearby.

99 Jubilee Pool,
The Promenade, Penzance
Tel: 01736 369224
www.jubileepool.co.uk
Sea pool, 100m x 73m on its longest axis. Includes a
'baby pool' within the main pool for kids. The
'Poolside café' next door serves coffee, lunch and
suppers.
MAIN TEXT ENTRY P.164

COUNTY DURHAM
169 Weardale Open Air Pool,
Castle Park, Bishop Auckland DL13 2LY
Tel: 01388 528466
www.woaspa.co.uk
Freshwater heated pool measuring 25m x 13m, set in
the picturesque Northern Dales.

CUMBRIA
171 Askham Swimming Pool,
Askham, Penrith CA10 2PN
Tel: 01931 712474
Freshwater heated 20m x 8m pool at Askham
Community Centre.

172 Barton Dale Swimming Pool,
Lazonby, Penrith CA10 1BL
Tel: 01768 898346
Freshwater heated pool, 20m x 8m.

173 Greystoke Swimming Pool,
Church Road, Greystoke, Penrith CA11 0TW
Tel: 01768 483637.
18m x 7m pool, heated.

174 Shap Swimming Pool,
Penrith CA10 3NR
Tel: 01931 716572
www.shapcumbria.co.uk under Swimming Pool.
At 250m above sea level Shap is said to be the highest
open air swimming pool in England. It was upgraded
in 2004. 17m x 8.5m, with an adjacent toddler pool.
Run by volunteers.

DERBYSHIRE
175 Castle Donnington Community College
Outdoor Pool,
Mount Pleasant, Donnington DE74 2LN
Tel: 01332 810428
www.nwleics.gov.uk/cdcc under Outdoor Pool.
Situated in the community college but open to
others, and during summer evenings.

176 Hathersage Open Air Swimming Pool,
Oddfellows Road, Hathersage S32 1DU
Tel: 01433 650843
Freshwater pool heated to 28°c, is 30 x 12 metres and
retains a veranda, lawns and bandstand with new
changing facilities.

DEVON
177 Ashburton Open Air Pool,
Love Land, Whistley Hill, Ashburton, Newton Abbot
TQ13 7DW
Tel: 01364 652828
www.teignbridge.gov.uk under Leisure and Green
Spaces/Leisure Centres and Sports Facilities.
Heated freshwater pool run by Teignbridge District
Council. 21m x 9m and part of the Golden Lion Hotel.
The water is heated to 27°c to 29°c.

178 Bovey Tracey Swimming Pool,
Newton Road, Bovey Tracey, TQ13 9BD
Tel: 01626 832828
www.boveyswimmingpool.co.uk
Freshwater heated pool (29°c), built in 1973,
measuring 25m x 12m.

179 Buckfastleigh Swimming Pool,
Victoria Park, Plymouth Road,
Buckfastleigh TQ11 0DB
Tel: 01364 642222
www.teignbridge.gov.uk under Leisure and Green
Spaces/Leisure Centres and Sports Facilities.
20m sheltered freshwater pool. Built in the early
1900s and upgraded in the 1970s.

96 Chagford Swimming Pool,
Chagford
Tel: 01647 432929
www.roundash.com/pool.htm
Riverfed solar-heated village pool situated in
Dartmoor National Park.
MAIN TEXT ENTRY P.157

180 Chudleigh Community Swimming Pool,
Lawn Drive, Chudleigh TQ13 0LS
Tel: 01626 854780
www.coombemoor.org.uk/pool/pool.htm
Claims to be the UK's newest lido having opened in
1997. 20m x 8m, heated and built in the grounds of
the local primary school.

181 Clyst Hydon Swimming Pool,
Clyst Hydon, nr Exeter (near Five Bells pub)
www.clysthydonswimmingclub.org.uk
Freshwater pool originally created by damming a
small stream. Community spirit runs high and much
recent upgrading has taken place, including a water
slide at the deep end and a paddling pool for younger
swimmers.

182 Kingsteignton Swimming Pool,
Meadowcroft Drive, Kingsteignton TQ12 3PB
Tel: 01626 366480
Freshwater heated pool measuring 21m x 12.5m.

183 Mount Wise Community Pool,
James Street, Plymouth PL1 4HG
Tel: 01752 306265
www.plymouth.gov.uk under Leisure and Tourism
/Sports and Recreation/Swimming Pools.
Community pool popular with local children, 25m x
13m with adjacent activity pool, paddling pool and
sun terrace.

184 South Dartmoor Leisure Centre Outdoor Pool,
Leonards Road, Ivybridge PL21 0SL
Tel: 01752 896999
www.southhams.gov.uk under Leisure/Leisure
Centres. This freshwater heated pool was built in
1986 with an indoor pool adjacent.

103 Shoalstone Pool,
Berry Head Road, Brixham, Devon, Torquay
Tel: 01803 851806
www.torbay.gov.uk under Leisure & Culture
/Beaches.
MAIN TEXT ENTRY P.168

104 Tinside Lido,
Hoe Road, Plymouth PL1 3DE
Tel: 0870 3000042
www.plymouth.gov.uk under Leisure and
Tourism/Sport and Recreation/Swimming Pools.
Beautiful 1930s art deco, semi-circular, Grade II-listed
lido. Filled with treated sea-water, Tinside recently
had £4 million worth of restoration of original
features such as colonnades, a central fountain,
multi-coloured underwater floodlighting and jets.
MAIN TEXT ENTRY P.169

185 Teignmouth Lido,
Eastcliff Walk, Teignmouth TQ14 8TA
Tel: 01626 779063
www.teignbridge.gov.uk under Leisure and Green
Spaces/Leisure Centres and Sports Facilities.
25m x 12m freshwater heated pool run by
Teignbridge District Council.

186 Topsham Swimming Pool,
Fore Street, Topsham EX2 0HF
Tel: 01392 874447
This freshwater heated pool is modern and 25m x
10m. Roof-mounted solar panels maintain water
temperature between 26°c and 29°c.

EAST SUSSEX
100 Pells Pool,
Brook Street, Lewes BN7 2PQ
Tel: 01273 472334
This 1860s Grade II-listed pool is the oldest
freshwater pool in the country – only Lymington's
sea-water pool is older (1833). 40m x 20m with a
paddling pool and grassy areas for sunbathing.
MAIN TEXT ENTRY P.166

101 Saltdean Lido, Shape Health Studios,
Saltdean Park Road, Brighton BN2 8SP
Tel: 01273 888308
www.saltdean.info/lido.htm
Saltdean was built in the 1930s in the 'Hollywood
Modern Style' and is 25m x 15m.
MAIN TEXT ENTRY P.166

ESSEX
187 Brightlingsea Open Air Pool,
Promenade Way, Brightlingsea, Colchester CO7 0HH
Tel: 01206 303067
www.tendringdc.gov.uk/TendringDC under Leisure
and Culture/Sports Facilities/Brightlingsea Open Air
Pool. Freshwater unheated pool next to the sea. 50m
x 20m with adjacent paddling pool.

188 Chelmsford Leisure Centre,
Victoria Road, Chelmsford, CM1 1FG
Tel: 01245 615050
www.chelmsford.gov.uk
The famous 18th-century garden designer Capability
Brown designed the original free form heated open
air pool (20m diameter) at Chelmsford, making the
setting part of the swim. Secluded and surrounded
by grass and terraces.

189 Kings Oak Swimming Pool,
Nursery Road, High Beech, Loughton IG10 4AE
Tel: 0208 508 5000
www.kingsoakhotel.co.uk see Attractions.
1930s freshwater, unheated pool, with fountain, deep
in the woods of Epping Forest. The pool is an integral
part of The King's Oak pub in High Beech and a
favoured venue for swimmers, bikers and walkers,
with pub barbecues in the summer. Run by the pub
landlord. Private hire available.

190 Woodup Pool,
Woodrolfe Road, Tollesbury, Malden CM9 8SE
www.maldon.gov.uk under Leisure/Parks and Open
Spaces/Parks.
Unique and popular saltwater pool set in the flat salt
marshes of Tollesbury with views of boats, birds and
boardwalks. Free and built in 1907. No lifeguards so
children must be supervised.

GLOUCESTERSHSIRE
191 Bathurst Swimming Pool,
High Street, Lydney GL15 5DY
Tel: 01594 842625
www.bbc.co.uk/gloucestershire/content/articles/20
07/06/27/lydney_pool_feature.shtml
One of Gloucestershire's hidden gems, with colourful
and exotic murals of sandy beaches, palm trees and
dolphins (just underneath the barbed wire on top of
the pool walls). Run by volunteers who saved it from
closure in 2003. Unheated, 41m x 17m, deep in the
countryside just two miles from the River Severn.

192 Cirencester Open Air Pool,
Riverside Walk, Thomas Street, Circencester GL7 2BA
Tel: 01285 653947
www.cirenopenair.co.uk
Set by a castle wall with grazing cattle nearby, this
freshwater heated pool is fed by a nearby well. 27m x
14m. Paddling pool.

102 Sandford Parks Lido,
Keynsham Road, Cheltenham GL53 7PU
Tel: 01242 524430
www.sandfordparkslido.org.uk
Elegant lido on the edge of the Cotswolds which has
been extensively refurbished over the past couple of
years. 50m x 27m, with a children's pool, slides and a
paddling pool.
MAIN TEXT ENTRY P.167

193 Stroud Open Air Pool,
Stratford Road, Stroud GL5 4AF
Tel: 01453 766771
www.stroud.gov.uk/docs/leisure/recreation.asp
One of the few pools left in the country with a diving
board (on three levels). Set in parkland, this freshwa-
ter pool measures 50m x 18m, with Cotswold stone
pavilions at each corner of the pool.

194 Wotton Pool,
Syman Lane, Wotton, Gloucestershire, GL12 7BC
Tel: 01453 842086
www.wottonpool.co.uk
Freshwater heated pool, 20m x 8m. Currently seeking
funding to build new changing rooms and replace
the 30 year-old solar panel.

GREATER LONDON
195 Brockwell Park Lido,
Brockwell Park, Dulwich Road, London SE24 0PAF
Tel: 0207 274 3088
This Grade II art deco lido was renovated and
refurbished in 2005 with the help of the Heritage
Lottery Fund and is now run by fitness group Fusion
as part of a gym. The 'Brixton Beach' community life
has changed as a result, but many locals are grateful
that it's still open. 50m x 27m.

196 Charlton Lido,
Hornfair Park, Shooters Hill Road, London SE18 4LX
Tel: 0208 856 7180
Constructed of red brick, with water cascades at the
shallow end, this unheated lido was opened in 1939
and stays open all year round, with the Charlton Lido
Swimming Club breaking the ice in the winter.
50m x 20m with a children's pool adjacent.

197 Finchley Lido,
High Road, Finchley, London N12 0GL
www.gll.org/centre/finchley-lido-leisure-centre.asp
The original lido was built in 1931 with an elegant
colonnade that has been filled in and turned into a
restaurant. The whole site was revamped and
opened in 1996 as the Great North Leisure Park and
now includes a very small outdoor pool as well as a
cinema and bowling alley.

198 Hampton Heated Open Air Pool,
High Street, Hampton TW12 2ST
Tel: 0208 255 1116
www.hamptonpool.co.uk
Set in two acres of woodland next to Royal Bushy
Park and heated to 28°c, open 365 days a year. The
original plan (1891) was for a floating swimming bath
in the Thames, and the pool was built to stop people
swimming in the river. It measures 36.5m x 14m
with a learner pool nearby.

199 London Oasis Swimming Pool,
32 Endell Street, London WC2H 9AG
Tel: 0207 831 1804
www.camden.gov.uk under Leisure/Sport and
Fitness/Sports centres/Oasis Sports Centre.
Right in the centre of Covent Garden and overlooked
by flats and an 11-storey office block, this chlorinated,
heated pool offers an unusual swim in the heart of
London. It is open all year and probably most
surprisingly during winter when the steam rises in
puffs, and three powerful underwater lights
illuminate the water. 27m x 10m. The complex
includes an indoor pool.

107 London Fields Lido,
Hackney, London E8 3EU
Tel: 0207 254 9038
www.hackney.gov.uk/c-londonfields-lido.htm
The original lido was opened in 1931, closed during
World War II, renovated in the 1950s and then closed
from 1988 to 2006 when it re-emerged, after a multi-
million pound restoration programme, into the new
heated lido which exists today. 50m x 17m and so
popular that sometimes the day has to be split into
four separate swim times to give everyone a dip.
MAIN TEXT ENTRY P.174

200 Park Road Leisure Centre,
Park Road, Hornsey, London N8 8JN
Tel: 0208 341 3567
www.haringey.gov.uk under Community and
Leisure/Sport and Leisure/Park Road.
Freshwater heated pool sheltered by a tall privet
hedge. 50m x 23m, with a fountain and children's pool.

108 Parliament Hill Fields Lido,
Gordon House Road, Hampstead, London NW5 1LP
(sometimes known as Hampstead Heath Lido)
Tel: 0207 485 3873
www.cityoflondon.gov.uk under Living Enviroment/
Open spaces/Hampstead Heath.
Grade II listed in January 1999 as one of the finest
surviving examples of a 1930s lido left in the UK. It
measures 70m x 30m and was fitted with a unique
steel lining in 2005 which twinkles at swimmers as
they plough up and down, changing the colour of the
water with the daylight, from pale green and pale
blue to silvery grey. Wonderful geometric simplicity
and open all year. Unheated.
MAIN TEXT ENTRY P.175

105 Richmond Pools on the Park,
Twickenham Road, Richmond, London TW9 2SF
Tel: 0208 940 0561
www.springhealth.net under Richmond.
Freshwater heated Grade II-listed lido, part of a
complex (which includes an indoor pool) in
Richmond's Old Deer Park. Both pools were built for
competitive events and measure 33.5m x 13m. The
complex was completed in 1966 and has been
upgraded since.
MAIN TEXT ENTRY P.172

89 Serpentine Lido,
Hyde Park, London W2 2UH
Tel: 0207 706 3422
www.serpentinelido.com
An unusual lido because it's a marked area of a lake –
the Serpentine Lake in Hyde Park. Founded in 1931,
unheated and a great favourite with Londoners. The
lido is only open during the summer but the
Serpentine Swimming Club members swim here all
year around (www.serpentineswimmingclub.com).
MAIN TEXT ENTRY P.146

106 Tooting Bec Lido,
Tooting Bec Road, London SW16 1RU
Tel: 0208 871 7198
www.wandsworth.gov.uk under Leisure and
Culture/Sport, Leisure and Health/Leisure Centres
and other sports facilities/Tooting Bec Lido.
This lido is home to the thriving South London
Swimming Club which swims all year round, with
races every Sunday. A friendly lido, with the SLSC
holding events such as the World Winter Swimming
Championships in 2008, complete with plastic
icebergs, hot tubs and competitors from Russia and
Finland. Popular with channel swimmers and winter
swimmers. (Swimming Club website:
www.slsc.org.uk)
MAIN TEXT ENTRY P.174

201 Trent Open Air Pool
(part of Middlesex University) Middlesex University, Bramley Road, Oakwood, London, N14 4XS
Tel: 020 8411 7337
www.middlesex.ac.uk
under Campus Life/Sport/Trent Park.
Originally part of Trent Park Estate and next to a Grade II-listed Orangery, the pool is now part of Middlesex University and used by students and staff. Members of the public can apply for membership. Fitted with an alarm system to stop midnight swimmers! 27m x 7.5m, heated.

HAMPSHIRE
202 Aldershot Lido,
Guildford Road, Aldershot GU12 4BP
Tel: 01252 323 482
www.rushmoor.gov.uk under Leisure and Tourism /Leisure Facilities/The Aldershot Lido.
Large, freshwater, unheated pool set in ten acres and locally popular. It has water slides, a water fountain, a spring diving board and toddler paddling pool.

203 Hilsea Lido,
Portsmouth PO2 9RP
Tel: 02392 664608
www.portsmouth.gov.uk
This water park had a grand opening in 1935 with water chutes, a 10m diving tower, cafés and floodlit night bathing. It has won recent fights to stay open (just!). A splashpool is open from May to September and the main 67m x 18m pool is open throughout the 6-week school summer holiday.

204 Lymington Seawater Baths,
Bath Road, Lymington SO41 3RU
Tel: 01590 674 865
www.lymingtonandpennington-tc.gov.uk
These seawater baths claim to be the oldest in Britain (built in 1833) and are sufficiently large (90m x 30m) to accommodate rowing boats and canoes as well as swimmers. Unheated.

205 Petersfield Open Air Pool,
Heath Road, Petersfield GU31 4DZ
Tel: 01730 265 143
www.petersfieldpool.org/wiki
Freshwater heated pool opened in 1962. 25m x 10m.

HERTFORDSHIRE
206 Sportspace Hemel Hempstead,
Park Road, Hemel Hempstead HP1 1JS
Tel: 01442 228 188
www.mysportspace.co.uk under Sports Facilities /Swimming Pool/Sportspace Hemel Hempstead.
Surrounded by lawns, trees and sunbathing areas, Sportspace includes a 25m x 12m outdoor pool (and four indoor ones).

207 Hitchin Swimming Centre,
Fishponds Road, Hitchin SG5 1HA
Tel: 01462 441646
www.north-herts.gov.uk
Set in parkland, this 50m x 18m freshwater heated pool was opened in 1938 but in 1991 an indoor pool was built alongside it.

208 Hoddesdon Open Air Pool,
The John Warner Sports Centre, High Street, Hoddesdon EN11 8BE
Tel: 01992 445 375
www.broxbourne.gov.uk under Leisure and Tourism/Where to go/Sports and Keep Fit/Swimming.
23m x 9m freshwater heated pool built in 1933.

209 Letchworth Open Air Pool,
Icknield Way, Letchworth SG6 4UF
Tel: 01462 684 673
www.north-herts.gov.uk under Discover North Herts/Leisure and Sports/Letchworth Outdoor Pool.
Situated in open parkland this pool is highly rated by locals. It is freshwater, heated and measures 50m x 20m with a paddling pool alongside. Plenty of room to sunbathe.

210 Ware Priory Lido,
Priory Street, Ware SG12 9AL
Tel: 01920 460703
www.wareonline.co.uk/lido
Freshwater heated lido, built in 1934 but substantially altered in the 1970s. Situated within the grounds of Ware Priory with tennis and basketball courts alongside. 30m x 9m with a teaching pool.

THE ISLES OF SCILLY
211 Normandy Community Pool,
St Mary's TR21 0LW
Tel: 01720 422537
www.scilly.gov.uk/leisure/swimpool.htm
Freshwater 14.5m pool built two decades ago, and refurbished in 2002. Popular community pool, available for private hire.

KENT
212 Faversham Pools,
Leslie Smith Drive, Faversham ME13 8PW
Tel: 01795 532426
www.swale.gov.uk/index.cfm?articleid=4246
Freshwater heated pool, 33m x 12m, with several diving boards. Part of a new complex which includes a 'fun pool' with rapids as well as an indoor pool. There is plenty of grass to relax on afterwards.

213 Gillingham Swimming Pool,
Strand Leisure Pool and Park, Pier Road, Gillingham
Tel: 01634 573176
www.medway.gov.uk/leisure/leisurecentres/strand
This pool was just a hole in the mudflats of the River Medway in 1894, but now it is part of a leisure complex. Unheated, 25m x 25m with fountains and slides.

214 Tonbridge Swimming Pool,
The Slade, Tonbridge TN9 1HR
Tel: 01732 367449
www.tonbridgepool.co.uk
Set in woodland, this freshwater heated outdoor pool, 20m x 13.5m, is now linked by a swim-through channel to three indoor pools.

LEICESTERSHIRE
215 Hood Park Outdoor Pool,
Hood Park Leisure Centre, North Street, Ashby de la Zouch LE65 1HU
Tel: 01530 412181
www.nwleics.gov.uk Under Leisure and Culture /Hood Park Leisure Centre/Outdoor Pool.
Freshwater outdoor pool, 30m x 15m, part of a leisure complex.

LINCOLNSHIRE
216 Billinghay Community Swimming Pool,
Fen Road, Billinghay LN4 4HU
Tel: 01526 861 470
www.sportsbase.co.uk/venues/billinghay_ community_swimming_pool/
25m x 10m freshwater heated pool (27° to 29°c). In the heart of the village and run by a committee of volunteers.

217 Bourne Outdoor Pool,
Abbey Lawns, Abbey Road, Bourne PE10 9EP
Tel: 01778 422063
www.bourneoutdoorswimmingpool.org
Bourne Abbey carp pond (the carp were bred for monks in 1138) was changed into an outdoor swimming facility during World War I. Threatened with closure in 1989, the pool, monks' garden and abbey lawns were retained by The Bourne Outdoor Preservation Trust after a protest march and 4000 signatures. Heated, Olympic-sized, with a toddler pool, sandpit and playhouse alongside.

218 Embassy Outdoor Swimming Pool,
Grand Parade, Skegness PE25 2UG
Tel: 01754 610 675
www.e-lindsey.gov.uk under Leisure/Sports Facilities/Swimming Pools/embassy-swimming-pool-skegness.cfm.
The original 1930s lido set on the Skegness foreshore was closed in the 1980s and a new freshwater heated outdoor pool, 25m x 13m, was built 35 metres away, with a paddling pool alongside.

219 Jubilee Park Swimming Pool,
Stixwould Road, Woodhall Spa LN10 6QH
Tel: 01526 353 478
www.e-lindsey.gov.uk under Leisure/Sports/swimming-pools/jubilee-park.cfm
This 33m x 13m freshwater heated pool is set among pine woods.

220 Metheringham Swimming Pool,
Princes Street, Metheringham, Lincoln PE11 1QD
Tel: 01526 320840
www.macla.co.uk/activity/pool.php
This 15.5m x 8.5m freshwater heated pool, in the centre of the village, is kept open by volunteers and fundraising efforts.

NORTHUMBERLAND
221 Haltwhistle Open Air Pool,
Greencroft Anenue, Haltwhistle NE49 9BP
Tel: 01434 320 727
www.hslc.freeserve.co.uk/swimming.htm
Lawns, trees and three freshwater heated pools in juxtaposition. The largest one measures 25m x 10m with smaller learner and paddling pools. Water is maintained at 27°c and when the weather's hot opening hours are extended.

OXFORDSHIRE
222 Abbey Meadow Outdoor Pool,
Abbey Close, Abingdon OX14 3JD
Tel: 01235 530678
www.soll-leisure.co.uk under Facilities.
Heated outdoor pool that has received recent investment and reopened in 2006.

223 Chipping Norton Lido,
Fox Close, Chipping Norton OX7 5BZ
Tel: 01608 643 188
www.chippylido.co.uk
This sheltered, freshwater heated lido was a community project award winner in the ASA (Amateur Swimming Association) Swimtastic Awards in 2007. It measures 25m x 14m, with a water slide at one end and the water is always above 23°c. (Jeremy Clarkson drove a silver Rolls Royce into it in 2005.)

224 Hinksey Pools,
Lake Street, Oxford OX1 4RP
Tel: 01865 467 079
www.oxford.gov.uk under Leisure/Sports Facilities. Built in 1934 using the old filter beds of the former Oxford waterworks, this outdoor freshwater heated pool is a mile from the city centre. Heated and close to a park and children's boating lake with paddle boats for hire.

225 Riverside Park and Pools,
Crowmarsh Gifford, Wallingford OX10 8EB
Tel: 01491 835 232
www.soll-leisure.co.uk
20m x 10m freshwater heated pool.

226 Woodstock Outdoor Pool,
Shipton Road, Woodstock OX20 1LP
Tel: 01993 811 785
www.wll.co.uk under Leisure Facilities in West Oxfordshire.
Freshwater heated (to 29°c) pool, 25m x 8.5m, with a diving board and toddler's paddling pool. Large grassed area for sunbathing.

SHROPSHIRE

227 Highley Pool,
Bridgnorth Road, Highley WV16 6JG
Tel: 01746 860000
www.severncentre.co.uk under Facilities.
Sited within The Severn Centre, which received
considerable investment by the Lottery Fund, this
30m x 10m freshwater pool is heated to between 26°c
and 27°c with solar heating fitted onto a huge pergola.

228 Market Drayton Swimming Centre,
Newtown, Market Drayton TF9 1JU
Tel: 01630 655177
www.northshropshiredc.gov.uk under Leisure and
Culture/Leisure and Swimming Facilities.
Freshwater heated pool, 16.5m x 14.5m – not ideal for
serious swimmers as it is kidney-shaped, but it lends
itself to fun swimming.

SOMERSET

229 Greenbank Swimming Pool,
Wilfrid Road, Street BA16 0EU
Tel: 01458 442468
www.greenbankpool.co.uk
Back in the 1930s local male workers at the Clarks
Shoe Factory used to swim naked in the River Brue.
The owner of the factory, Alice Clark, was a strong
supporter of women's rights and left money for a
pool that would give women and girls an
opportunity to swim too. This freshwater heated pool
has been greatly improved in the last few years, with
a popular 'splash' area for children.

230 Huish Episcopi Sports Centre Swimming Pool,
Wincanton Road, Langport TA10 9SS
Tel: 01458 251055
www.visitsomerset.co.uk/site/things-to-do/leisure-
centres 25m x 8.5m freshwater heated pool built in
the 1970s and is accessed through the gates of Huish
Episcopi Comprehensive school.

231 Portishead Open Air Pool,
The Esplanade, Portishead BS20 7HD
Tel: 01275 843454
www.visitsomerset.co.uk/site/things-to-
do/swimming-pools under Leisure/Sports and
Leisure/Leisure and Sports – centres and facilities.
Freshwater heated pool with stunning views of the
Severn estuary. 33m x 12.5m with a tiered sunbathing
area beside it.

232 Wiveliscombe Community Sports Centre,
Recreation Ground, Wiveliscombe, Taunton
Tel: 01984 624720
www.wiveliscombe.com under Our
Community/CommunityDirectory/Sport/Community
Swimming Pool Wiveliscombe.
27m x 10m freshwater heated pool given to the
community by a local brewing family in 1927 and
extensively renovated in 2002. It is open every
afternoon during the summer and staffed solely by
enthusiastic volunteers who held a '10 Parishes
Swimathon' here in 2007.

SUFFOLK

233 Beccles Swimming Pool,
Puddingmoor, Beccles NR34 9PL
Tel: 01502 713297
www.waveney.gov.uk under Leisure/Sport and
Leisure/Leisure Facilities.
This freshwater heated pool is situated by the river
Waveney and is 33m x 16m with adjacent toddler and
baby pool. The water temperature is kept between
26°c and 30°c. There is plenty of grass to relax on
nearby.

SURREY

234 Abbey Fit Sports Centre Pool,
School Lane, Addlestone KT15 1TD
Tel: 01932 858966
Freshwater heated pool, 23m x 9m, built in 1977 and
part of a sports centre.

235 Guildford Lido,
Stoke Park, Guildford GU1 1HB
Tel: 01483 444888
www.guildfordlido.co.uk
1930s lido, 50m x 28m, set in three acres of
landscaped gardens at Stoke Park. Heated (23°c) and
in the middle of Guildford. There are paddling pools,
water slides and free parking.

WARWICKSHIRE

236 Abbey Fields Swimming Pool,
Abbey Fields Park, Bridge Street, Kenilworth CV8 1BP
Tel: 01926 855478
www.warwickdc.gov.uk under Leisure and
Culture/Sports/Sports Facilities.
Freshwater heated outdoor pool, 25 x 10 metres, built
in 1986 next to an indoor pool. There is a poolside
sauna available during public swimming times.

WILTSHIRE

237 Droitwich Spa Lido,
Worcester Road, Droitwich WR9 8AA
Tel: 01905 799342
www.wychavonleisure.co.uk/index.asp?pgid=56
Droitwich, known for its natural reserves of rock salt,
re-opened its revamped 1935 brine heated lido in
2007 after a long SALT (Save A Lido Today) campaign.
26.5m long with a wet play area at one end and
landscaped borders.

238 Highworth Recreation Centre,
The Elms, Highworth, Swindon SN6 7DD
Tel: 01793 762602
www.swindon.gov.uk under Leisure and Sport.
Freshwater heated pool with a sliding roof, 25m x
10m, part of a large sports complex.

WEST SUSSEX

239 Arundel Lido,
Queen Street, Arundel BN18 9JG
Tel: 01903 882404
25m x 10m freshwater heated pool built in the 1960s,
with a paddling pool.

240 Aztec Pool,
Triangle Leisure Centre, Triangle Way, Burgess Hill
RH15 8GA
Tel: 01444 876000
www.olymposcentres.com under Sport and other
activities/Swimming.
This freeform freshwater heated pool is part of an
indoor and outdoor pools complex, complete with
rapids in the outdoor pool. The original lido in St
John's Park was closed in 1998. It is open all year
round.

YORKSHIRE

241 Helmsley Open Air Swimming Pool,
Baxtons Lane, Helmsley YO62 7TA
Tel: 01439 770617
Built in the 1960s, this freshwater heated pool, 20m x
8m is set deep in the North Yorkshire dales and is run
by the Feversham Memorial Committee.

97 Ilkley Pool and Lido,
Denton Road, Ilkley LS29 0BD
Tel: 01943 600453
Situated on the edge of Ilkley Moor and surrounded
by wide open countryside, this freshwater, unheated
lido is circular (46m in diameter) with a central
fountain and slide. There is a heated pool on site.
MAIN TEXT ENTRY P.160

242 Ingleton Swimming Pool,
Ingleton LA6 3EL
Tel: 01524 241147
www.ingleton.co.uk
With a riverside setting this freshwater heated pool
in the Yorkshire Dales National Park was originally
dug out by local volunteers in 1933. In recent years it
has been significantly modernized, measures 20m x
8m, and is available for private hire.

SCOTLAND

243 Stonehaven Open Air Pool,
Queen Elizabeth Park, Aberdeen
Tel: 01569 762134
www.stonehavenopenairpool.co.uk
Seawater (fully filtrated) heated lido, 50m x 18m, built
in 1930s art deco style, and painted in primary
colours to look cheerful even when its terraces are
being lashed by rain. Offers weekly floodlit midnight
swims.

244 Gourock Open Air Pool,
Albert Road, Inverclyde PA19 1ND
Tel: 01475 63156
www.inverclydeleisure.com
Stunning pool set against the rough grey seas of
Gourock. Originally opened in 1909 this pool, situated
on the coast, has been refurbished many times. Salt
water is taken from the River Clyde, filtered and
heated to a minimum of 28°c. Very popular.

245 Magnum Leisure Centre,
Irvine KA12 8PP
Tel: 01294 278381
www.naleisure.co.uk under Swimming Activities.
Freshwater heated circular pool, part of a leisure
pool complex.

246 New Cumnock Swimming Pool,
New Cumnock HA18 4AH
Tel: 07985 381051
Freshwater heated pool, 23m x 12m, built in the 1960s.

WALES

247 Brynamman Swimming Pool,
off Station Road, Brynamman, Ammanford, Dyfed
SA18 1SF
Tel: 01269 824907
Unheated pool established in the 1920s and 27m long.

21 TIDAL POOLS

Tidal pools were often built to keep bathers safe from high and rough seas, so there are many around the surf beaches of Cornwall. They vary in size from rock pools for one to grand lido-like pools complete with lifeguards and tea huts. All are refreshed by good high tides and there's a strong chance you'll share your swim with a crab or a fish brought in with the waves. Go at low tide to be sure of a swim or sit and wait on a cliff top for sea levels to fall and the pool to be revealed beneath the salt-water – a nice variation on the swimmer's experience of 'waiting for the pool to open'.

We have completed a list of tidal pools in the UK, with reference to Oliver Merrington's site www.lidos.org.uk, a public portal that welcomes updates from swimmers who know of more tidal pools. Many tidal pools are wild, just natural bathing places in rock without signposts or street names – but ask around and you will generally find a local who can point you in the right direction. Where they exist, we have provided a telephone number and a website address.

ENGLAND
CORNWALL

248 Copperhouse Pool,
Hayle, Nr St Ives TR27
Man-made tidal pool in Hayle.

249 Cape Cornwall Pool,
Priest's Cove, St Just TR19
www.pznow.co.uk/locplace1/cape.html
A 10m x 7m sea water pool near Lands End built 50 years ago among craggy rocks. Nearby fishermen's huts and boats give it a Cornish feel.

250 Millendreath,
Looe PL13
A tidal pool lies at the east side of Millendreath beach.

251 Perranporth,
Perranzaboloe, TR6
A tidal pool situated on the beach at Perranporth at Chapel Rock.
MAIN TEXT ENTRY P.55

252 Polperro,
Looe, PL13
A natural Cornish seawater rock pool situated at Polperro.
MAIN TEXT ENTRY P.57

24 Porthtowan,
Truro TR48
Beautifully wild tidal pool surrounded by cliffs and rock, with a retaining concrete wall.
Porthtowan OS ref: SW694477
MAIN TEXT ENTRY P.57

123 Portreath Pool,
Redruth TR16
This swimming pool was made by adding a retaining wall to a rock pool. Local schoolchildren were taught to swim here until the 1970s.
MAIN TEXT ENTRY P.57

253 Lady Basset's Baths,
Portreath, Redruth TR16
To the west side of Portreath beach are Lady Basset's Baths, a number of pools built in the 1800s out of rock at different levels. Lady's Basset's father believed in the health benefits of bathing in cold seawater.
MAIN TEXT ENTRY P.57

254 Treyarnon Bay,
St Merryn, Padstow PL28
There is a small 10m x 5m tidal pool in the rocks at Treyarnon, between Padstow and Newquay.

DEVON
255 The Rock Pool,
Westward Ho!, Bideford EX39
A sea water tidal pool. Recently renovated, it sits among the rocks on the southern side of the beach.

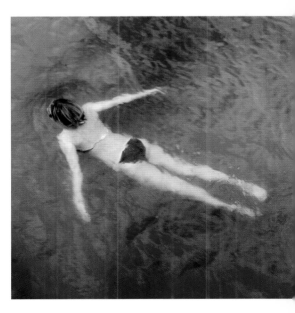

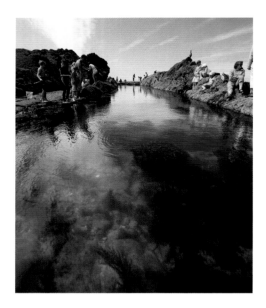

256 Tunnels Beach,
Ilfracombe EX34
Tel: 01271 879882
www.tunnelsbeaches.co.uk
In 1823 a team of Welsh miners were hired to dig
tunnels from Ilfracombe through a cliff to link the
town to two coves and build three tidal pools. The
tunnels and one of the three pools have been
restored. This is a tourist, rather than wild,
experience (pay for entry, lots of information boards).

27 Devil's Point Tidal Pool,
Durnford Street, Stonehouse, Plymouth PL3
A man-made tidal pool on Plymouth Sound,
surrounded by shingle, rocks and great views.
Durnford Street
MAIN TEXT ENTRY P.60

DORSET
8 Dancing Ledge,
Langton Matravers, Swanage BH19
Owned by the National Trust, this small seawater
pool was cut into a disused stone quarry by local
school masters. About two strokes long (more of a dip
than a swim), lined with barnacles and limpets and
difficult to access.
MAIN TEXT ENTRY P.28

KENT
257 Walpole Bay Pool,
Cliftonville, Margate CT9
A salt water pool, surrounded by a sandy beach. Can
be reached via an Art Deco funicular lift down the
cliff-face.

THE ISLE OF MAN
258 Port Skillion
Cliftonville, Margate, CT9
A seawater pool built in 1874 and originally men-
only. The pool is in a creek with walls built across at
varying depths.

SCOTLAND
ABERDEENSHIRE
259 Portsoy Open Air Pool,
Portsoy, Banff AB45
This tidal pool was created between two rocks in the
1940s. An ideal viewing spot for seals and dolphins.
Run by a local swimming club with changing rooms
and a tea stall.

260 Rosehearty Open Air Pool,
Fraserburgh AB43
This tidal pool lies on the north coast of
Aberdeenshire, west of Fraserburgh.

THE HIGHLANDS
261 Pittenweem Tidal Swimming Pool,
Anstruther, Fife KY10
This tidal pool, set in the rocks, offers a water chute
and diving board.

262 The Trinkie Wick Bay Outdoor Swimming Pool,
Wick, Caithness, KW14
Created in a quarry in the 1930s, this tidal pool is near
the old coastguard station just under a mile from
Wick. It is scrubbed and painted white annually.

JERSEY
263 Havre des Pas Bathing Pool,
St Helier
Tel: 01534 728782
A grand Victorian building and semicircular sea-
water swimming pool, reached by a boardwalk. Built
in 1895 it has been recently restored and has a
toddlers' pool.

GUERNSEY
264 La Vallette Bathing Pools,
St Peter's Port, GY1 1AX
A series of sea pools built in the 19th century.

25 TRIATHLON TRAINING SITES

There are now over 650 triathlons in the UK a year, introducing thousands of new people to swimming in open water. Tri swimming is very different from other types of outdoor swimming; it's fast and competitive, with swimmers pounding away with little time to appreciate surroundings. The start of the race is like being in a mosh-pit: your face in someone's feet, your feet in someone's face, hands clawing at wetsuits as people swim over each other in the water.

The horrors of race day aside, many tri clubs organise open water swimming sessions throughout the summer at lakes and in the sea. It's often possible to attend these just as a keen swimmer. Sessions typically run from April to September, often in locations where swimming is forbidden at other times. Some sessions are in beautiful locations, some are in less inspiring places, but joining the sessions can be helpful in overcoming any fears of swimming in natural water, improving open water technique and vastly increasing distances that can be swum confidently. They are also a good way to try out triathlon wetsuits before you invest. They may even introduce you to other people keen to explore the various types of swimming covered in this book. Many groups are now introducing sessions for juniors.

This is a list of some training sites around the UK. There may be others closer to you and the growing popularity of triathlons means new ones are opening all the time. To find your nearest, contact your local tri clubs which can be found at www.britishtriathlon.org. Lakes typically charge under £5 for a session. Forums at www.swim-club.co.uk can also give great up-to-date local advice. The websites listed belong to the groups that organise triathlon training: go to the section on open water swimming. All swims are located on the map by number.

ENGLAND
BERKSHIRE
265 Dorney Lake,
Eton College, Rowing Centre, Windsor, Berskire
www.dorneylake.com
Weekend open water swim sessions at this Eton rowing lake depend on the rowing schedule but are packed when they're open. Run by SBR sports.

266 Open Water Swim UK,
Liquid Leisure, Datchet, Berkshire SL3 9HY
www.openwaterswim.co.uk
A swim group open four days a week over summer based by a picturesque lake in the heart of Berkshire countryside. Liquid Leisure has its own beach and facilities include a club house, changing rooms, sauna and Jacuzzi. Personal coaches, individual swimming and group swims are all available in the 750m area.

CAMBRIDGESHIRE
267 Histon Lake,
Cambridge, CB4
www.cambridgetriathlonclub.co.uk
Cambridge Triathlon club trains in Jesus Green lido and Histon Lake over the summer. Non-members may also swim (fee payable) and wetsuits must be worn.

ESSEX
268 Roydon Lake,
Roydon Mill Leisure Park, Roydon, Essex CM1 5EJ
www.swimfortri.com
SwimforTri organises 6.45am weekend swims at this lake in a leisure park. London triathletes join from the train from Liverpool Street or by tube to Buckhurst Hill Tube Station (Central Line) where swimmers can arrange to be met.

269 Gosfield Lake Resort,
Church Road, Gosfield, Halstead, Essex CO9 1UD
www.gosfieldlake.co.uk
Tuesday evening and Sunday morning sessions are
held at this lake deep in the Essex countryside and
within easy reach of Stansted Airport and the A120,
M11 and A12 roads. Coaching is available and there
are picnic areas and a café. An ideal venue for open
water novices as you can stay within your depth in
the majority of places.

GLOUCESTERSHIRE
75 Henleaze Lake,
Lake Road, Henleaze, Bristol BS10
www.badtri.org
Members of BAD Tri, a large Bristol tri group, are
lucky to have access to the lovely Henleaze lake north
west of Bristol. (Restricted to 30 swimmers at a time.)
MAIN TEXT ENTRY P.126

LANCASHIRE
270 Salford Watersports
15 The Quays, Salford, Lancashire M50 3SQ
www.salford.gov.uk
Long-distance swimmers and triathletes can train at
the Salford Watersports Centre on Thursday
evenings, 6.30-8.30pm from May 1. The Centre is built
on a derelict dock and has changing rooms and other
facilities such as a climbing wall.

271 Delph Diving Training Centre,
**Delph Quarry, Halfpenny Lane, Heskin, Chorley,
Lancashire PR7 5PR**
www.thedelph.com
'The Delph' is a scuba-diving centre in a quarry in
Lancashire which offers open water swim sessions
for triathletes every Wednesday during the summer
and has a café and changing rooms. The water is
from a fresh water spring from the hills of Parbold.

272 Lakeland Leisure Village,
Dock Acres, Carnforth, Lancashire LA6 1BH
www.lakelandleisurevillage.co.uk
This freshwater lake in Lancashire is surrounded by
holiday lodges along the shore and offers open water
swimming for triathletes only during summer.
Sessions are attended by Tri Preston
(www.tripreston.co.uk) and Lancaster Tri groups.

LEICESTERSHIRE
273 King Lear's Lake,
Watermead Park, Syston, Leicestershire, LE7
www.leicestertriathlonclub.co.uk
Watermead Country Park, just outside of Leicester, is
a popular wetland area for walking, cycling,
picnicking, birdwatching and fishing. There are 12
lakes, the largest of which, King Lear's Lake, is used by
Leicester Triathlon Club from May until October.

LONDON
73 Hampstead Ponds,
Millfield Lane, London N6 6JL
www.cityoflondon.gov.uk
The three swimming ponds on Highgate are
generally for pleasure swimming in costumes only,
but triathletes can now attend in wetsuits for
specific sessions.
MAIN TEXT ENTRY P.123

89 Serpentine Lido,
Hyde Park, London W2 2UH
www.swimfortri.com/open-central-serplido.asp
This lake is used all year around by the Serpentine
Swimming Club and users of the Serpentine Lido, but
now there are triathlete sessions 6.30-8.30pm on
Wednesday nights in summer. Sessions are run by
Swim For Tri.
MAIN TEXT ENTRY P.146

MIDDLESEX
274 Princes Club,
Clockhouse Lane, Middlesex TW14 8QA
www.princesclub.com/slipperyfish.asp
Princes Club is a waterski and wakeboard centre 14
miles from Central London. Open water 'Slippery
Swim' sessions are run by Glenn Walker (see
website). Changing rooms, showers, toilets, café and
gym on site. Open to members and non-members,
wet suits compulsory.

275 Heron Lake,
**The Tony Edge National Centre, Hythe End,
Wraysbury, Middlesex TW19 6HW**
www.sbrsports.com
This lake close to London attracts over 400 swimmers
each weekend. Sessions arranged by SBR Sports run
from 6am to 8.30am. Anyone can join in and
coaching is available. The 1500m circuit is marked
out by buoys and popular with channel swimmers.

SUSSEX

276 Eastbourne Sea,
Royal Parade, Eastbourne BN22 7LQ
www.eastbourneswimmingclub.org.uk
Members of the Eastbourne Swimming Club masters section swim in the sea throughout the summer, generally meeting on the beach opposite the Langham hotel. Swims are up to 3km parallel to the promenade. The club is gradually extending the season although there are fewer swimmers in winter. In summer there can be over 30 swimmers in the water.

TYNE & WEAR

278 Seaburn Centre,
Whitburn Road, Seaburn, Sunderland, Tyne And Wear SR6 8AA
www.suncitytri.com
Sun City Tri in Sunderland holds open water swim sessions at Seaburn during the spring and summer months. The sessions are great for novices gaining experience in the sea and more experienced open water swimmers can practise race tactics. The group uses the changing facilities at the Seaburn Centre then heads across the road to the beach. The sessions are open to everyone and monitored by club coaches plus beach lifeguards.

279 Hetton Lyons Country Park,
Downs Pit Lane, Hetton-Le-Hole, Houghton Le Spring DH5 0RH
www.ryton-tri.com
Ryton Tri and other groups run open water swimming sessions at the lake in Hetton Lyons Country Park, which is off the A690 between Durham and Sunderland.

SCOTLAND

280 Musselburgh Ash Lagoons,
near Musselburgh Racecourse, Linkfield Road, Musselburgh, East Lothian EH21 7RG
www.edinburghtri.org
Edinburgh triathletes use Musselburgh lagoons for open water swim training during summer. The lagoons were created by Scottish Power as a place to dump ash from Cockenzie Power Station and the tri group describes them as 'more like rain-filled ponds'. The triathletes usually swim from April to September one Tuesday a month but there are ad hoc sessions as well (see website). The lagoons are accessible by road off the B1348, just past Musselburgh Race Course.

281 Portobello Beach,
Edinburgh EH15
www.edinburghroadclub.co.uk
The triathlon branch of the Edinburgh Road Club runs Friday night sessions on Portobello beach from May to October.

WALES

282 Bala Lake/Llyn Tegid,
Llanuwchllyn, Bala, Gwynedd LL23 7DD
www.welshtriathlon.com
www.bala.co.uk
Llyn Tegid is the largest natural body of water in Wales and is set in a mountain valley. It is owned by National Parks and as swimming is allowed at any time it is used freely by triathletes for training during the summer season. Contact Welsh Triathlon for possible group sessions.

283 Coney Beach,
Porthcawl, Mid Glamorgan CF36 5BY
www.cardifftri.net
Cardiff Triathlon organise summer swim sessions at Porthcawl (and sometimes the Gower) over the summer.

WARWICKSHIRE

277 Bosworth Water Trust,
Far Coton Lane, Wellsborough Road, Nr Nuneaton, Warwickshire CV13 6PD
www.bosworthwatertrust.co.uk under Watersports
Triathlon swimmers are allowed to swim in the lake at Bosworth Water Trust on Saturday mornings and Thursday evenings during the summer. The lake is situated on the B585 within a mile west of Market Bosworth.

YORKSHIRE

284 Otley Sailing Club,
The Clubhouse, Weston Water, Bridge End Quarry, Otley, West Yorkshire
www.lbt.org.uk
Leeds and Bradford Triathlon club runs popular open water training sessions at Otley on Tuesday nights and Saturday mornings over summer.

285 Semer Water,
Countersett, (south of Askrigg) Yorkshire Dales
www.kbtc.co.uk
Yorkshire's only natural lake, this remote spot is used by Kudu Bikes Triathlon club who organise ad hoc swim sessions there over the summer. Ideal for beginners as you can stay in your depth throughout – but when it rains the temperature drops rapidly.

286 Ellerton Waterpark,
Scorton, Nr Richmond, Yorkshire
www.clevelandtriathlon.co.uk
From April onwards Cleveland Triathlon Club trains at Ellterton Waterpark on Tuesday evenings at 6pm. It's a scenic swim in a country village, with about 20 swimmers. Some members also swim on the River Tees from Yarm.

29 FESTIVE SWIMS

Going for a festive dip is a ritual all around Britain with thousands of swimmers plunging into open water (most often the sea) on Christmas Day, Boxing Day and New Year.

In many cases, the origins of the tradition are lost in the mists of time. Some festive swims, such as the Christmas Day swim at Brighton, have been going since the mid-19th century. Many are a tradition of local lifeguarding clubs, and some, such as the swims at Abersoch and Felixstowe, have only started up in the last couple of years. Building up an appetite for Christmas lunch? Bracing themselves for the year ahead? Doing something nutty for charity? Whatever their motives, nippy dippers generally don't swim far – running in and out and screaming is generally what these dips are all about.

Elaborate fancy dress is common, as is raising money for local charities and lifeboats. Turn up early – some swims ask dippers to register (mostly free) in order to be covered by their insurance.

General safety rules apply: no alcohol should be consumed before a swim and beware of the cold if you're not used to mid-winter outdoor swimming. (The over-60s and anyone with a heart condition should check with their GP.)

Most swims are organised and advertised locally so this list, put together with the help of Outdoor Swimming Society members all around the country, is not exhaustive. Dates, times and places are provided wherever possible but they may be subject to change so please check before setting off with your towel. The Outdoor Swimming Society website (www.outdoorswimmingsociety.com) has an annually-updated list and welcomes additions from swimmers. All swims are located on the map by number.

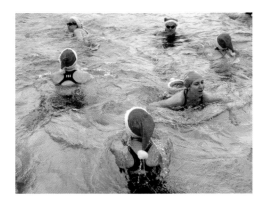

ENGLAND

CAMBRIDGESHIRE

98 Jesus Green Lido,
Cambridge
Britain's longest lido started a New Year's Day swim in 2007, from 12 noon to 2pm.
Entrance is £10 (including hot drink).
12–2pm, New Year's Day.
MAIN TEXT ENTRY P.162

DERBYSHIRE

287 Mappleton Bridge,
Mappleton
Every New Year thousands of people turn up to watch the Mappleton Raft Race and Bridge Jump. It usually consists of ten teams of three people who paddle half a mile down the River Dove (one of the coldest rivers in the UK), fling themselves off a 30ft bridge, and then run 500 yards to The Okeover Arms pub. Some turn up just to join in the jump.
New Year's Day.
www.okeoverarms.com

DEVON

288 Budleigh Salterton Beach,
Budleigh Salterton
Hundreds of locals (including children) take part in the annual Christmas Day swim at 11am on Budleigh Beach, with crazy costumes.
11am, Christmas Day.

289 Exmouth Beach,
Exmouth
A Christmas Day dip with hundreds of swimmers, and thousands of supporters.
11am, Christmas Day.
www.exmouth-guide.co.uk/xmasswim.htm

290 Sidmouth Lifeboat Station,
The Esplanade, Sidmouth
A Boxing Day sea swim which starts at 11am by the lifeboat station. In 2007, 184 swimmers registered for the free dip and hundreds of supporters came out to watch. Fancy dress is traditional with delights such as a pantomine polar bear.
11am, Boxing Day.
www.sidmouthlifeboat.org.uk

DORSET

291 Boscombe Pier,
Bournemouth
Bournemouth Spartans Winter Sea Swimming Club
Tel: 01202 304854
The Bournemouth Spartans Winter Sea Swimming Club holds the fanciest swim at 11am on Christmas morning. Crazy outfits are part of the fun in and out of the water for their annual splash in the English Channel, near Boscombe Pier.
11am, Christmas Day.

GLOUCESTERSHIRE

102 Sandford Parks Lido,
Cheltenham
A traditional Christmas Day dip takes place at Sandford Parks Lido in Cheltenham.
Christmas Day. Check time with the lido.
www.sandfordparkslido.org.uk

GUERNSEY

292 Cobo Bay
Beau Sejour Barracudas Swimming Club
Tel: 01481 255352
An annual swim in the icy English Channel attended by up to 200 swimmers.
11am, Boxing Day.
www.barracudas-sc.org.gg

ISLE OF MAN

293 Peel Beach
Peel New Year's Day Dip has been raising money for charity by persuading the brave and the foolhardy to take a quick dip in the Irish Sea (and surf) for more than 20 years. 'There can't be a better way to brace yourself for the year ahead than to wade boldly into the icy January water around the Isle of Man,' says one swimmer.
11.30am for 12 noon, New Year's Day.

LONDON

89 Serpentine Lido,
Hyde Park
The 'Peter Pan Christmas Cup Race' is an annual fixture for Serpentine Swimming Club members only at Serpentine Lido, Hyde Park. Note that you cannot join the swimming club on the day and swim in the race.
9am, Christmas Day.
www.serpentineswimmingclub.coms.
MAIN TEXT ENTRY P.146

73 Hampstead Ponds,
Hampstead
The ponds on Hampstead Heath host a number of swims. There are races on Christmas Day at Highgate Men's Pond and on New Year's Day there's a social swim at the Kenwood Ladies Pond.
11am, Christmas Day, Highgate Men's Pond (for men and women)
12 noon, New Year's Day, Kenwood Ladies Pond (women only)
MAIN TEXT ENTRY P.123

106 Tooting Bec Lido,
Tooting Bec
Tooting Bec has seasonal races open to South London Swimming Club members only.
Christmas Day, Boxing Day and New Year's Day.
www.slsc.org.uk for times
MAIN TEXT ENTRY P.172

NORFOLK

294 Blakeney Beach
Blakeney Beach
Around 30 people put a brave face on the start of their New Year by taking part in the annual Blakeney dip.
Midday, New Year's Day.

295 Cromer Beach
Cromer Beach
Charity Boxing Day swim on Cromer Beach with 100 or more swimmers.
Registration from 11am, Boxing Day.
North Norfolk Beach Runners:
www.nnbr.co.uk

296 Hunstantan Beach,
Hunstanton
Tel: 01485 572651
Started by a 'Hunstanton Seagulls Swimming Club' on Christmas Day 1947 with four of the original eight swimmers crying off at the last minute, this swim in the Wash now attracts hundreds of swimmers, thousands of spectators and impressive fancy dress costumes (sharks, swimmers dressed as a stack of presents, santas – and chimneys...)
10.30am for 11am, Christmas Day.
Organised by Hunstanton Round Table:
psearle@searles.co.uk

297 Mundesley Beach
Mundesley
A Fancy Dress Boxing Day Dip takes place at 11am each year with about 20 swimmers and 1000 spectators. Run by Mundesley Volunteer Inshore Lifeboat.
11am, Boxing Day.
www.mundesleylifeboat.co.uk

SUFFOLK

298 Cobbold's Point,
Felixstowe
Swimmers gather at 10am at Cobbold's Point for a swim at 10.30am on Christmas Day. This swim is entering its sixth year in 2008 and raises money for St Elizabeth Hospice, Ipswich.
St Elizabeth Hospice Fundraising Team
Tel: 01473 723600
10am for 10.30am.
fundraising@stelizabethhospice.org.uk

299 South Beach,
Lowestoft
Lowestoft, Britain's most easterly point, has held an annual Christmas plunge since 1967, attracting a few hundred swimmers and thousands of spectators. Last year it raised over £13,000 for charity. Swimmers gather at Hotel Hatfield on South Beach.
10am, Christmas Day.
www.splash4cash.org.uk

SUSSEX
3 Brighton Beach
On Christmas Day hundreds turn up for a festive swim in their cossies and santa outfits at 11am on Brighton Beach.
Brighton Sea Swimming Club (who will know the details but aren't official organisers) can be found at arch 205E, near Brighton Pier,
11am, Christmas Day.
www.brightonsc.co.uk/sea.htm.
MAIN TEXT ENTRY P.19

TYNE & WEAR
278 Seaburn Centre,
Sunderland
Started in 1974, the Seaburn Boxing Day dip claims to be the biggest of its kind in the northern hemisphere, attracting 1000 swimmers in fancy dress cheered on by over 5000 supporters. Swimmers are doused by the fire brigade before jumping into the North Sea. 'It's mass hysteria that takes them in and hypothermia that brings them out,' says the organiser, Stuart Kohn, from Sunderland Lions Club. Many swimmers enter in teams, and all are encouraged to arrive at the Seaburn Centre at 9.45am to register and get into costumes.
9.45am for 11am, Boxing Day.
www.lions105ne.org/clubs/sunderland.php

300 Whitley Bay
A Boxing Day swim has been held by the North Sea Volunteer Lifeguards (NSVL) every year since the club started in 1998, with swimmers jumping into the North Sea from the NSVL base at Whitley Bay.
11am, Boxing Day.
www.nsvl.org.uk

WARWICKSHIRE
277 Bosworth Water Trust,
Market Bosworth
Often there is a swim, dunk or paddle (depending on how brave swimmers feel) with triathletes and their families at Bosworth Water Trust, early on Boxing Day morning. 'Big respect goes to those who can swim out to the island and back without a wetsuit!' says one swimmer.
Has been held at 10am but check time, Boxing Day.
www.bosworthwatertrust.co.uk

YORKSHIRE
301 Lee Dam,
Lambutts, Todmorden
An annual charity race on Lee Dam, Todmorden that started in 1950 and takes place on the first Sunday of the New Year. Swimmers race to recover wooden cups thrown into the water, and trophies are presented to the winners of the men's and women's races and also for best fancy dress at the Top Brink Inn.
Registration from 1.30pm, first Sunday of the New Year.
configureeight@aol.com

SCOTLAND
302 Broughty Ferry,
Dundee
What better way to celebrate Hogmanay than joining 'Ye Amphibious Ancients' Bathing Association' (the Dundee sea swimming club) for a dip. Hundreds of swimmers meet at Broughty Ferry and wade into the Tay – occasionally they even get to break the ice.
2pm, New Year's Day.
www.yeaaba.btik.com

303 South Queensferry,
Edinburgh
Massive New Year's Day swim called the 'Loony Dook' that has been going since 1985. Some 3000 spectators gathered to witness the fantastic spectacle of around 600 'Loonys', many in fancy dress, plunge into the freezing waters of the Forth at South Queensferry.
New Year's Day.
www.theloonydook.co.uk

WALES
304 Abersoch Main Beach,
Abersoch, North Wales
Only started in 2007, by 2008 this New Year's Day swim had over a thousand spectators and at least 180 dippers raising money for the Abersoch RNLI Lifeboat. It's fancy dress and the pantomime theme for 2008 saw the Ugly Sisters, Captain Hook, Snow White and Seven Dwarves all racing for the sea.
Midday, New Year's Day.
www.rnliabersoch.co.uk

305 Cefn Sidan Beach,
Pembrey Country Park, Llanelli, Carmarthenshire
Tel: 01554 833913,
The Walrus Dip at Pembrey Country Park has been going for just over 20 years, with a few hundred swimmers dressed as anything from Vikings to walruses. The swim is held on the Blue Flag award-winning Cefn Sidan Beach, so non-swimmers can walk off the Christmas pudding with a stroll along eight miles of golden beach.
10.50am for 11am, Boxing Day.
www.carmarthenshire.gov.uk

306 North Beach,
Tenby, Pembrokeshire
Tenby Boxing Day swim is run by the Tenby Sea
Swimming Association and sponsored by a local
travel company. The swims are themed – in 2004 'The
Twelve Days of Christmas' saw 493 lords a-leaping
into the glacial waters of South Wales. Since then
themes include Legends and Children's Fairytale
Favourites. Money is raised for local charities.
11am, Boxing Day.
www.tenbyboxingdayswim.co.uk

307 Porthcawl,
South Wales
The Porthcawl Christmas Swim has been going for 40
years and is getting bigger every year, with hundreds
of swimmers and thousands of spectators. People
gather at 11am for carol singing at the Hi Tide Inn
Square, with swimmers assembling and registering
in the Hi Tide by 11.15am, and braving the winter
waves at 11.45am.
11.15am for 11.45am, Christmas Day.
www.christmasswim.co.uk

TIPS FOR WILD SWIMMING
Safety

'Wild swimming is not dangerous unless
undertaken recklessly,' says Rob Fryer. The
key is to know your limits, and swim within
them. Limits include swimming ability, cold
water acclimatisation, and how much you
know about currents, tides and the water in
front of you. Wild swimming is like any other
outdoor activity: you need to respect both
the power of nature and limits of your
experience. Plan to swim within your limits and
try to make a conservative estimate of those
limits. The basic rule is: if in doubt, stay out.

Conditions change all the time depending on
factors such as rainfall, wind, tides, the moon
and upstream wiers, and while we have swum
safely in swims numbered from 1 to 104 but it
is beyond the scope of this book to provide
comprehensive advice on currents, tides and how
to read water. However, local knowledge is
invaluable and, according to Rob, 'If you want to
know where to swim, ask teenage boys – if there's
a good swim in the area, they'll generally know.'
Lifeguards, other swimmers and other water
users (sailors, canoeists and others) are also
good people to ask when assessing a swim. But
remember that you always swim at your own
risk.

It is also a good idea to increase your own
knowledge by swimming with experienced
swimmers. Group swimming with outdoor
swimming clubs, on organised swimming
holidays and on charity or festive swims will
all increase knowledge of wild swimming in
a safe environment.

Following a few basic rules will keep you
safe in most circumstances.

Good practice

* Swim with other people who are either in
 the water, or nearby on the bank or shore.
* Stay within 100 metres of the bank or
 shore, unless you have a boat escort.

* Keep an eye out for boats – they will not be expecting you. Swimming where boats move fast has obvious risks, and even with a brightly-coloured swimming hat you may not be visible. It is sensible to swim with a kayak or boat escort flanking swimmers (all estuary swims in this book were done with boat cover for that reason).
* Don't swim in reservoirs. Apart from it generally being prohibited to swim in reservoirs, they are too deep, too cold and too big which makes it easy to get in trouble. Automatic suction systems can create downward currents and steep banks can make it hard to get out.
* Use tact! Skinny dip only when you know you can't be seen.

Gear-up for safety

* Wetsuits – wetsuits improve safety, through buoyancy and warmth. Cold is a major factor in good swimmers getting into difficulty, as muscles (and stroke rate) slow when they chill.
* Swimming hats – always wear a brightly coloured swimming hat for visibility, and choose silicon for warmth.
* Boat cover – play safe. In the Scillies we took a kayaker with us 'just in case' as local boatmen warned of currents we didn't fully understand. The conditions were so flat when we set off that he seemed redundant until halfway through the swim when the fog came in and visibility reduced to nothing. The onboard compass became extremely useful.

Plan carefully

* Do your own risk assessment. Is the water safe, flowing slowly and shallow? Or is it a torrent of milky water flowing fast, high and strong? If a river is moving faster than you can swim upstream, it will not be possible to swim to the side or out of the

path of trees or bridges.
* Locate exit points before getting in when swimming in rivers. High banks and nettles may make exits impossible for long stretches.
* Jumping is dangerous. If you can see the bottom, it's probably too shallow, and if you can't see the bottom, it's too murky to see trees or bridge buttresses or other objects that might be beneath. Always depth-test the water at the exact spot that you will enter the water if you are determined to jump, and remember that what is safe one week may have invisible and submerged objects beneath it the next. If you can't submerge yourself completely below the surface of the water with your arms stretched above your head then it's definitely not safe to jump. It is possible to knock yourself out jumping from heights.
* When sea or estuary swimming, be aware of the tides. It takes about six hours for the tide to come in and another six hours for it to go out, so there are two high tides and two low tides every day (moving on by about 50 minutes every day). When the tide is in it creates deeper water, so you don't have to go far to be out of your depth. When the tide is coming in, it can cut you off from the land unexpectedly. When the tide is going out, the natural flow of the water can pull you out to sea. The tide tables for paticular areas can be found in local newspa-pers and on the BBC weather website (www.bbc.co.uk/weather under Coast and Sea/Tide Tables).

Water cleanliness

Our rivers and lakes are cleaner than they've been in years and are regularly monitored and rated by the Environmental Agency on a scale from A to E. A is generally so pure it indicates a high mountain stream and most people are happy to swim in water rated B and C.

Water quality ratings are most likely to dip during heavy rains and floods when a greater quantity of biological and chemical pollutants may be carried into the water. To find an-up-to date rating for your river go to www.environment-agency.gov.uk/maps. Swimmers tend to swallow less water than other water users (such as windsurfers, who may fall in and gulp in shock) protecting them from stomach upsets that could occur from drinking natural water.

* Avoid swimming near blue-green algae blooms which are sometimes seen in lakes and very slow moving rivers over summer. Encouraged by warm water temperatures and stable, sunny conditions, algae are easily visible as a blue-green scum. Vomiting, skin irritation and diarrhoea are among the symptoms reported in the UK. Blooms typically gather at the edges of lakes, and it is often possible to swim in another part of the water without coming into contact with them (in many swimming and boating lakes, lake wardens will simply skim away the algae if they occur).
* Avoid swimming with open cuts or wounds in case of picking up Weil's disease – a very nasty condition that can be caught in rivers and lakes. If flu-like symptoms develop within three weeks, see your doctor. Some swimmers use waterproof plasters to protect cuts, but you might want to research the disease so that you can take your own view of the risks.
* Go to www.environmentagency. gov.uk/maps to find out the state of river cleanliness in particular areas.

COLD WATER ACCLIMATISATION

It helps to have a mindset which 'embraces the rejuvenating effects of cold water' if you want to be an outdoor swimmer. After regular use of indoor pools, a dip outside can feel bracing but it doesn't take long for indoor pools to feel unhealthily warm and only freshwater to feel invigorating or even pleasant. Live water has a soothing effect that you simply can't get in indoor pools. Outdoor swimmers don't deny that the water they swim in is cold, they just think it's lovely.

People vary hugely in their tolerance of cold water (and it isn't just a matter of body fat) but everyone can increase their tolerance by swimming in it. A triathlon wetsuit (made for swimming, unlike surf wetsuits) can also greatly extend the time you can spend in the water.

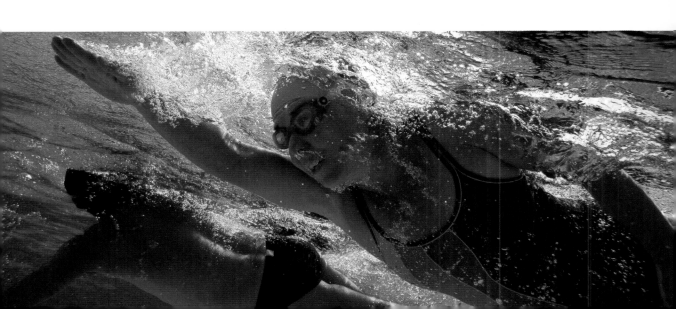

The following tips on cold water acclimatisation come from Lewis Gordon Pugh – the only man to have swum at the Arctic (-1.7°c) and off Antarctica (0°c), without a wetsuit.

* The more regularly you swim, the better you acclimatise. Summer strip and dips can be incidental but a regular cold-water habit is needed for longer swims and winter swimming. Most people recommend going at least once a week as temperatures start dropping below 12°c so the body can adjust.

* Have a good mental attitude. Is the water cold – or bracing, invigorating, rejuvenating, fresh?

* Get in with a purpose: focus on the tree or rock you are swimming to (rather than the cold gripping your ankles). 'Don't dilly dally on the edge dipping your toe in and wondering whether you are going for a swim or not; set your purpose and get in,' says Lewis. Many people find running straight in easier than slow immersion or splashing themselves.

* To avoid hyperventilation, try exhaling on entrance – sudden immersion in cold water can make the chest contract, but breathe out and the next breath comes naturally in. A little puffing is natural, but keep breathing calm and relaxed.

* Know your limits and stay within them, building up your time in cold water gradually, a few minutes at a time. When the body loses heat, muscles slow, stroke rate slows and swimming becomes increasingly difficult. A risk to swimmers is overestimating the time that they can swim in open water, attempting to cross a river or lake, and finding halfway across that their body is reacting to the cold.

OUTDOOR SWIMMING TECHNIQUE

Swimming doesn't have to be complicated and outdoors any stroke that keeps you afloat works. It's only recently that our swimming horizons have narrowed down to four official strokes (front crawl, breaststroke, butterfly and backstroke). A 1939 edition of *The Complete Swimmer* (by Sid D Hedges) gives as much weight to 'the seal stroke', 'the trudgen', 'the dog paddle' and 'the side stroke' as to front crawl and breaststroke.

Anyone who can swim can swim outdoors. Less proficient or confident swimmers can still wild swim, by choosing dips and river pools where they stay safely within their depth. A few swim lessons as an adult can radically improve your stroke – many people don't know how to breathe in front crawl but find it easy after a few lessons.

Those swimming in open water or over longer distances have two new factors to consider: chop (turbulence), and the need to 'spot' – see where you're going (without lines on the bottom of the pool). Here are some tips, with the help of Simon Murie from SwimTrek.

Tips for front crawl

* Exhale underwater.
* Practise bilateral breathing (breathing on both sides). Breathing every third stroke (to either side) is more efficient than breathing every second stroke and allows breathing away from wind and waves when necessary. The symmetry makes swimming in a straight line easier.

* Stretch your arm fully forward before placing it in the water to increase the length of your stroke.
* Glide – faster strokes does not mean faster swimming. Good long-distance swimmers often have a slow steady rhythm and good glide between strokes. Time yourself in the pool. Reducing the number of strokes you take to do a length often increases speed.
* Practise breathing above the chop. In the pool it's possible to breathe with your mouth just above the surface of the water. Outdoors it helps to rotate your head higher to avoid inhaling mouthfuls of waves in windy choppy conditions. Practise increasing that rotation. When your front arm is straight, your flat hand provides a pivoting point as you inhale: simply rotate your chin further from the surface of the water before breathing in.
* On the underwater pull, brush the thumb of your hand against your hip before taking it out of the water to finish the stroke. This is the most powerful part of your stroke.
* As you bring your arm forward, keep the elbow high, ensuring your hands clear the water in rough conditions. A good drill to practise this is to touch you ear with your hand on each stroke.
* Keep up a steady leg kick. Legs only provide a small part of your propulsion but they keep the body horizontal in the water, which makes everything easier! Men tend to drag their legs more than women without realising, because they can often move forward on upper body strength alone. Introducing a leg kick improves efficiency and elegance. A horizontal body creates less drag.
* Learn to 'spot' – to look up and see where you're going as you swim. To spot in front crawl, take a breath and then, on the next stroke, simply look forward as you swim, like a partly submerged hippo or crocodile.

Don't breathe on this stroke (your throat will be too constricted) just look up enough so that you can see and then lower your head and complete the stroke. Breathe on the next stroke.

Breaststroke

* Practise breathing well above the water surface so that your mouth clears waves in choppy conditions.
* Glide at the end of every stroke. It will make you more efficient over longer distances.
* Kick below the surface of the water for maximum propulsion.
* Be aware that swimming breaststroke can be difficult in wetsuits and aqua shoes. Wetsuits can increase the strain on your knees of the breaststroke kick, and make legs so buoyant that kicks are above the surface of the water. Few people swim breaststroke long distances in wetsuits. Aqua shoes can create the same buoyancy problem.

KIT

'We must not think of the things we could do with, but only of the things that we can't do without,' says George at the start of Jerome K Jerome's Three Men In A Boat. Wise words. It's highly possible to wild swim with nothing – just strip off, skinny dip and dry with a T-shirt or the sun or wind. But having forgotten things we needed on almost every swim trip (trunks, the map…), here is a potential checklist of things to pack:

* Swimming costume
* Goggles – Aqua Sphere Seal masks are the best ones on the market for open water swimming at the moment. Looking a little like a scuba mask, they are comfortable, give a wide-angled view of the world and don't mist
* A towel or two (fast drying, compact, pack towels are useful)

* Silicon swimming hat in a bright colour – for warmth and visibility (to other swimmers and to boats)
* Woolly hat – essential after-swim gear even in summer. Having a hat (even the silicon swimming hat) on your head while changing makes a big difference to warmth
* Warm layers – getting chilly during a swim isn't such a problem, it's not being able to warm up afterwards. Take more layers than you would normally wear. Specialist technical clothing – such as merino wool tops, thermal base layers and sheepskin Ugg boots – are worth the investment
* Triathlon wetsuit for buoyancy and warmth on longer swims
* Wetsuit booties and gloves. If you get cold hands and feet these can be useful, even without wetsuits
* River shoes – beach shoes, water shoes, river slippers, Crocs and velcro sandals can also make rocky swims, river wading and lake beds more comfortable, and many are fine to swim in
* Rash vests and swim skins – some rash vests (the thermal layer worn by surfers under-neath wetsuits) provide a good thermal top layer while swimming (others create drag in the water, ask when buying). Swim skins are thinner than wetsuits and allow you to feel the water better, but do provide some warmth
* Water bottle
* Thermos flask
* Waterproof jacket and trousers
* Walking boots and gaiters
* Waterproof sun block
* (Waterproof) camera
* Maps
* Compass/GPS, and
* A rucksack to carry it all in!

LEGAL ACCESS

The legal right to swim is currently as cloudy as the waters many people wish to swim in but here are some basic pointers.

* You have the right to swim in most tidal waters.
* In England and Wales you have the right to swim in all 'navigable waters', ie those where there are public navigation rights for boats. You must not trespass on the way in (or out) so use a public access point such as a public footpath.
* Some traditional bathing sites have gained historic bathing rights, which the landowner would have to take out a court injunction to remove.
* With rights come responsibilities. Be considerate to other land and water users. Don't litter, trespass, pollute (with noise or rubbish) or disrupt others. Do care for the environment and take responsibility for your own actions. Don't rise to or provoke conflict with other water users. People can be territorial and wild swimmers everywhere will benefit if you are non-confrontational and polite.
* In the UK, the owners of a river or riverbank own half the riverbed, which means that, as a swimmer, you could be trespassing. Owners of public land – local councils, the National Trust, the Environment Agency – may permit walking, cycling, kiting, picnicking and a host of other activities in a particular area without allowing swiming.
* In Scotland there is the 'right to roam', which was brought in under the 2003 Scottish Land Reform Act. This gives the presumption of access to all estates larger than 1000 acres, which extends to riverbanks – so, where you can ramble, you can swim.
* Further information is available through the Rivers Access Campaign (www.riversaccess.org) which is a campaign for water users to have a 'right to roam' in England and Wales as they do in Scotland.

SOME WILD SWIMMING TERMINOLOGY

Wild swimming, like surfing or sailing, has its own language. Some of the words below are slang, some are technical terms derived from other watery activities (surfing, sailing, kayaking, pool swimming, fishing) and some are ancient and Scottish/Welsh terms for wild, wet places that may be useful for map reading.

Afon, Afonydd: (Welsh) river

Aqua Shoes: shoes that can be worn in and out of the water, eg Crocs, Teva's and specially designed river shoes

Aquatic Stroll: a stroll, in water, typically ambling downstream in a river or meandering around a lake

Beck: (northern England) a fast-flowing stream or a brook, in various different dialects also referred to as a *bourn*, *burn*, *rill*, *ghyll*, *runlet* and *runnel*

Bilateral Breathing: breathing on both sides of the body while swimming front crawl, which allows outdoor swimmers to breathe away from any chop (wind blowing waves of water into the face)

Bioprene: (slang) naturally insulating fat layer (as opposed to neoprene, the insulating material that wetsuits are made from)

Boat Cover: taking a boat on a swim to look out on behalf of swimmers

Booties: neoprene boots used for watersports that keep feet warm in the water

Bourn: (chiefly southern Britain) a stream, especially an intermittent one in chalk areas

Bow: the forward end of a boat or ship

Brackish Water: slightly salty water, as found in estuaries – more buoyant than freshwater

Burn: (Scottish) small stream or brook. Also see *Beck*

Canoe: a light, open, slender boat with pointed ends, propelled by paddles (see also *Kayak*)

Channel: 1 bed of a stream or river; 2 navigable channel through a body of water; 3 broad strait that connects two areas of sea

Channel 'Crossing': swimmers who wear wetsuits are said to have 'crossed the Channel', rather than 'swum' it

Chop: turbulent irregular wave motion on the surface of the water, often created by wind

Cold Water Catatonia: (slang) a common state of extreme tiredness induced by a cold swim that affects some swimmers

Crow Land: open country

Current: steady flow of water in a particular direction

Downstream: in the direction of a stream's current

Drag: resistance that impedes movement (clothes, costumes, physical bulk and bad swimming position will all create drag in the water)

Dry Bag: type of waterproof bag that can be rolled over and made watertight and can be attached to a leash and used to carry clothes on a swim

Duck Dive: a 'tail over head' dive down into the water

Dump: (surf slang) what waves do when they break in a way that hurls swimmers or surfers down

Ebb: a receding current

Eddy: a current moving contrary to the di
rection of the main current, especially in a
circular motion (like a miniature whirlpool)

Fins: little flippers made especially for
swimming to increase speed (it's possible
tobuy breaststroke fins as well as ones for
front crawl)

Flashy River: one with a water level that
goes up and down rapidly

Flood: flood tends to refer to a river that has
burst its banks and travelled on to land that
is usually dry. ('But we have created artificial
ideas of where a river's limits should be,'
says Mark Lloyd from the Angling
Conservation Association. 'Flood plains are
just parts of the channel that the river uses
only occasionally'.) See also *Spate*

Free Diving: diving without an oxygen tank
(by lowering their heart rate and getting
into a meditative state the world's best free
divers can hold their breath for minutes)

Freshwater: water that is not salty

Ghyll: see *Beck*

Glassy: conditions where there is so little
wind or current that the water surface is
smooth enough to resemble glass

Glen: (from Scottish and Old Irish) a deep
mountain valley

Glide: the part of the stroke where you
'glide' or 'slice' through the water with ease

Gloves: neoprene gloves are used by many
winter swimmers to keep hands warm, even
if they do not wear wetsuits – it's the
extremities that get cold first

Gnarly: surf slang for intimidating seas,
usually where waves are powerful and there
are rocks in awkward places

Hyperventilation: abnormally fast or deep
breathing out of proportion to the body's
needs. (Sometimes the shock of getting into
cold water causes hyperventilation. See
Safety section)

Hydrophilia: in wild swimming language,
the state of feeling at one with the water

Hydrophobia: abnormal fear or dislike of
water

Hypothermia: abnormally low body
temperature often caused by prolonged
exposure to cold

Ice Cream Head: (slang) a gripping,
instantaneous headache from putting your
head in cold water

Infinity Pool: pool with a vanishing edge,
giving the impression that the water goes
on to 'infinity', to the horizon

Inland Waters: the global term for all
inland water e.g. rivers, lakes, canals, bays

Inland Waterways: inland rivers and
canals used for navigation whether or not
subject to public or private rights of
navigation

Kayak: differs from a canoe in that the
paddler typically uses a double-bladed
paddle (one blade on each end) and uses a
'spraydeck', a waterproof skirt that clicks
around the cockpit to make it watertight

Leash: a cord that generally attaches a
surfer's board to their leg, but can be used to
attach a small dry bag (full of clothes or
other provisions) to a swimmer's leg on
aquatic journeys

Leat (or *Lete*): a man-made watercourse or
aqueduct that supplies water to a water
mill or its mill pond

Lido: in the UK and some other countries, a
public outdoor swimming pool that has
surrounding facilities, and space for sitting
out beside it

Llyn: (Welsh) pond or lake

Loch: (or *Lough*, Gaelic/Irish English) a body of water, applied to most lakes in Scotland and to many sea inlets in the west and north of Scotland

Lumpy: (surf slang) waves that have lots of lumps and bumps (rather than breaking smoothly), often as a result of onshore wind

Mere: a small lake, pond or marsh, as in Windemere or Buttermere

Messy: (slang) when a strong onshore wind is creating lots of chop and causing waves to appear ragged and break erratically

Navigable Water: in the UK, a stream, canal or river on which or through which you can legally sail, swim or travel

Neap Tide: smaller than average tides occurring twice a month when the high tide is not as high and low tide is not as low (cf Spring Tide)

Neoprene: thermally insulating material used for making wetsuits

Offshore Wind: wind moving away from the shore (this smoothes off the face of the wave, making it more hollow and easier to swim through)

Phosphoresence: seawater sometimes develops phosphorescent bacteria which sparkle when waves break or swimmers disturb the water at night

Pont: (Welsh) bridge

Portage: carrying one's kayak, canoe or baggage overland (eg around a lock)

Rash Vest: a vest worn as a first layer under a wetsuit to minimise chafing of the skin, as well as for extra warmth

Rhaedr: (Welsh) waterfall

Rill: see *Beck*

Rip: short for rip tide, a ridge or swell moving through or along the surface of a large body of water, often used to describe a strong current heading out to sea

Riparian Land: land associated with the banks of a river or stream (landowners who own 'riparian land' generally own the stream-bed up to the centre of the stream, but not the water itself)

River Shoes: shoes designed for walking in and out of the water, useful for swim ming in rivers and lakes where shore stones are sharp. See also Aquashoes

Runlet: see *Beck*

Runnel: see *Beck*

Run-Off: water from rain or irrigation that flows over the land surface and is not absorbed into the ground, instead flowing into streams, rivers and lakes. (Run off increases when ground is saturated or impermeable and can carry pollutants, eg pesticides from a recently sprayed crop, with it into rivers.)

Seston: all material, both organic and inorganic, suspended in a waterway

Set: term used for a group of waves

Shore-Break: when waves break right on or very close to the beach on a steep sand bank, which can be dangerous for swimmers

Silicon Hats: thicker than usual swimming hats made of silicon, warmer and more suitable for outdoor swimming

Skinny Dipping: swimming without clothes

Slack: in the sea, the tide is typically 'slack' an hour either side of high and low tide which means it is still, or flowing with little speed

Spate: a sudden flood following a sudden heavy downpour or release of water from reservoirs. Rivers in spate will be flowing faster and higher than normal and may breach their banks. See also *Flood*

Spotting: looking up to see where you're going while swimming (automatic in breaststroke, but see Outdoor Swimming Technique for how to spot in front crawl)

Spring Tide: exceptionally high and low tides that occur at the time of the new moon or the full moon when the sun, moon and earth are approximately aligned (c.f. Neap Tide)

Stern: the rear part of a boat

Swell: the undulating movement of the surface of an open sea

Swim Skin: technical thin swimming layer, designed to maximise warmth in water

Tarn: small mountain lake, especially one formed by glaciers

Trudgen: old-fashioned swimming stroke similar to front crawl

Tumble Turn: the quickest way to change direction at the end of a swimming pool, a somersault in water followed by a push-off

Upstream: towards the source of a stream, in the direction against the stream or river's current

Wake: waves, ripples or path left behind by a boat moving through the water

Water: lake, as in Crummock Water, Elterwater and Wast Water in Cumbria

Wetsuit: neoprene suit that keeps swimmers and surfers warmer in the water. Triathlon wetsuits are made of more flexible material than surf wetsuits, and have less drag, making them easier to swim in. Shorties are surf suits with short arms and legs

White Caps: on windy days, the white caps or heads of foam tossing along on the tops of waves, also called sea horses.

34 WAYS TO SAY 'IT'S COLD'

Refreshing, invigorating, enlivening – or gelid, biting, brumal and freezing? Summer swimmers have it easy, but winter swimmers may need to dig deep to get in the water and at the same time describe how their swim is feeling. To help you, here are 34 synonyms for 'cold', with their various nuances of meaning.

Algid: cold, chilly

Arctic: extremely cold, frigid

Biting: nipping, smarting, keen

Bitter: causing a sharply unpleasant, painful or stinging sensation; harsh

Boreal: pertaining to the north wind

Brisk: sharp and stimulating , enlivening and invigorating

Brumal: wintry

Chilly: mildly cold

Cool: comfortably cold, free of heat, moderately cold

Freezing: capable of turning liquids to solids or cause death from frost

Frigid: very cold

Frore [frawr]: (archaic) frozen, frosty

Frosty: freezing, very cold

Gelid: extremely cold, icy

Glacial: icy

Hiemal: of, or pertaining to, winter

Icy: bitterly cold, freezing

Inclement: severe, rough, harsh, merciless

Keen: sharp, piercing, extremely cold

Nippy: chilly, sharp, biting

Numbing: depriving of feeling

Penetrating: cold that finds its way through your skin and into your bloodstream

Perishing: cold you could die in

Piercing: extremely cold or bitter

Polar: of, or pertaining to, the North or South Pole

Raw: disagreeably damp and chilly

Rimy: covered with rime (a coating of ice formed when extremely cold water droplets freeze almost instantly on a cold surface)

Severe: difficult to endure

Sharp: keenly cold, biting

Shivery: causing shivering

Sleety: of, pertaining to, or like sleet (a mixture of rain and snow or hail)

Snappy: pleasantly cold and invigorating

Stinging: causing a sharp, smarting pain

Wintry: of, or characteristic of, winter

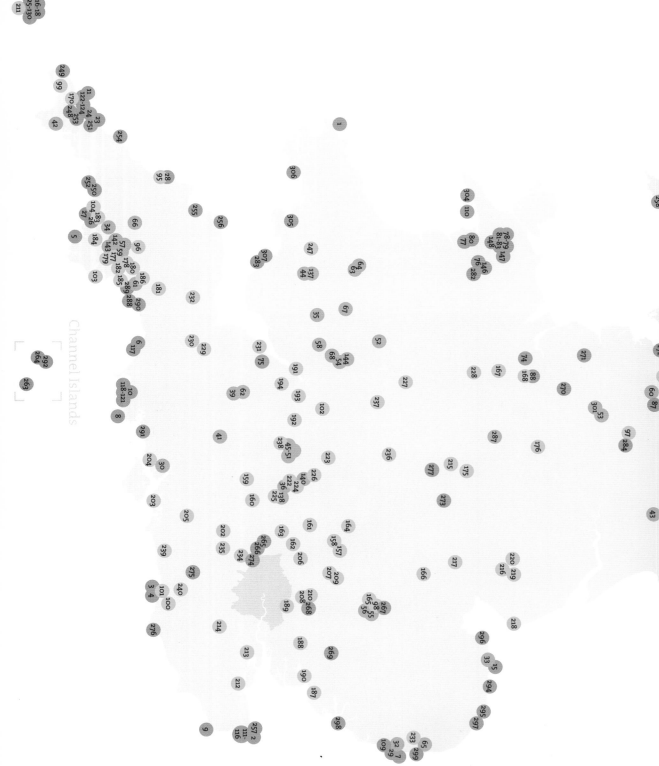

Channel Islands

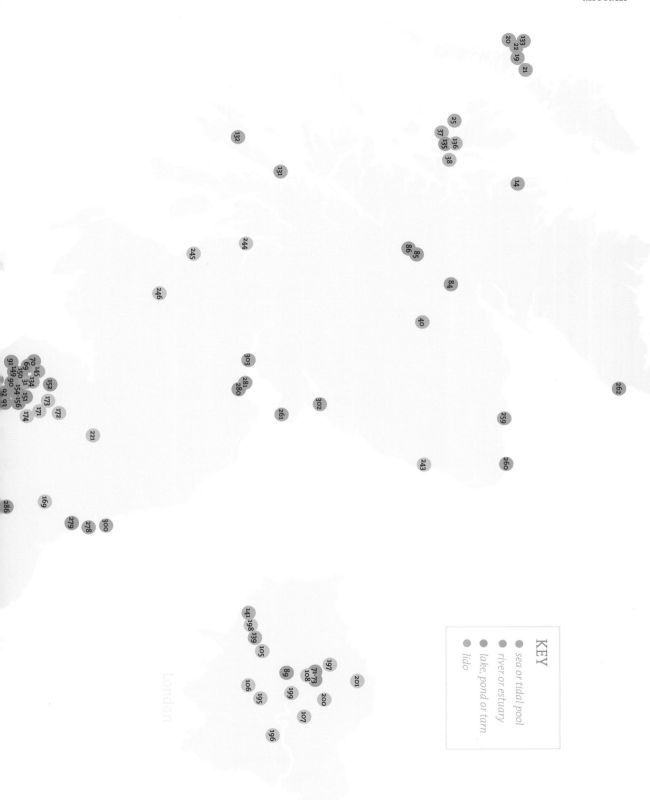

London

KEY

- sea or tidal pool
- river or estuary
- lake, pond or tarn
- lido

INDEX OF SWIMS
BY MAP REFERENCE

KEY:

- sea or tidal pool
- river or estuary
- lake, pond or tarn
- lido

SWIMS BY REGION

KEY:

- ● sea or tidal pool
- ● river or estuary
- ● lake, pond or tarn
- ● lido

ENGLAND

WILD SWIMMERS FEATURED
THROUGHOUT THIS BOOK

Dominick Tyler

Dominick, this book's photographer, started swimming outdoors when he was little. 'My grandparents had a fish pond which I went in illegally. When I got a little older a friend and I used to tell our parents we were going for a walk and then go on epic journeys in the River Lynher at Bathpool, walking in the bits that were walkable and swimming in the parts that were swimmable. We'd arrive home soaking wet and get stern lectures'. He has now swum all over Britain, his favourite swims being in the Isles of Scilly.

Michael Worthington

Out of trees, off bridges, through limestone sea caves and down what seem a bit more like ditches: Michael has broadened the range of swims we have researched for this book. He has led us across estuaries and down rivers under a full moon in autumn (and also let us use his boat). 'I definitely follow the adage that I've never been on a swim and wished I hadn't,' he says. 'Millponds in February, Scottish waterfalls any time of the year: I'm always up for it.'

Essential ingredients for a good swim? 'Like walks, I think swims benefit from some sense of adventure – if it's slightly longer than you intended, or accidentally hair-raising, it's always improved.' Michael likes swimming in the bits of rivers that aren't always seen as the best – under trees and through weeds at the edge. And he's always up

for climbing trees and jumping, taking his nieces and nephews aged between four and 10 on jumping expeditions. 'They don't complain that it's cold; just that it's not high enough.'

Beneath the guerrilla swimmer there's a great map reader and a lot of common sense about safety. 'People have got to be comfortable to have fun. If a swim scares someone or freezes them it's going to put them off. I always stay within my comfort zone so if anyone gets out of their depth I can pick up the slack.'

Vicky Peterson

Vicky swam around Dorset, Devon, Herefordshire, Oxfordshire and Cumbria for this book, and yet describes herself as a quite 'unmotivated swimmer' in that she would never go to a pool. 'I like splashing around and being nosy – seeing Thames houses from the back, seeing riverbanks and wildlife from a different perspective. I'm quite tall so I'm always looking down and it's nice to be looking up.'

She also does a fresh take on 'freestyle'. 'As you can see from the picture of me on the Waveney I don't really follow the basic strokes – in surf wetsuits I sometimes find myself almost running along on the vertical when in the water.' Why does she do it? 'I've just always loved being in the water.'

Kari Furre

Kari is the stylist of the group, a sculptor and swimming teacher who does butterfly across Norwegian fjords and takes her smooth stroke on swimming

pilgrimages, such as the swim from Alcatraz to San Francisco. She travelled around the Lake District, Outer Hebrides, Devon and Cornwall for this book. 'I often have an"Eeyore"moment before I get in where the distance, depth or cold seems off-putting, and the minute I flip the switch and get in I'm transported. I just wish I could flip the switch in the car park rather than on the waters edge.'

There's a twinkly side to her swimming too. 'The transition from land to water, to being in another medium, has a calming effect,' she says. 'You get in and you stop, the rhythm of your whole being changes, your breathing slows, your emotional state slows. With swimming, you have to be in the moment, in the present. And you're in the landscape too.'

Mark Sawyer

Mark Sawyer has the ultimate swimmer's shoulders, which he deserves, as a result of hours in the water. He swims every day all year round with the South London Swimming Club and trains three times a week with local club Spencer, swimming three to five kilometres in each session. He's done four Channel relays, Lake Windermere (17 kilometres) and some long distance sea races, and came up with some of the longer adventure swims for this book (the Seven Bay Swim and the Wye). 'The lido is a magical start to the day even when the sun isn't shining, and I don't think there's a club in the country that's more sociable. We have everyone from people in their teens to their 80s and the events we run include Sunday races, BBQs, swims on the Thames, and even attempts at the world record for mass doggy paddle – 101 swimmers doing a width together.'

As a member of SLSC he also helped to set up the World Winter Swimming Championships in Tooting Bec, complete with plastic floating icebergs, hot tubs and entrants from 22 countries including Finland and Russia.

Mark's particular love is the sea. 'It's the power of nature – the water tends to be colder, the volume is immense and you can't see the bottom. It's not a form of exercise anymore, you're going from A to B.'

Rob Fryer

Rob Fryer is the most dedicated river swimmer in the country, running the only remaining Riverbank club, Farleigh, and co-founding the River and Lake Swimming Association (RALSA). He's been researching popular bathing spots around the country since Roger Deakin's book *Waterlog* came out in 1999 and now has a list of 450 from his grassroots research, many of which he shared for this book. 'During the summer I go on the road two weekends out of three, and during the winter I also do research. I just try and find people who have lived somewhere a long time, and get the names of places where people swim or have swum. I'm quite a chatty person and I'm 80 to 90 per cent right in spotting swimmers, even when they're in a public place. There's a type of person who likes swimming outdoors,' he says. 'They don't tend to be fashion followers, they're people seeking real enjoyment and not from consumerism.'

How long is the swimming going to

carry on? 'I do tend toward crazes, things I study hard till I know all about them and move on, but no other crazes of mine have lasted this long.'

Simon Murie

Simon is the swimming superstar of the featured swimmers, a man who breaks the ice in Finland, has swum the channel and has the trunks to prove it. He owns and runs SwimTrek (www.swimtrek.com), which takes people on swimming holidays all over the world. 'I like cold water, the rushing effect of the blood around your body – the best way to feel awake is going swimming in cold water.' He swims in Tooting Bec Lido all year round, and has a particular love of undertaking significant crossings, such as the Hellespont in Turkey or the Gulf of Corryvrecken in the Inner Hebrides. 'A pool is a tedious medium to be submerged in,' he says. 'You generally know exactly how far you've gone as you can count the distance. It's wonderful to take swimmers outdoors and find they can swim much further than they think – three to five kilometres straight off – just because they're not bored.'

He also enjoys the bonding aspect of swimming trips. 'A lot of bonding goes on because you're undertaking a challenge together, doing a crossing and spurring each other on. After a week people often understand a lot more about each other than friends they've known for years socially, because with a swimming challenge you understand each other's inner self.'

Kate Rew

Kate, this book's author, grew up swimming in the river Culm which ran the length of her father's farm in Devon. 'My brother Alex and I would start at the deep section at the top of the farm, shout our echoes under a bridge, paddle frantically to get out before we got sucked over the waterfall, and then hold on to slimy rocks at the base of the falls to batter our heads under its flow.'

'From there the journey was on! A sprint down a narrow straight, knees banging against stones and minnows in clear view, joint terror around 'eel corner' and then a long stretch past willows before dodging cowpats and thistles barefoot on the way home.'

She has never lost the draw of water, scaling lido fences at university for midnight swims and jumping into rivers and seas at the slightest opportunity.

First published by Guardian Books 2008
119 Farringdon Road, London EC1R 3ER
guardianbooks.co.uk

Guardian Books is an imprint of Guardian News and Media

text © Kate Rew
photographs © Dominick Tyler
foreword © Robert Macfarlane
The Swimming Song © Loudon Wainwright III
swimming map © Guardian News and Media

A catalogue record for this book is available from the British Library

ISBN: 978-0-85265-093-6

Designed and set by Two Associates
Printed and bound in Germany by Mohn Media

ACKNOWLEDGMENTS

In addition to the wild swimmers featured in this book, we'd like to thank the following for their valuable contributions of love, laughter, advice, daring, recklessness, wisdom, logistical planning, inspiration, encouragement, validation, resourcefulness, understanding, skill, honesty, truth and spatial orientation: all vital for wild swimming (and life).

Sebastian Bailey, Ellie Baker, Amanda Bluglass, Richie Bullock, Ashley Charlwood, Rob Carrier, Lisa Darnell, Joanna Eede, Egg, Jackie Jacobs, Anne Celine Jaegar, John Cunningham Rolls, Molly Fletcher, Sally Fletcher, Gail Gallie, James Gallie, Kathryn Hall, Natalie Savona, Richard Hamerton Stove, Emma Harvey, Sophie Hughes, Mark Lloyd, James McConnachie, Robert Macfarlane, Noa Maxwell, Sophie Morrish, Yacov Lev, Nick Lishman, Oliver Pitt, Lewis Gordon Pugh, James Purnell, Beatrice Newbery, Margy O'Sullivan, Abi Traylor Smith, Lulu Wilkinson. And finally, especial thanks to Vicky Peterson, who is visible in some of the pictures and, to use a phrase of poet Andy Brown's, 'invisible in every word'.

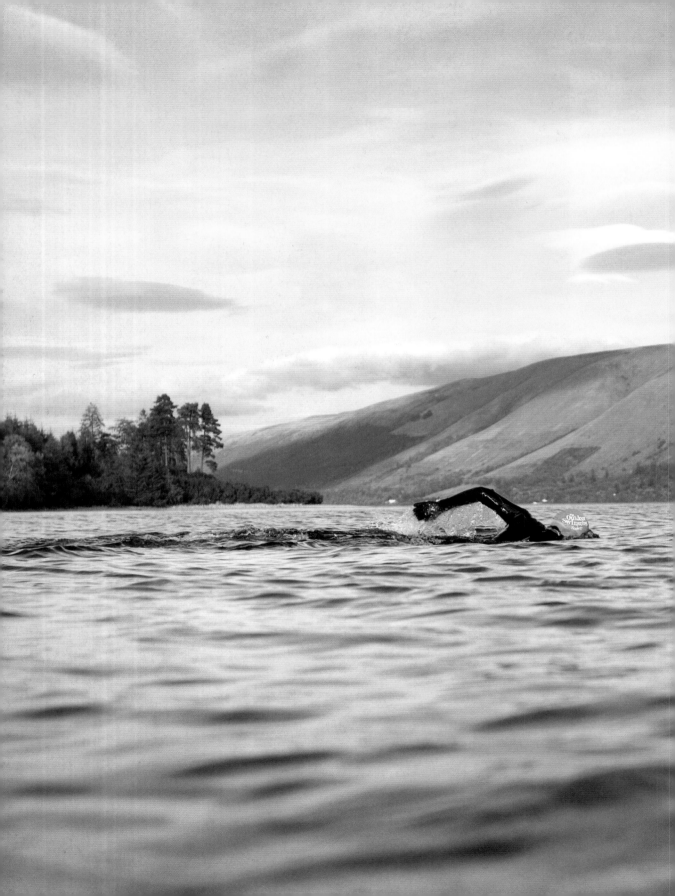